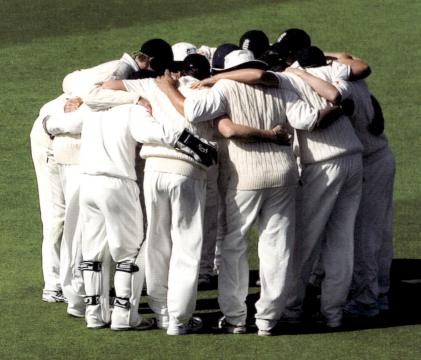

THE BRADMAN MUSEUM'S

WORLD OF CRICKET

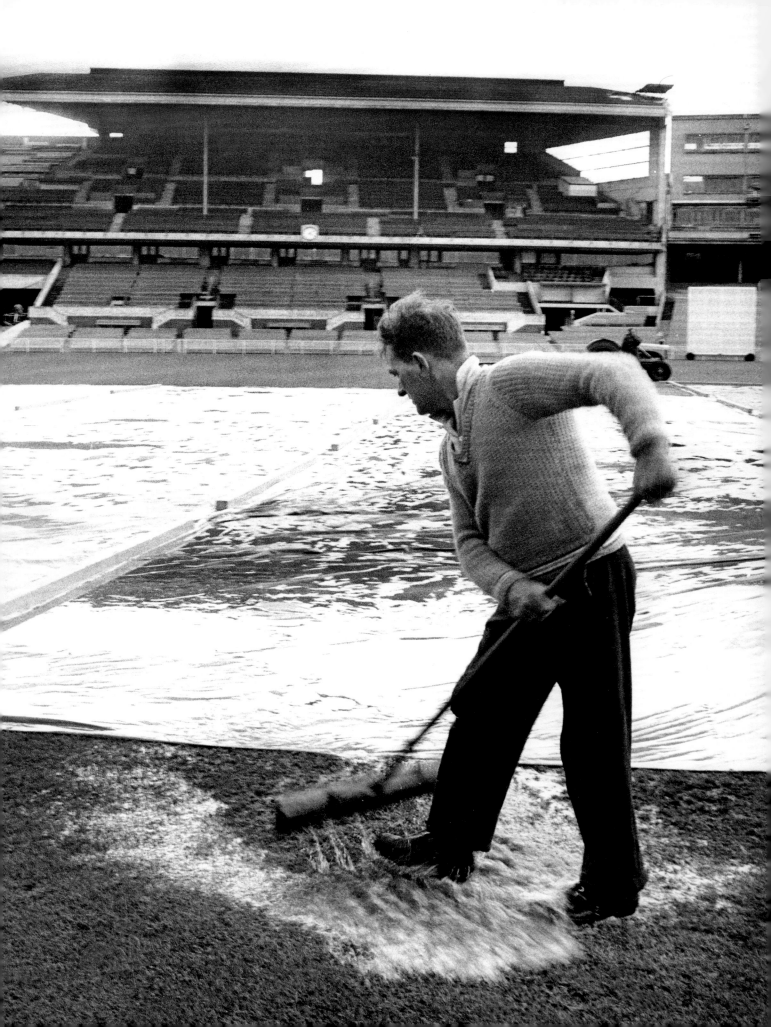

THE BRADMAN MUSEUM'S
WORLD OF CRICKET

MIKE COWARD

Photographs selected by Philip Brown

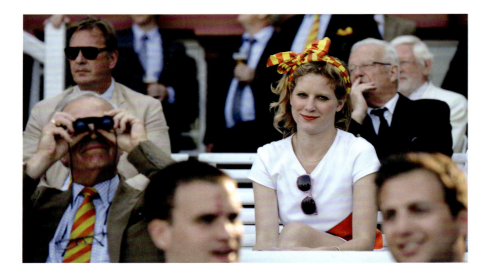

A young woman wears a headscarf in the 'egg and bacon' colours of the Marylebone Cricket Club at Lord's, a rock-solid male bastion until 1999. (Philip Brown)

PAGE II: *Cricket changed irrevocably in 1971 as a consequence of the persistent and heavy rains that ushered in the New Year in Melbourne. As no play was possible in the scheduled Third Ashes Test, the game's governors decided to program the first limited-overs international at the Melbourne Cricket Ground on 5 January. Australia won the 40-over match by five wickets. (Bruce Postle)*

First published in 2015

Copyright © Mike Coward and the Bradman Museum 2015

All rights reserved. No part of this book may be reproduced or transmitted in any form or by any means, electronic or mechanical, including photocopying, recording or by any information storage and retrieval system, without prior permission in writing from the publisher. The Australian *Copyright Act 1968* (the Act) allows a maximum of one chapter or 10 per cent of this book, whichever is the greater, to be photocopied by any educational institution for its educational purposes provided that the educational institution (or body that administers it) has given a remuneration notice to the Copyright Agency (Australia) under the Act.

Allen & Unwin
83 Alexander Street
Crows Nest NSW 2065
Australia
Phone: (61 2) 8425 0100
Email: info@allenandunwin.com
Web: www.allenandunwin.com

Cataloguing-in-Publication details are available
from the National Library of Australia
www.trove.nla.gov.au

ISBN 978 1 76011 194 6 (hardback)
ISBN 978 1 76011 195 3 (collectors' edition)

Design by Seymour Designs
Printed and bound by C&C Offset Printing Co. Ltd, China

CONTENTS

FOREWORD BY JOHN BENAUD VI

INTRODUCTION VIII

PART 1

DONALD BRADMAN'S SLIDE COLLECTION 1

SLIDING THROUGH HISTORY
by David Wells, OAM, Curator, Bradman Museum 1

SIR DONALD BRADMAN 7

THE SLIDES 8

PART 2

THE BRUCE POSTLE COLLECTION 51

A NEW BEGINNING 51

BRUCE POSTLE 57

THE PHOTOS 58

PART 3

THE VIVIAN JENKINS COLLECTION 99

EYEWITNESS TO REVOLUTION 99

VIVIAN JENKINS 105

THE PHOTOS 106

PART 4

THE PHILIP BROWN COLLECTION 147

CONSEQUENCES OF REVOLUTION 147

PHILIP BROWN 153

THE PHOTOS 154

ACKNOWLEDGEMENTS 198

Foreword

This book celebrates the art of cricket photography. So—for a fleeting moment, as long as it might take a Mitchell Johnson missile to startle Alastair Cook—imagine yourself in the space of the cricket photographer.

Finger on the button . . .

Let your mind drift a little . . . perhaps seeking out a nostalgic cricketing moment, of which there are many, though posterity invites you to look favourably on a glorious Ashes battle. Your choice falls on Steve Waugh, local hero, at stance, Sydney Cricket Ground, New Year's Test of 2003, score on 98, awaiting the last ball of the day which he . . . cover drives for four.

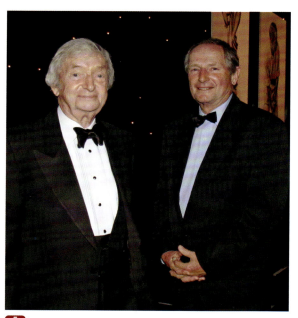

John Benaud (right), a former director of the Bradman Foundation, with his elder brother, Richie, the 28th Australian captain, and patron of the Bradman Foundation. (Bradman Museum Collection)

Click!

Such joy. As the crowd erupts you have captured a timeless moment in cricket's history. Waugh is king, his 29 hundreds the equal of Don Bradman. Your photograph tells the story.

But do not think such joy is the constant companion of the cricket photographer. Sit instead for a day—make that two—at Brisbane's Gabba. The year is 1958, December, the First Test. Heat oppressive, humidity stifling, breeze missing, England batting. Mostly it's Trevor Bailey. Makes 68 runs. Scores them over two days. In seven and a half hours he hits . . . four boundaries.

So tedious. A newspaper headline writer unsurprisingly called that match The Battle of the Snooze. Confronted by this still life in an action format how will you define 458 minutes of boredom? Even the 'good riddance' photo—a trundler from Ken Mackay nudging Bailey's stumps—is meaningless. You have to wait another day for your 'moment', a tall, dark, handsome and young Norman O'Neill, the new Australian hero, striding off the Gabba on the last afternoon, worshipped by a throng of jubilant fans, his unconquered innings of 71 signalling the arrival of Richie Benaud's winning era.

Stamina, concentration and patience are as much in a photographer's DNA as a player's. Focus, as it is for the player, is everything for the photographer. Physically theirs is a ringside seat at the fight; mentally, though, they have to be in the ring, getting a feel for the play.

Cricket photography is not just aim and fire. In the same way a player might anticipate a tactic, so the photographer must try to anticipate the 'moment' the tactic works. A photo has to project personality, reflect drama, in its own way tell the story of the contest. Cricket and its depiction have evolved over time: Tests to Twenty20, creams to vibrant coloured uniforms, day-only to day-night. Once, tight budgets made the photographer count his rolls of film like a strike-farming batsman counts balls. Digital is more generous.

In 2015 we acknowledge two major cricketing events: the eleventh staging of the World Cup, fourteen nations engaged in 49 matches of 50-over sizzle; and, celebrating its first 25 years, the Bradman Museum, a monument to the greatest Test cricketer of all time, and to the magic of cricket and all its uncertainty.

The game's eras, glorious and grim, are defined by particular events and individuals. Such moments in time, now or then, are most clearly remembered through the lens of the cricket photographer. In the following pages, closely examine the images by Bruce Postle, Viv Jenkins, Philip Brown. At the same time, reflect on the Bradman Museum's founding treasure, the Don's personal collection of historic 35 mm slides. Some simply illustrate the game's finer points, others remind us of its history, but above all they offer us a unique insight into the mind of the man whose name lives on as the most significant contributor to the greatest game of all.

JOHN BENAUD

For your added enjoyment, this book contains technology that allows you to watch exclusive video of great players, such as Sachin Tendulkar, Sir Vivian Richards, Sir Richard Hadlee and Sir Ian Botham talking about their cricket.

Download the Bradman Centre app and wherever you see the smartphone icon **scan the adjacent image**. For example, scan the photo of Richie Benaud (opposite) to see the museum's welcome and Richie's interview.

The app can be found in the iTunes Store (iOS) and Google Play Store (Android) by searching for 'Bradman Centre'. Download and open the free app, tap 'Videos', tap the Menu icon at the top right, tap 'Scan', and follow the onscreen prompts. This function will work best in a well-lit room.

We recommend using Wi-fi when possible. Watching video over cellular networks may be costly. For help please contact store@bradman.com.au

INTRODUCTION

IN 1989 THE BOY FROM BOWRAL, Sir Donald Bradman, supported the establishment of a museum in his home town that would bear his name and become a repository of historic significance for cricket's most cherished memories. His vision was a collection that would be a resource to honour and strengthen the game rather than a shrine to his life and achievements.

Donors are the backbone of any museum collection and the Bradman Museum is no different. From the beginning Sir Donald himself donated unique and important items to strengthen and enrich the collection and pay tribute to the great game. These donations have enabled the museum to interpret the game of cricket for future generations, particularly Sir Donald's achievements and values, and to honour his name, which is synonymous with the spirit of the game. The Bradman Museum pays homage to Bradman's childhood and early cricket memories by maintaining the stories associated with every item the iconic cricketer donated.

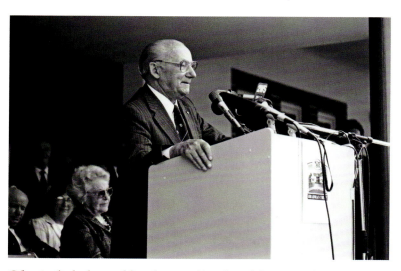

Often in the background but always at his side and foremost in his thoughts, Lady Jessie Bradman listens intently as Sir Donald speaks at the ceremonial opening of the Bradman Museum, Bowral, in October 1989. 'Our Don Bradman' was speaking to admirers from the balcony of the pavilion overlooking the beautiful oval in Glebe Park that has borne his name since 1947. (Bradman Museum Collection)

One of the museum's most significant objects is Bradman's very first bat, which can be found in the Bradman Gallery. In 1930 Bradman said: 'It was about this time that I came into possession of a real bat. And I was now the happiest boy ever. It was given to me by a Mr Cupitt, a member of the Bowral Town team. It was man's size, but that did not matter . . . With a saw my father cut three inches off the bottom, and rounded it off at the foot, and I went into the paddock with my prized possession.'

Since 1989 many individuals have generously donated significant items to enrich the museum's displays. The scope and depth of the collection now cannot be underestimated; the oldest item is a bat dating from around 1750 and the most contemporary items come from the Twenty20 domestic game and ICC-endorsed tournaments. Among the earliest items accessioned into the collection are an ornate trophy that was created from an emu egg to celebrate the Australian Ashes victory in the 1897–98 series, Fred Spofforth's

1884 tour blazer, Victor Trumper's 1904-05 Sheffield Shield premiership medal, and a match ball from the first game between New South Wales and Victoria, played in 1856.

Since its inception, the museum's collection has developed to show the diversity of cricket and its global reach, with items represented from every Test-playing nation as well as many other cricketing countries.

Over the years the museum has lent objects to other museums to assist with temporary exhibitions. For example, Bradman's service medals from World War II were on display at the Australian War Memorial as part of a tribute to war and sport, while the Sydney Cricket Ground Trust, National Museum of Australia and Museum of Sydney have been recipients of object loans over the years.

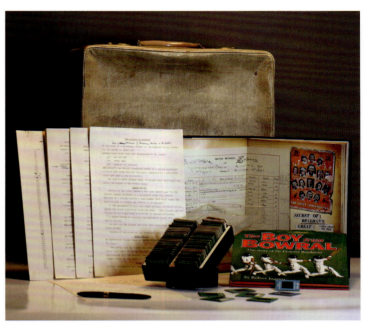
Sir Donald Bradman's slide collection.

In addition to the Bradman era, World Series Cricket is strongly represented within the collection. Many WSC objects—such as uniforms, helmets, trophies and ephemera that have sat in the attics or storage spaces of former players, administrators, affiliates and sporting fans are now showcased in the museum. Without the recent support of players including Tony Greig, Dennis Lillee and Rick McCosker, the museum's WSC collection would not have developed as it has.

Today the Bradman Museum also boasts an extensive digital collection, including recorded interviews with international cricketers both past and present. These wide-ranging and candid interviews are stored on high-definition master discs with segments available via touch screens for museum visitors to enjoy. The Philip Brown, Vivian Jenkins and Bruce Postle images that are so lavishly featured in this publication also feature prominently in the museum.

After 25 years of gathering cricket's most significant artefacts, the Bradman Museum showcases the rich diversity of the game and is now considered by many as the rightful home of cricket's memories.

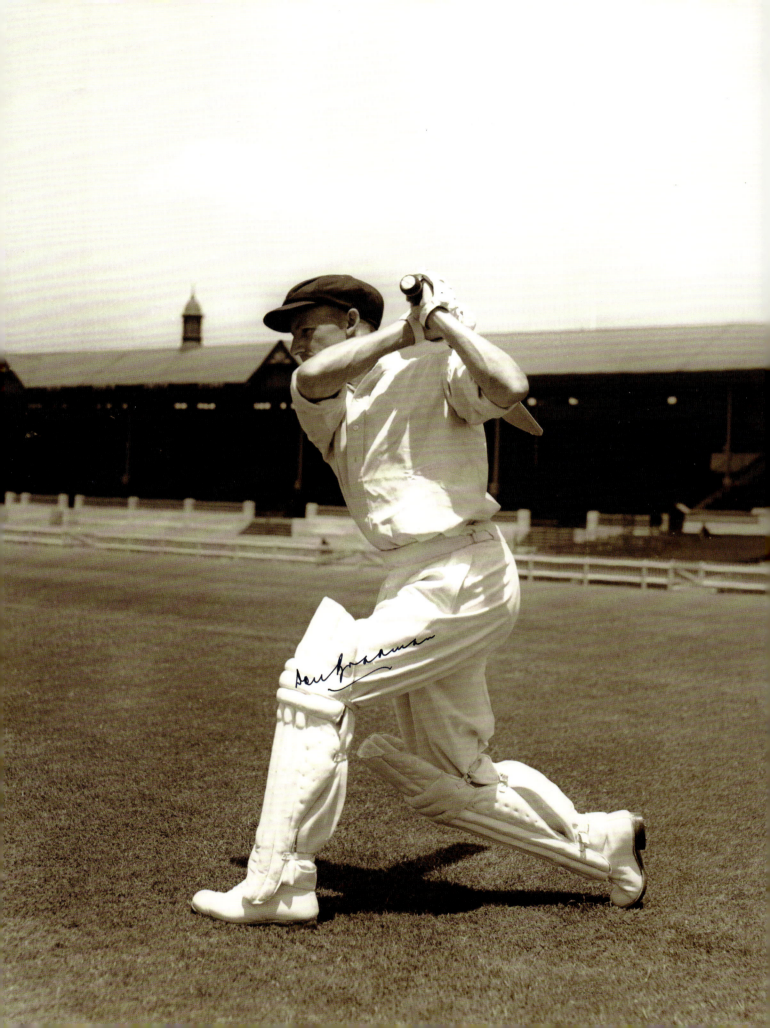

PART 1

DONALD BRADMAN'S SLIDE COLLECTION

SLIDING THROUGH HISTORY

DAVID WELLS

STORED CAREFULLY AMONG OTHER COLLECTION items at the Bradman Museum, where I started as curator in 2002, was a small, innocuous-looking cream suitcase. Inside the suitcase was a collection of 35 mm black-and-white slides. These were arrayed in plastic boxes, with the scene depicted in each slide described in Bradman's own clear prose—page after page of typed foolscap notes, along with amendments, crossings-out, asterisks, and additional comments and clarifications scrawled in blue pen. Clearly Bradman had gone back to his notes again and again, reading and re-reading, finessing the detail ahead of presentations he'd deliver from his home in Adelaide.

What struck me was Bradman's decisiveness, his perceptiveness, the sheer entertainment of his writing. The slides told the history of cricket, tracing the game's rudimentary beginnings in agrarian England through its formalisation by the aristocracy to its eventual status as a game of Empire, fit for introduction to the colonies. They ended, 136 slides later, with portraits of Test players Bradman had read about, played with or seen: Grace, Hobbs, Hendren, Larwood, O'Reilly, McCabe, Lindwall, Trueman . . . With characteristic directness, Bradman would venture his opinion on their prowess. Immediately I recognised the importance of the slides, their potential to publicly shed further light on Bradman's own character and cricket knowledge. Way back in 1930, when a young female cricketer Norene 'Girlie' Harding wrote to congratulate Bradman's mother Emily on her son's performance in that winter's Ashes series, Emily wrote back: 'I am very proud of Don. He is not only a good cricketer but has always been a good-living boy.'

The quote is instructive, and any study of Don Bradman's character begins with his mother and father, Emily and George. Of paramount importance to Emily was

OPPOSITE: A signed photo of Donald Bradman illustrating the poise and power of his driving to photographer Kenneth Crane at Adelaide Oval in 1934. Bradman included a similar image in his celebrated slide collection. (National Library of Australia, an11555750)

the way the 'boy' conducted himself. His taking apart of England's cricket team and the consequent outpouring of national jubilation were secondary. Strict by today's standards, Emily and George were resolutely supportive of their three girls and two boys, raising them in an environment of hard work, family pride, Christian values and music. The violin and piano were favoured instruments. Sing-a-longs in the Bradman family home at 20 Glebe Street, Bowral, were fondly recalled by neighbours and family members alike. Throughout Bradman's life, making and listening to music would prove powerful rejuvenating forces.

George Bradman was a respected carpenter and fence builder who worked in a timber yard. Tall and austere, he walked to and from work in an immaculate three-piece suit. Emily ran the home, like most women of her day, in between managing five busy children. Both parents came from families where cricket was regularly played and keenly discussed. Emily's brothers Richard and George Whatman were enthusiastic local cricketers, and Emily bowled her own left-arm deliveries at her youngest son in the backyard after school. 'First my parents taught me to be a cricketer off the field,' Bradman would recall in *Farewell to Cricket*, 'as well as on. It was not "did you win" but did you play the game that made the man.'

Don had an inquiring mind. Whatever task confronted him in life, he would apply himself to understanding utterly the challenge at his feet and taking decisive action to master it. As a boy he had left school at fourteen because the district had no senior high school, and started work at a Bowral stock and station agency. Somewhat self-conscious about his truncated education, he offset this perceived inadequacy partly through reading. He read widely about cricket—decades later, aware of the cricketing education books could provide, he insisted that a publicly accessible research library be part of the Bradman Museum's charter. He watched his father and uncles play the game and played himself, whenever he could, in the Bowral men's senior team. From a young age he learned not just about the physical and social enjoyment that cricket provided but the game's wider context.

His parents' influence instilled in him a sense of duty. Cricket, he marvelled, had given a boy from the country so much opportunity—international and domestic travel, meeting the rich and famous, a chance to test his skills against the world's finest players. These experiences left him duty-bound, he felt, to use his considerable influence to promote and develop the game that he loved. The Bradman Slide Collection is one small poignant example. Compiled in the shadow of his stellar on-field career, in between business directorships and cricket administration responsibilities, the slides demonstrate Bradman's lifelong interest in the fundamentals of cricket and the game's intriguing history. Meticulously and insightfully he reviews cricket's evolution, often in a jaunty and humorous style, and always exuding a palpable enthusiasm for the game being played to its most sublime standard:

SLIDE NO. 129 The finest picture of a fast bowler I've ever seen. Frank Tyson in an astounding position after delivering the ball. You couldn't possibly generate more power from the human frame than this.

SLIDE NO. 130 As a change from bowling actions, here is my favourite batting photo. Wally Hammond in all his majesty, executing a perfect cover drive. That picture is magnificent.

SLIDE NO. 134 Back to bowlers. The man whom old timers rank as the greatest of all—S.F. Barnes. Against South Africa in 1913/14 he took 49 wickets in the first 4 Tests and couldn't play in the 5th owing to illness. This performance has never been approached by anyone else.

SLIDE NO. 135 I never saw Barnes bowl, but my own choice for the greatest of all falls on Bill O'Reilly. This is a fine action study of O'Reilly. Power and control simply ooze out of that picture.

SLIDE NO. 136 In this next study of O'Reilly can't you feel the tenacity and ferocity of the fellow? Bill had the lot.

Bradman's references to O'Reilly show his enduring respect for the great bowler. He was never too proud to let off-field personal differences between the two men cloud his judgement.

SLIDE NO. 5 Neither do I know how the bishops of today would react if they saw this advertisement involving the Church of England in these professional activities.
It is on record that the Old Etonians played England for £1,500 a side. Bats were then 4/6 each. Taking the value of a bat today as a guide, it was equivalent to playing for a sum of *over** $100,000 in today's money.

A fascinating window into Bradman's interests and what he considered important opens up through the pictures he selects and comments on. His allusion to big amounts changing hands for an eighteenth-century match is a reminder of how money has always been part of the game. As an administrator Bradman was almost obsessively vigilant about the influence of money on players. To him, income was more appropriately made through a recognised profession or trade. His own relocation bore testimony to this belief, Bradman moving from New South Wales to South Australia to take up a trainee position with Harry Hodgetts' stockbroking firm in 1934—a time, ironically, when he was one of the few cricketers in the world who could probably have made a decent living from cricket. But for Bradman, as he repeatedly wrote and said, cricket was a pastime to be played and enjoyed for the game's sake.

Bradman was besieged all his adult life with requests to speak publicly, and he did so selectively. The slides were to illustrate talks for audiences with whom Bradman chose to share his knowledge in the 1960s and '70s. He had honed his oratory skills during his time as Australian captain. A superb judge of an audience, Bradman combined incisive and thoroughly researched information with humour, timing and wit.

SLIDE NO. 87 A man well known to South Australians, not only as an English international but because he came *to Adelaide* and coached *South Australian* players in the 1920's—Patsy Hendren.
 Patsy once dropped an easy catch in the outfield and a spectator yelled out 'I could have caught it in my mouth.' Patsy hastily replied 'If I had a mouth as big as yours, so could I.'

SLIDE NO. 133 I've included this one of Arthur Wood, the England and Yorkshire wicketkeeper, just to tell you a story.
 Arthur went in to bat for England at The Oval in 1938 with the score 770 for 6. He made 53 and got out with the score 876 for 7.
 As he entered the pavilion an admirer shouted 'Well played Arthur.' Arthur looked up and replied 'Thanks—I'm always at my best in a crisis.'

Another slide, using brevity to excellent effect, sketches the infamous inflictor of Bodyline bowling on Australian batsmen during the 1932–33 Ashes series:

SLIDE NO. 88 Of later vintage and lesser humour, Douglas Jardine. You can tell by looking at the picture there wasn't much compromise about him.

Bradman's notes contain frequent comparisons between past and present. The evolution of player attire interested him. No fewer than eleven slides—under the subheading 'Cricket Dress'—are dedicated to the subject.

SLIDE NO. 24 . . . We come to a more eloquent dress worn about the beginning of the 17th century.
 The usage of breeches, silk stockings, buckled shoes, frilled shirts and peculiar hats followed.

SLIDE NO. 25 The latter are in evidence in this view of a game in progress in the year of 1740.

SLIDE NO. 26 Twenty years later, here is a sample of the cricket dress of the day.

SLIDE NO. 30 . . . About 1810 trousers began to replace breeches. Braces were often used.

SLIDE NO. 31 And what braces they were. Have a look at those worn by William Lillywhite about 1827. His name on cricket bats was once as famous as any of the modern makes, and he was the originator of the famous Lillywhite's Annual . . .

SLIDE NO. 32 Then came the colour fashion. Bow ties, spotted shirts and billy cock hats became the rage.
Oxford wore dark blue shirts. Cambridge light blue.
The Harlequins wore blue trousers.
I understand that Rugby School still retains the fashion of a colored shirt.

SLIDE NO. 33 About 1900 the dress changed to something like the modern attire and there have been no major changes since, *except perhaps the move towards colored clothing for television purposes in the limited over games.*

Possibly the most intriguing, insightful descriptions adorn Bradman's playing contemporaries, such as his tribute to fellow batting star Archie Jackson, who died of tuberculosis at 23:

SLIDE NO. 106 Archie Jackson. *He made a* wonderful 164 at Adelaide in 1929 *in his first Test.* I batted with him *that day.* Three years later I was one of those who carried him to his last resting place. It all happened because he placed his love of cricket before his health.

SLIDE NO. 113 Bill Johnston. I want you to look *carefully* at these two slides. In the first one, notice the gay carefree abandon of his youthful action. Now look at the second one . . .

SLIDE NO. 114 Quite obviously his delivery is tight—not free. It is all because he has changed his foot position to try and protect his knee which had developed cartilage trouble after an injury in England.

Two England bowlers, who he encountered at the start and end of his career, are singled out for detailed comparison: Maurice Tate and Alec Bedser. Bedser was the only man to dismiss Bradman twice for a Test duck.

SLIDE NO. 118 *Possibly* the two greatest medium pace bowlers of all time were Tate and Bedser. Their actions were not very similar to watch on the cricket field but in basic principles they were very much alike. Here is Bedser coming into the delivery stride . . .

SLIDE NO. 119 Maurice Tate is shown doing the same thing but the photo has been taken a fraction of a second earlier.

SLIDE NO. 120 There is a greater similarity between the next two pictures. First
Bedser as he delivers the ball. You will find it is almost identical with this . . .

SLIDE NO. 121 As Tate delivers the ball.
What a superb position that is. You can't fault it.

In three slides Bradman himself appears. How he chooses to place himself within the sweep of the game's history is illuminating. First comes the most famous duck ever made—Bradman's final Test innings—presented with breathtakingly brief understatement:

SLIDE NO. 79 Perhaps it is only fair to also show you my last match on English soil.
Bowled Hollies for 0, at The Oval, 1948.

Next, an equally catastrophic zero during his first appearance of the Bodyline series:

SLIDE NO. 79A Another unfortunate memory. Bowled by Bowes first ball on the
Melbourne Cricket Ground 1932/3.

Often self-deprecating, history's greatest batsman publicly masked a healthy ego in the hope of thwarting the jealousy to which he was subjected throughout his life. He does, however, permit himself this one moment to savour near the end of the presentation. It follows the Wally Hammond photo previously mentioned and another of Keith Miller driving aggressively. Bradman is playing his iconic cover drive during his 452 not out against Queensland on the Sydney Cricket Ground:

SLIDE NO. 132 And one of myself executing a drive—taken *about 1930.*
It contains perhaps a shade more vigour than the others but in those days
I had it to spare. ~~Wish I could say the same today.~~

The Bradman Museum collects material in many forms. Yet it is perhaps within our growing photographic collections that the game speaks most clearly to visitors. Bradman used photos to subtly thread together notions of ambition, controversy, celebration, failure, achievement. He understood the power of the image in telling the story of cricket.

*Words in *italics* in the quoted material indicate Bradman's handwritten amendments to his typed foolscap notes.

SIR DONALD BRADMAN

DON BRADMAN SPENT THE FIRST 40 YEARS OF HIS LIFE making certain of his immortality and much of the rest of his life trying to live with the uniqueness of his mortality.

He was a genius batsman, adjudged by *Wisden Cricketers' Almanack* to be the twentieth century's greatest cricketer. Each of the 100 experts assembled from around the globe to determine the five cricketers of that century voted for him: another perfect score for an indomitable figure who strove for perfection. Runner-up Sir Garfield Sobers polled 90 votes, Sir Jack Hobbs 30, Shane Warne 27 and Sir Vivian Richards 25.

Cricket is an ancient game with a rich culture and a fantastic and fabled fascination for numbers. The one statistic burnt into the psyche of the game's followers everywhere is 99.94, Bradman's Test average. That he was one scoring shot away from an average of 100 and so nirvana will always beggar belief.

England's incomparable cricketer of the Victorian age, W.G. Grace, is the only other truly immortal servant of the game. The centenary of his death at 67 will be marked in October 2015. Bradman's legend, similarly, has intensified rather than diminished since his death at 92 in 2001.

So phenomenal was his scoring that the magnitude of the numbers tends to render him a one-dimensional figure. There is amazement, even awe, but no warmth in hard statistics. In his acclaimed 1946 work *Between Wickets*, celebrated cricket writer Ray Robinson drew attention to the dangers of seeing Bradman 'embalmed with decimal points'. He argued the maestro had been 'over-simplified to the public', had not been done full justice.

Bradman made his own emphatic observation about the relevance of statistics in *Farewell to Cricket*, one of his five books on the game. 'Figures are not entirely conclusive, especially short-term figures, but it is difficult to avoid their significance if a man produces them year after year against every type of opponent and under all conceivable conditions.'

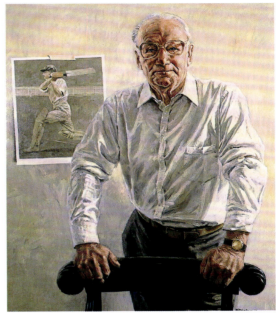

A portrait of Sir Donald Bradman by renowned artist Bill Leak, which hangs in the Bradman Museum.

He was more than a peerless cricket player. He was an insightful and intuitive captain and tactician, a canny selector, an astute and progressive administrator, and an expansive thinker, writer and correspondent on the game. He boasted a vast knowledge of cricket law and lore and in many respects was as powerful, persuasive and influential a figure off the ground as on it.

But it was as a batsman that he attained celebrity if not cult status wherever the game of Empire was played. His pomp was the 1930s, when the world was racked with political and economic chaos, Bradman offering his devotees distraction, inspiration, even perfection, in an imperfect world. His exploits as a cricket person transcended all boundaries. From the moment he toured England as a 21-year-old prodigy in 1930 he became a giant figure of Australian history.

DONALD BRADMAN'S SLIDE COLLECTION

THE HISTORY OF CRICKET

Shot of [struck] Portrait of Bradman painted in the 1950's.

IN THE MINDS OF MANY PEOPLE, CRICKET IS THE GREATEST OF ALL GAMES.
BUT ITS ORIGIN IS UNCERTAIN.

SEVERAL EARLY GAMES BORE SOME RESEMBLANCE TO IT, NAMELY

(A) CAT AND DOG

(B) STOOL BALL

(C) HAND-IN AND HAND-OUT

DR. MURRAY'S NEW ENGLISH DICTIONARY REFERS TO A FRENCH MANUSCRIPT
IN WHICH THEY FOUND THE WORD "CRIQUET", REFERRING TO A GAME WHICH
MIGHT HAVE BEEN A FORM OF CRICKET.

THE BEST EVIDENCE HOWEVER SEEMS TO SUGGEST THAT "CLUB BALL" WAS
REALLY THE PARENT OF OUR PRESENT GAME.

SLIDE NO. 1.

WRITING OF THAT EARLY PERIOD A MAN NAMED STRUTT SAID "IN THE
BODLEIN LIBRARY AT OXFORD IS A MANUSCRIPT DATED 1344 SHOWING
ETCHINGS OF 2 FIGURES PLAYING A GAME CALLED 'CLUB BALL' WHERE THE
SCORE IS MADE BY HITTING AND RUNNING AS AT CRICKET".

IN THE MANUSCRIPT IT SAYS THAT THERE ARE MALE AND FEMALE FIGURES
BEHIND THE BOWLER WAITING TO CATCH THE BALL. THESE FIGURES ARE NOT
VISIBLE ON OUR SLIDE WHICH IS CONFINED TO BATSMAN AND BOWLER.

A MODERN WRITER WHO EXAMINED THE MANUSCRIPT CLAIMS THAT THERE
ARE NO FEMALES.

HE SAYS ALL THE FIGURES ARE MONKS WITH THEIR COWLS UP AND DOWN
ALTERNATIVELY.

LOOKING AT THE SLIDE ONE CAN UNDERSTAND THIS POSSIBILITY

SLIDE NO. 2.

TO DISTINGUISH BETWEEN MALE AND FEMALE DRESSED IN THIS FASHION IS
NOT EASY.

THE ACTUAL NAME OF CRICKET WAS PROBABLY DERIVED FROM THE ANGLO-
SAXON WORD "CRIC" OR "CRYCC" MEANING A STAFF OR CROOKED STICK.
AND REMEMBER THAT THE ORIGINAL CRICKET BATS WERE CROOKED LIKE
HOCKEY STICKS AS SEEN HERE ...

SLIDE NO. 3.

IN THIS ILLUSTRATION OF A MATCH IN PROGRESS ABOUT 1770.

1

2

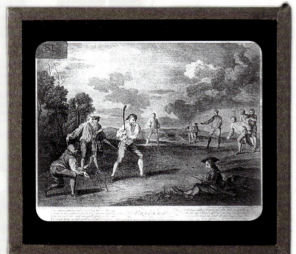

3

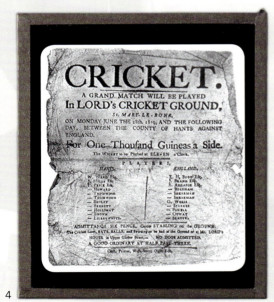

5

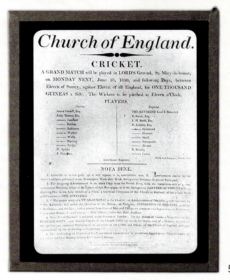

4

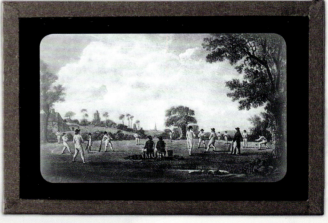

6

DONALD BRADMAN'S SLIDE COLLECTION 9

2.

IN THE EARLY DAYS IT WAS COMMON FOR MATCHES TO BE PLAYED FOR BIG STAKES. PROOF OF THIS MAY BE SEEN IN THE NEXT SLIDE

SLIDE NO. 4.

DEPICTING A POSTER ADVERTISING A MATCH FOR 1000 GUINEAS A SIDE.

I DON'T KNOW WHO PUT UP THE MONEY OR WHO TOOK THE STAKES.

SLIDE NO. 5.

NEITHER DO I KNOW HOW THE BISHOPS OF TODAY WOULD REACT IF THEY SAW THIS ADVERTISEMENT INVOLVING THE CHURCH OF ENGLAND IN THESE PROFESSIONAL ACTIVITIES.

IT IS ON RECORD THAT THE OLD ETONIANS PLAYED ENGLAND FOR £1,500 A SIDE. BATS WERE THEN 4/6 EACH. TAKING THE VALUE OF A BAT TODAY AS A GUIDE, IT WAS EQUIVALENT TO PLAYING FOR A SUM OF ~~ROUGHLY~~ over $100,000 IN TODAY'S MONEY.

SLIDE NO. 6.

NOW WE SEE A MATCH IN PROGRESS ON BROAD-HALFPENNY-DOWN, THE HOME GROUND OF THE MOST FAMOUS OF ALL THE EARLY CLUBS - HAMBLEDON - IN HAMPSHIRE.

FORMED IN 1750, THE CLUB WAS, FOR MANY YEARS, MORE THAN A MATCH FOR THE REST OF ENGLAND.

BROAD-HALFPENNY-DOWN IS NO LONGER USED FOR CRICKET BUT IS LOVELY PASTURE LAND.

SLIDE NO. 7.

STANDING ACROSS THE ROAD FROM THE DOWN IS THIS RELIC OF THOSE DAYS - THE BAT AND BALL INN - FORMERLY THE CLUBHOUSE OF THE HAMBLEDON CLUB.

SLIDE NO. 8.

YOU MAY BE INTERESTED TO KNOW WHAT TYPE OF MAN USED THE CLUB HOUSE. HERE IS ONE OF THEM - A HAMBLEDON PLAYER - A REAL CRICKET PIONEER.

IN 1785 WE HAVE THE FIRST RECORDED MATCH OF THE WHITE CONDUIT CLUB

SLIDE NO. 9.

WHICH HAD BEEN FORMED 5 YEARS EARLIER BY A COMMITTEE OF NOBLEMEN AND GENTLEMEN WHO WERE CRICKET ENTHUSIASTS.

TWO OF ITS MEMBERS WERE DISSATISFIED WITH THEIR SURROUNDINGS. ONE OF WHOM WAS THE EARL OF WINCHELSEA. HE EMPLOYED AS A LABORER,

3.

AND SOMETIMES AS A GROUND BOWLER, A MAN NAMED THOMAS LORD, AND
THE EARL SUGGESTED TO THOMAS LORD THAT IF THE LATTER WOULD OPEN
A PRIVATE GROUND OTHERS WOULD SUPPORT HIM. LORD OBTAINED AND
PREPARED A GROUND IN DORSET SQUARE, LONDON, WHERE THE FIRST
MATCH WAS PLAYED IN 1787 AND WHICH YOU ARE LOOKING AT NOW.

A YEAR LATER THE WHITE CONDUIT BECAME THE MARYLEBONE CRICKET
CLUB AND THE LAWS OF CRICKET HAVE BEEN REVISED AND RE-ISSUED
UNDER THE SEAL OF THAT AUTHORITY EVER SINCE.

SLIDE NO. 10.

CRICKET HAD BEEN PLAYED IN THE LONDON SUBURB OF MARY-LE-BONE
LONG BEFORE, AS THIS SKETCH OF A MATCH AT MARYLEBONE FIELDS IN
1748 SHOWS.

SO THE FOUNTAINHEAD OF CRICKET, THE M.C.C., DATES BACK TO 1788,

SLIDE NO. 11.

AND ITS ORIGINAL HOME WAS THE FIRST LORDS GROUND, SHOWN HERE AS
IT WAS IN 1793.

THE LAND RAPIDLY BECAME MORE VALUABLE AND IN THE FACE OF
RISING COSTS, THOMAS LORD SECURED A SECOND GROUND TO WHICH HE
MOVED HIS PRECIOUS TURF DURING THE 1810/11 WINTER.

SLIDE NO. 12.

HERE YOU SEE THOMAS LORD WHO, LIKE OTHER PIONEERS, WAS NOT IMMUNE
FROM DISAPPOINTMENTS. SHORTLY AFTER OBTAINING HIS SECOND GROUND,
PARLIAMENT DETERMINED THAT REGENTS CANAL SHOULD PASS THROUGH IT.
LORD COULDN'T VISUALISE A CRICKET GROUND WITH A CANAL IN THE
CENTRE OF IT SO IN THE WINTER OF 1813/14 HE AGAIN PHYSICALLY
REMOVED HIS PRECIOUS TURF TO THE PRESENT SITE IN ST. JOHN'S WOOD
WHERE THE FIRST MATCH WAS PLAYED IN JUNE 1814.

SLIDE NO. 13.

I HAVE NO ETCHING OF THAT YEAR, BUT THE SLIDE YOU ARE VIEWING
SHOWS A MATCH AT LORDS 4 YEARS LATER, 1818.

IT IS ON RECORD THAT MRS. LORD WAS A GREAT ENCOURAGEMENT TO
HER HUSBAND

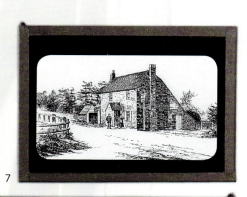

7

8

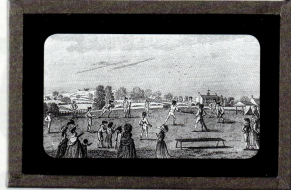

9

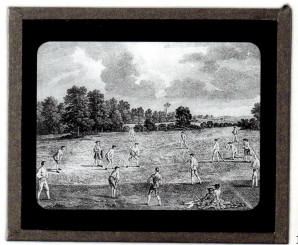

10

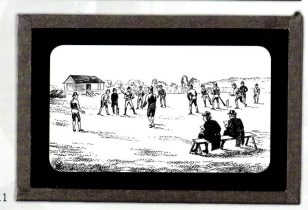

11

12

13

THE BRADMAN MUSEUM'S WORLD OF CRICKET

 SLIDE NO. 14.

I DON'T KNOW WHETHER SHE PLAYED BUT THIS PRINT PROVES THAT THE LADIES

DID PARTICIPATE IN CRICKET AS LONG AGO AS 1811.

 ALL THE MARYLEBONE CRICKET CLUB'S POSSESSIONS, SCORE BOOKS, AND TROPHIES

WERE HOUSED IN A WOODEN PAVILION AT LORDS BUT REGRETTABLY EVERYTHING WAS

DESTROYED BY FIRE A FEW HOURS AFTER THE WINCHESTER v HARROW MATCH IN 1825

AND MANY HISTORIC RECORDS WERE LOST FOR EVER.

 SLIDE No. 14a

 ANOTHER MAN WHO DID MUCH FOR CRICKET WAS MR. J. H. DARK, PICTURED HERE.

 HE BECAME PROPRIETOR OF LORDS IN 1835 AND ABOUT THAT PERIOD THE GROUND WAS

KNOWN AS "DARKS" GROUND JUST AS MUCH AS "LORDS" GROUND.

 THE ALL ENGLAND CLUB WAS FORMED IN 1846.

 SLIDE No. 14 b.

 HERE YOU SEE THEM WITH THE GREAT ALFRED MYNN, KNOWN AS THE LION OF KENT,

FOURTH FROM THE LEFT.

 BEFORE THAT TIME CRICKET WAS CONFINED TO CERTAIN DISTRICTS AND MOST OF

THE COUNTRY CLUBS WERE ATTACHED TO SOME NOBLEMAN.

DINNERS AFTER THE GAME WERE AN IMPORTANT PART OF THE PROCEEDINGS.

 A REPORT OF ONE DINNER AFTER A MATCH BETWEEN KINGSCOTE AND EPSOM CLUBS,

DESCRIBES THE AMOUNT OF FOOD EATEN AND DISCLOSES THAT THE CELLAR RAN DRY.

 THE CHAIRMAN IS SAID TO HAVE CLOSED THE INNINGS OF THE CLARET WITH THESE

REMARKS.

 "GENTLEMEN I AM SORRY TO SAY THERE IS ONLY ONE BOTTLE LEFT AND AS IT

WOULD BE RIDICULOUS TO DIVIDE THAT AMONG SO MANY, WITH YOUR PERMISSION, I WILL

DRINK IT MYSELF".

 AND HE PROCEEDED TO DO SO.

14

14a

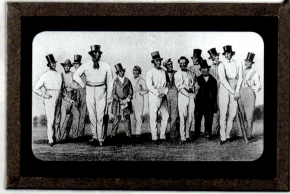
14b

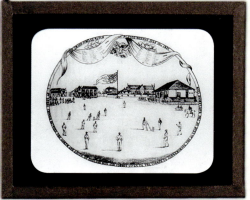
15

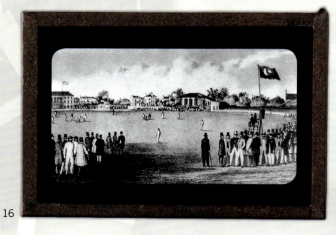
16

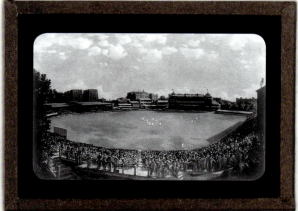
17

14 THE BRADMAN MUSEUM'S WORLD OF CRICKET

4.

SLIDE NO. 14A. 14.

I DON'T KNOW WHETHER SHE PLAYED BUT THIS PRINT PROVES THAT
THE LADIES DID PARTICIPATE IN CRICKET AS LONG AGO AS 1811.

SLIDE NO. 15.

LORDS AS IT WAS IN 1837 IS SHOWN HERE. DEVELOPMENT WAS NOT
VERY FAST ALTHOUGH YOU CAN NOTICE AN IMPROVEMENT BY 1850, THE
DATE OF THE NEXT PICTURE.

SLIDE NO. 16.

THE GROUND WAS HELD ON LEASE AND WHEN THE FREEHOLD WAS SOLD IN
1860, THE CLUB STRANGELY DECLINED TO BID FOR IT, DESPITE REQUESTS
FROM THE SECRETARY AND OTHERS.

IT WAS SOLD FOR £7,000. SIX YEARS LATER, THE PURCHASER SOLD
IT BACK TO THE CLUB FOR ABOUT £18,000.

IN 1887 THE CLUB PURCHASED HENDERSON'S NURSERY OF 3½ ACRES
WHICH ADJOINED ONE END OF THE GROUND. THAT AREA IS TODAY USED
FOR PRACTISE. IT IS OPPOSITE THE MEMBERS' PAVILION AND GIVES
RISE TO THE EXPRESSION THAT SO AND SO IS BOWLING FROM THE NURSERY
END.

FURTHER ADDITIONS TO THE GROUND HAVE OF COURSE BEEN MADE

SLIDE NO. 17.

THIS COMPARATIVELY MODERN PHOTO GIVES YOU AN IDEA OF WHAT IT
IS LIKE TODAY.

IN A CITY OF SOME TEN MILLION PEOPLE IT STILL HOLDS ONLY ABOUT
THIRTY THOUSAND SPECTATORS AND ITS USE IS CONFINED SOLELY TO
CRICKET.

SLIDE NO. 18.

THIS UNIQUE PICTURE SHOWS THE PLAYERS LYING PRONE ON THE GROUND
AS A GERMAN BOMBER SQUADRON INTERRUPTED A SERVICES MATCH DURING
THE WAR.

SLIDE NO. 19.

HERE IS A SLIDE OF THE FAMOUS LONG ROOM AT LORDS WHERE SO MANY
HISTORIC MEMENTOES ARE KEPT AND THROUGH WHICH THE PLAYERS OF BOTH
TEAMS MUST PASS ON THEIR WAY TO THE PLAYING FIELD FROM THE DRESSING
ROOMS. *

IN REGARD TO LORDS, A WRITER IN THE EARLY DAYS SAID THE PITCH
RESEMBLED A BILLIARD TABLE ONLY IN THE POCKETS.

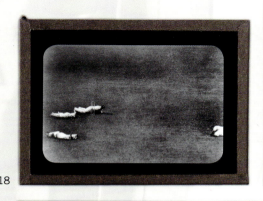
18

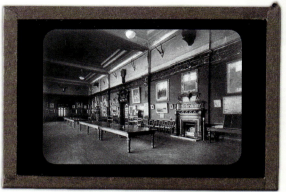
19

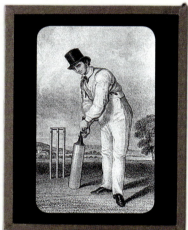
20

21

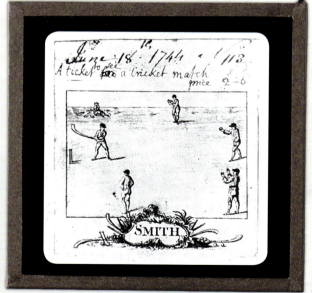
22

16 THE BRADMAN MUSEUM'S WORLD OF CRICKET

5.

SHEEP WERE BROUGHT IN A DAY OR TWO BEFORE THE GAME TO BRING
THE GRASS DOWN.

SLIDE NO. 20.

HERE WE SEE THEM GRAZING AT LORDS IN 1836. THE INTRODUCTION
OF A MOWING MACHINE WAS OPPOSED FOR A LONG TIME, ESPECIALLY BY
ONE GENTLEMAN NAMED THE HON. GRIMSTON, WHO LATER BECAME PRESIDENT
OF M.C.C. NOT FOR THAT REASON I HOPE.

AT A PLACE CALLED TRURO, A FIELDSMAN PUT UP A BRACE OF
PARTRIDGES FROM THE LONG GRASS, WHILST AT GLASGOW, FULLER PILCH

SLIDE NO. 21.

PICTURED HERE, A FAMOUS PLAYER OF HIS GENERATION, BORROWED A
SCYTHE TO CUT THE GRASS ON THE PITCH BEFORE THEY COULD START.

ADMISSION CHARGES AS LONG AGO AS 1744 WERE 2/6

SLIDE NO. 22.

AS WILL BE SEEN BY THIS SLIDE OF AN ADMISSION TICKET FOR A MATCH
KENT V ENGLAND.

CONSIDERING THE SUBSEQUENT DEPRECIATION IN CURRENCY, THE PUBLIC
SEEM TO BE WELL TREATED TODAY.

NOW LET ME DEAL WITH SOME OF THE CHANGES WHICH OCCURRED IN THE
EVOLUTION OF THE GAME.

CRICKET DRESS SLIDE NO. 23.

FIRST WE SEE THE OLD FASHIONED ATTIRE WORN IN THE PERIOD OF
CLUB BALL.

SLIDE NO. 24.

THEN WE COME TO A MORE ELOQUENT DRESS WORN ABOUT THE BEGINNING
OF THE 17TH CENTURY.

THE USAGE OF BREECHES, SILK STOCKINGS, BUCKLED SHOES, FRILLED
SHIRTS AND PECULIAR HATS FOLLOWED.

SLIDE NO. 25.

THE LATTER ARE IN EVIDENCE IN THIS VIEW OF A GAME IN PROGRESS
IN THE YEAR OF 1740.

SLIDE NO. 26.

TWENTY YEARS LATER, HERE IS A SAMPLE OF THE CRICKET DRESS OF
THE DAY.

23

24

26

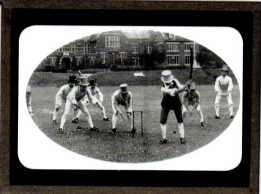

25

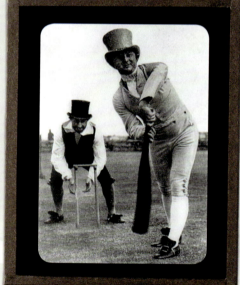

27

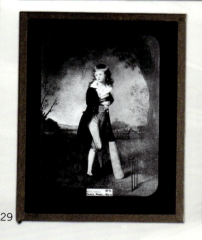

28

29

30

THE BRADMAN MUSEUM'S WORLD OF CRICKET

6.

SLIDE NO. 27.

WHAT WOULD YOU GIVE TO SEE A TEAM FILE ONTO THE ADELAIDE OVAL TODAY WITH THESE TOP HATS. THEY APPEAR MORE SUITABLE FOR THE DERBY THAN A CRICKET MATCH.

SLIDE NO. 28.

AND HOW ABOUT THIS GORGEOUS OUTFIT OF TOP HAT, SILK BREECHES AND BUCKLED SHOES.

~~SID BARNES LIVED IN THE WRONG ERA.~~

SLIDE NO. 29.

ROYALTY SUPPORTED THE GAME THEN, AS NOW. BUT WHAT A COMPARISON BETWEEN SAY THE DUKE OF EDINBURGH IN HIS CREAMS WITH THIS GENTLEMAN WHO IS NONE OTHER THAN GEORGE, THE PRINCE OF WALES, IN ALL HIS CRICKETING SPLENDOUR.

SLIDE NO. 30.

THIS IS LORD FREDERICK BEAUCLERK, RATED BY HISTORIANS AS THE GREATEST NAME IN THE HISTORY OF M.C.C. HE WAS A FINE PLAYER AND A TREMENDOUS INFLUENCE AROUND THE YEAR 1800.

ABOUT 1810 TROUSERS BEGAN TO REPLACE BREECHES. BRACES WERE OFTEN USED.

SLIDE NO. 31.

AND WHAT BRACES THEY WERE. HAVE A LOOK AT THOSE WORN BY WILLIAM LILLYWHITE ABOUT 1827. HIS NAME ON CRICKET BATS WAS ONCE AS FAMOUS AS ANY OF THE MODERN MAKES, AND HE WAS THE ORIGINATOR OF THE FAMOUS LILLYWHITE'S ANNUAL. THEY GAVE HIM A BENEFIT MATCH AT LORDS WHEN HE WAS 61.

SLIDE NO. 32.

THEN CAME THE COLOR FASHION. BOW TIES, SPOTTED SHIRTS AND BILLY COCK HATS BECAME THE RAGE.

OXFORD WORE DARK BLUE SHIRTS. CAMBRIDGE LIGHT BLUE.

THE HARLEQUINS WORE BLUE TROUSERS.

I UNDERSTAND THAT RUGBY SCHOOL STILL RETAINS THE FASHION OF A COLORED SHIRT.

SLIDE NO. 33.

ABOUT 1900 THE DRESS CHANGED TO SOMETHING LIKE THE MODERN ATTIRE AND THERE HAVE BEEN NO MAJOR CHANGES SINCE, *except perhaps the move towards coloured clothing for television purposes. in the limited over games.*

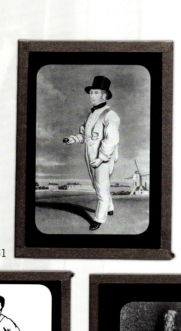
31

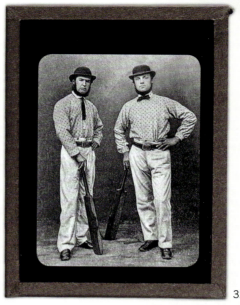
32

33

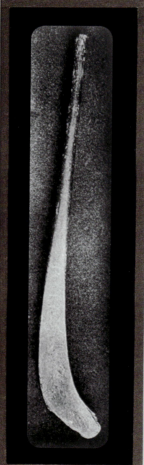
34

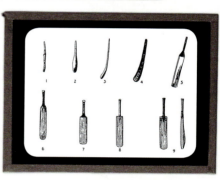
35

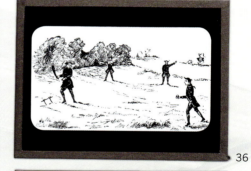
36

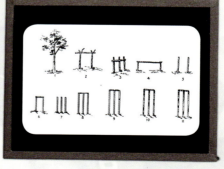
37

20　　THE BRADMAN MUSEUM'S WORLD OF CRICKET

7.

THE BAT SLIDE NO. 34.

 THE BAT WAS ORIGINALLY CURVED AS YOU WILL OBSERVE IN THIS SLIDE OF THE OLDEST BAT KNOWN. IT WAS OF COURSE CURVED TO DEAL WITH UNDERARM BOWLING.

 THERE WERE AT FIRST NO RESTRICTIONS AS TO SIZE, BUT IN 1774 THE WIDTH WAS LIMITED TO 4¼ INCHES. IN 1835 THE LENGTH WAS RESTRICTED TO 38".

 CANE HANDLES WERE INVENTED IN 1853.

SLIDE NO. 35.

 HERE YOU SEE THE CHANGES IN SHAPES AND SIZES OVER THE YEARS.

 IN 1820 WILLIAM WARD MADE A SCORE OF 278 WITH A BAT WEIGHING 4 LBS. 2 OZS.

 TODAY THE AVERAGE WEIGHT IS ~~NEARER HALF THAT.~~ *very much less.*

THE PITCH HAS ALWAYS BEEN 22 YARDS LONG BUT THE SIZE OF THE WICKETS HAS BEEN CHANGED ON NUMEROUS OCCASIONS.

SLIDE NO. 36.

 HERE YOU SEE A MATCH IN PROGRESS ABOUT 1770 DEPICTING CLEARLY THE OLD GOAL POST TYPE OF WICKET.

SLIDE NO. 37.

 THEN WE SEE A SERIES OF WICKETS ILLUSTRATING THE DEVELOPMENT OF THE VARIOUS TYPES FROM THE VERY BEGINNING.

SLIDE NO. 38.

 FINALLY YOU SEE A SUPER-IMPOSED DRAWING WHICH GIVES THE COMPARISON BETWEEN THE ORIGINAL 2 STUMPS, 24" WIDE AND 12" HIGH, 1 BAIL, AND THE MODERN 3 STUMPS, 9" WIDE, 28" HIGH, WITH THE STAGES OF GROWTH IN BETWEEN.

SCORING SLIDE NO. 40.

 THE SCORE WAS AT FIRST RECORDED BY CUTTING NOTCHES IN STICKS.

 HERE WE SEE SOME OLDTIMERS BUSILY DOING SO.

SLIDE NO. 41.

AND HAVE YOU EVER SEEN A HAPPIER PICTURE THAN THIS OLD SCORER WITH HIS QUILL PEN AND HIS BOTTLE OF REFRESHMENT. IF ONLY IT WAS A COLOR SLIDE, I'LL BET HIS NOSE IS BRIGHT RED.

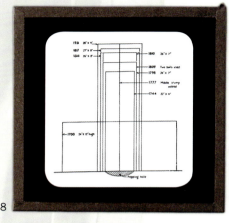
38

40

41

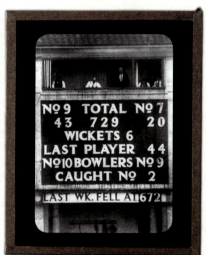
42

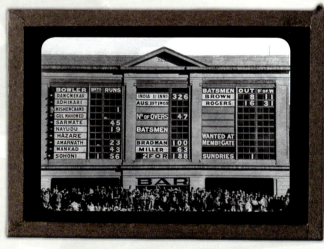
43

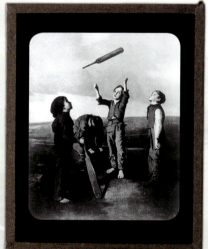
45

22 THE BRADMAN MUSEUM'S WORLD OF CRICKET

SLIDE NO. 42.

IN ADDITION TO THE MEN WITH THE SCORING BOOK, WE NOW HAVE SCORE BOARDS, THOUGH AT MANY PLACES, INCLUDING LORDS WHOSE SCORE BOARD IS PICTURED HERE, YOU STILL HAVE TO BUY A SCORE CARD TO FIND THE NUMBERS OF THE PLAYERS SO THAT YOU MAY UNDERSTAND THE SCORE BOARD.

SLIDE NO. 43. *on the day I made my hundredth century)*

I STILL THINK THE SYDNEY SCORE BOARD (SHOWN HERE) TO BE THE MOST ATTRACTIVE LOOKING IN THE WORLD FROM AN ARCHITECTURAL POINT OF VIEW (EVEN THOUGH IT HAS A BAR SIGN UNDERNEATH). *Sadly it has been replaced by the ~~electronic scoreboard and is no longer~~ modern electronic marvel.*

SLIDE NO. 44.

~~IN SOME RESPECTS THIS NOTTINGHAM SCORE BOARD EXCEEDS THEM ALL.~~

~~THANKS TO A KIND BENEFACTOR WHO PROVIDED THE MONEY, THE SCORES OF THE 2 BATSMEN AT THE WICKETS, SUNDRIES AND THE TOTAL ARE WORKED ELECTRONICALLY THROUGH A DIAL SIMILAR TO A TELEPHONE, AND THE FIGURES WHICH ARE RECORDED BY BLACK AND WHITE BALLS, CHANGE IN A FLASH.~~ *44 omitted Lords score board.*

out?

SLIDE NO. 45.

TOSSING FOR INNINGS HAS BEEN THE CUSTOM SINCE THE GAME STARTED.

IT IS DONE WITH A COIN BUT ONE OF THE WORLD'S MOST FAMOUS PICTURES IS THIS ONE FROM THE LORDS GALLERY, SHOWING YOUTHS TOSSING A BAT FOR CHOICE OF INNINGS. *

SLIDE NO. 50.

THIS FUNNY LOOKING LITTLE CHARACTER, HEIGHT 5'4", IS JOHNNY WISDEN, A GREAT PLAYER IN HIS DAY AND FOUNDER OF WISDEN'S ALMANACK, WHICH REMAINS EVEN NOW THE CRICKETERS' BIBLE.

SLIDE NO. 51.

THE FIRST PRONOUNCEMENT REGARDING CRICKET IN AUSTRALIA IS CHRONICLED IN 1810 AND THE FIRST RECORDED SCORES OF A GAME IN SYDNEY, 1833.

THIS SCENE SHOWS THE ARRIVAL IN 1861, AT THE CAFE DE PARIS, BOURKE STREET, MELBOURNE, IN THEIR HORSE-DRAWN VEHICLES, OF THE FIRST ENGLISH TEAM TO VISIT AUSTRALIA. BELIEVE IT OR NOT, I WENT FROM THE MELBOURNE CRICKET GROUND TO SPENCER STREET RAILWAY STATION, IN A SIMILAR VEHICLE AT THE END OF THE 5TH TEST ~~IS~~ *in 1929* ~~EXACTLY AS 1929.~~

50
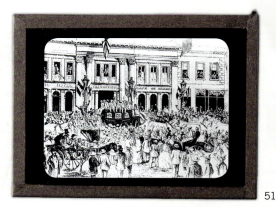
51

52
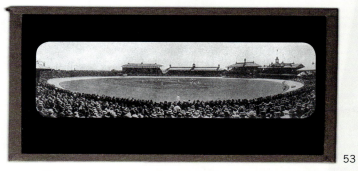
53
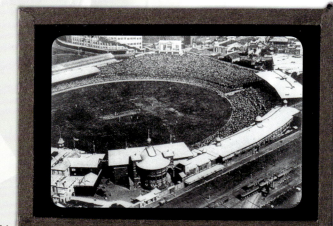
54
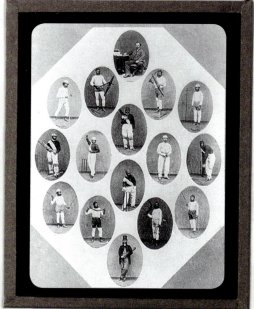
55

24 THE BRADMAN MUSEUM'S WORLD OF CRICKET

9.

SLIDE NO. 52.

THIS IS THE SAME ENGLISH TEAM, IN THE SUMMER OF 1861/2, PLAYING AGAINST 22 OF N.S.W. IN THE SYDNEY DOMAIN. AS YOU CAN SEE THE WHOLE 22 ARE FIELDING. I'M GLAD I WASN'T A BATSMAN IN THOSE DAYS.

THAT SYDNEY PICTURE IS VERY DIFFERENT FROM THE NEXT ONE ...

SLIDE NO. 53.

... TAKEN OF THE SYDNEY CRICKET GROUND IN 1911, WHEN THERE WAS A CYCLE TRACK AROUND THE GROUND. MY FATHER HELPED PUT THE ELECTRIC LIGHTS ROUND THE TRACK.

SLIDE NO. 54.

HERE WE SEE THE SYDNEY CRICKET GROUND TAKEN FROM THE AIR *in the 1930's* AND GIVING A SPLENDID VIEW OF THE FAMOUS HILL, *as it was in those days.*

THE FIRST AUSTRALIAN TEAM TO VISIT ENGLAND WAS IN 1868 WHEN A WHITE MAN NAMED LAURENCE CAPTAINED A TEAM OF ABORIGINALS.

HERE THEY ARE ...

SLIDE NO. 55.

SOME OF THEIR NAMES WERE:

 MULLAGH
 DICK-A-DICK
 RED CAP
 TIGER
 JIM CROW
 KING COLE
 TWOPENNY
 BULLOCKY
 JIMMY MOSQUITO

THEY WORE COLORED SASHES SUCH AS MAROON, PINK, YELLOW AND MAGENTA FOR IDENTIFICATION. ~~FROM MY EXPERIENCE WITH THE WEST INDIANS IN AUSTRALIA I THINK IT WAS A GOOD AND NECESSARY IDEA.~~

THESE ABORIGINALS WERE MEMBERS OF THE WERRUMBROOK TRIBE, A RACE THEN LIVING IN VICTORIA, BUT NOW EXTINCT.

IN THE PHOTO SOME APPEAR TO BE WEARING SHORTS OVER THEIR TROUSERS. SOME HAVE BARE FEET. SOME CARRY SPEARS - SOME BOOMERANGS.

AT FIRST THEY HAD DIFFICULTY IN ARRANGING MATCHES BUT AFTER A GAME AT THE OVAL, THEY PUT ON AN EXHIBITION OF SPEAR AND BOOMERANG THROWING WHICH APPEALED TO THE CROWD. ALSO, DICK-A-DICK ALLOWED 5 GENTLEMEN OF SURREY TO PELT HIM WITH CRICKET BALLS BUT

10.

HE SWAYED AND DODGED THEM SUCCESSFULLY. THEY BECAME AN
ATTRACTION AND IN ALL PLAYED 47 MATCHES.

AFTER THE LONG AND UNCOMFORTABLE BOAT JOURNEY AND WITHOUT
TODAYS MOTOR TRANSPORT, THIS WAS A STRENUOUS PROGRAMME.

MULLAGH WAS THEIR BEST PLAYER. HE IS IN THE 2ND CIRCLE FROM
THE TOP IN THE CENTRE. HE MADE 1670 RUNS, TOOK 250 WICKETS AND
IN HIS SPARE TIME KEPT WICKETS, CLAIMING 40 VICTIMS.

SUNDOWN (IN THE LOWER LEFT CIRCLE) PLAYED IN ONLY 2 MATCHES
OUT OF THE 47. HE MADE 1 RUN IN THE FIRST, BUT WAS NOT SO
SUCCESSFUL IN THE SECOND. HE NEVER MADE A RUN BEFORE THE TOUR
NOR CAN IT BE FOUND WHERE HE EVER MADE A RUN AFTERWARDS.

THE WEATHER DID NOT IMPROVE THEIR HEALTH. ONE OF THEM, KING
COLE, CAUGHT PNEUMONIA AND DIED IN GUY'S HOSPITAL IN LONDON.

SLIDE NO. 56. *end of side 1*

side 2 → THE FIRST ANGLO-AUSTRALIAN TEST MATCH TOOK PLACE IN 1880 BUT
IT WAS NOT UNTIL AUSTRALIA'S FAMOUS VICTORY AT "THE OVAL" IN 1882
THAT THE TERM "THE ASHES" WAS APPLIED TO A SERIES. THESE ARE THE
AUSTRALIANS WHO WON THAT GREAT VICTORY. *

SLIDE NO. 57.

HERE IS A PHOTO OF THE URN WHICH CONTAINS "THE ASHES" AND
WHICH RESTS PERMANENTLY AT LORDS. * *Australia*

IN 1892, TO TRY AND ORGANISE CRICKET IN ~~THIS COUNTRY~~, THE
AUSTRALIAN CRICKET COUNCIL WAS FORMED. DISSENSION AROSE - N.S.W.
WITHDREW AND THE COUNCIL DISBANDED.

IN 1905, THE AUSTRALIAN BOARD OF CONTROL CAME INTO BEING.
IT HAD A STORMY PASSAGE AT FIRST. THERE WAS A REVOLT IN 1912
WHEN 6 PLAYERS REFUSED TO TOUR ENGLAND BECAUSE THEY COULDN'T HAVE
THE MANAGER THEY WANTED, BUT THE BOARD STOOD FIRM AND TODAY IS IN
COMPLETE CONTROL OF INTERNATIONAL CRICKET FROM THE AUSTRALIAN END.

THESE DAYS WE GET OUR BIGGEST GATES ~~FROM~~ *in* MELBOURNE,

SLIDE NO. 60.

BUT LIKE ALL OTHER PLACES, MELBOURNE HAD ITS BEGINNINGS.
THIS IS HOW THE GROUND LOOKED IN 1841.

SLIDE NO. 61.

BY 1864 ITS APPEARANCE HAD CHANGED TO THIS

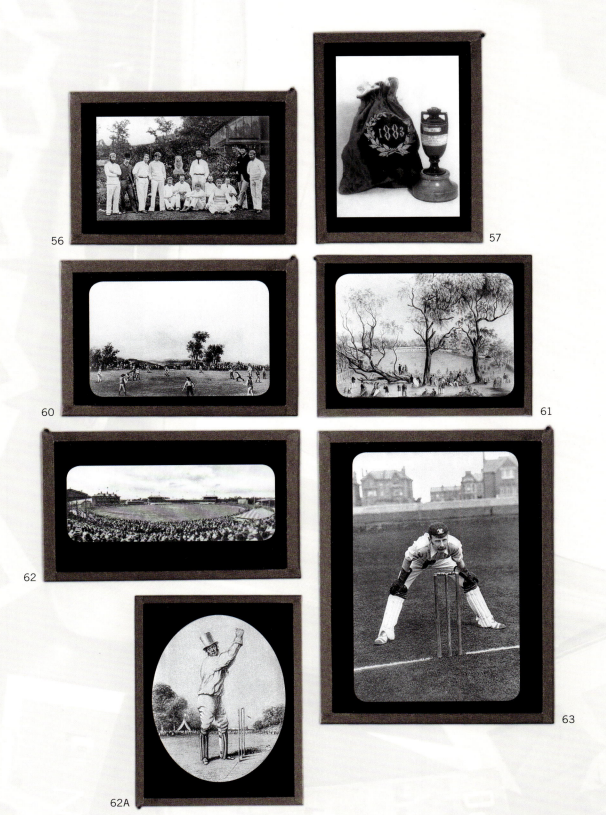

DONALD BRADMAN'S SLIDE COLLECTION

11.

SLIDE NO. 62.

NEXT WE SEE THE GROUND AS IT LOOKED IN 1912. TODAY OF COURSE
IT HOLDS THE GREATEST CROWD OF ANY CRICKET GROUND IN THE WORLD,
THANKS TO THE STANDS WHICH WERE BUILT FOR THE OLYMPIC GAMES.

NOW LET ME TURN TO THE PLAYING SIDE OF THE GAME.

SLIDE NO. 62A.

AN OLD BOOK TEACHING US THE ART OF ~~THE GAME~~ cricket, GIVES US THIS
ETCHING OF A WICKET-KEEPER IN 1853. I'M NOT TOO SURE THAT ~~BARRY
JARMAN~~ modern wicket keepers WOULD WANT TO COPY THAT TECHNIQUE.

SLIDE NO. 63.

HERE WE HAVE A.P. WICKHAM - FAMOUS 'KEEPER' OF HIS DAY. I
WOULD HARDLY CALL HIM WELL BALANCED AND HIS GLOVES ARE SOMEWHAT
SMALL BY ~~MODERN~~ current STANDARDS.

SLIDE NO. 64.

THEN THERE IS GREGOR McGREGOR, CLASSED AS THE BEST OF HIS TIME.
AGAIN, NOTE THE VERY SMALL GLOVES. *

SLIDE NO. 65.

Here is one of the finest wicket keepers I ever saw,
~~AND THE MAN WHO HAS PLAYED IN MORE TESTS THAN ANY OTHER PLAYER -~~
GODFREY EVANS.

HE MAY NOT BE THE GREATEST 'KEEPER' OF ALL TIME ...

SLIDE NO. 65A.

... BUT HIS RECORD ENTITLES HIM TO BE COMPARED WITH ANY OF THEM AND
FEW HAVE GIVEN THE SPECTATORS AS MUCH ENJOYMENT.

NOW HOW ABOUT THIS COMPARISON

SLIDE NO. 66.

HERE WE HAVE AN OLD TIME ETCHING SHOWING HOW THE LEG-HIT SHOULD
BE MADE. WOULD YOU PREFER THAT OR ...

SLIDE NO. 67.

... WOULD YOU PREFER THE GREAT WEST INDIAN, LEARIE CONSTANTINE, AS
HE PLAYED THE LEG-HIT IN THE 1930's.

SLIDE NO. 68.

AN OLD ETCHING OF "HOW TO PLAY FORWARD" COMES NEXT.
TECHNICALLY IT IS NOT BAD, ALTHOUGH SCARCELY AS GRACEFUL AS

SLIDE NO. 69.

THIS MODERN PLAYER WHO DEMONSTRATES THE CORRECT METHOD.

ANOTHER SUPERB DEMONSTRATION IS GIVEN HERE ...

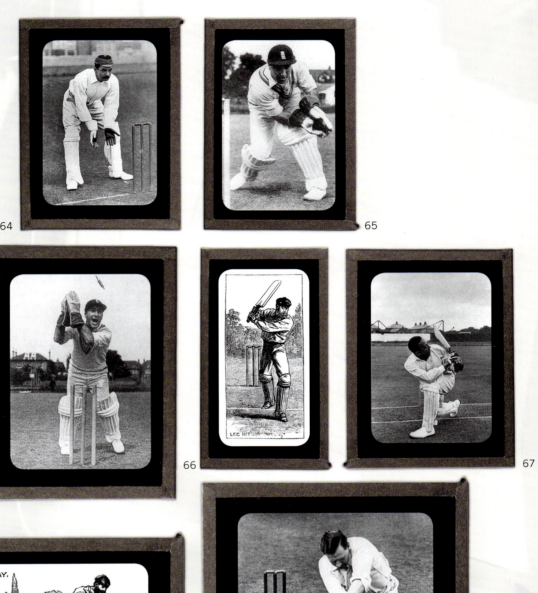
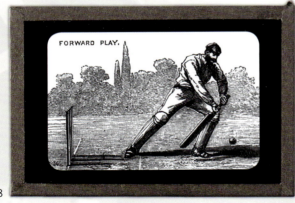
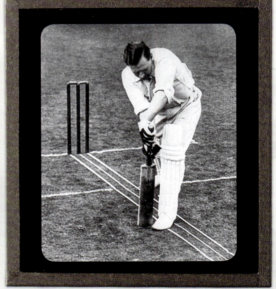

DONALD BRADMAN'S SLIDE COLLECTION

12.

SLIDE NO. 69A.

BY ONE OF SOUTH AFRICA'S FINEST BATSMEN, G.A. FAULKNER. FOR
SOME UNKNOWN REASON HE DIED BY HIS OWN HAND AT THE AGE OF 48.
~~HEAD IN GAS OVEN.~~ BUT EVEN MODERN PLAYERS CAN GO WRONG.

SLIDE NO. 70.

THIS IS HOW "NOT" TO PLAY FORWARD. LEAVING A BIG GAP BETWEEN
BAT AND PADS CAN HAVE FATAL CONSEQUENCES.

SLIDE NO. 71.

THE METHOD OF PLAYING BACK HAS NOT ALTERED MUCH. THE OLD
CHAP WITH THE BEARD SHOWS HOW IT WAS DONE IN HIS DAY.

SLIDE NO. 72.

IF YOU MAKE ALLOWANCE FOR THE BEARD AND THE STATURE, HE WAS
NOT SO VERY DIFFERENT FROM ONE OF THE BEST MODELS OF ~~RECENT TIMES~~,
LINDSAY HASSETT.

SLIDE NO. 73.

THE MOST FAMOUS ENGLISH PLAYER OF ALL TIME WAS DR. W.G. GRACE.
EVEN BY TODAYS STANDARDS, HIS PERFORMANCES WERE TERRIFIC.

GRACE STARTED PLAYING 1ST CLASS CRICKET WHEN HE WAS 17 AND
HAD 43 SEASONS IN FIRST CLASS CRICKET. AT THE AGE OF 58, HE MADE
A GRAND 74 FOR THE GENTLEMEN OF ENGLAND AGAINST THE PLAYERS AT
LORDS.

IT WAS GRACE WHO SAID "I DON'T LIKE DEFENSIVE STROKES - YOU
ONLY GET THREE FROM THEM". HIS CAREER, STRANGELY ENOUGH, ENDED
THE YEAR I WAS BORN.

SLIDE NO. 74.

NO DOUBT W.G. INHERITED MUCH OF HIS ABILITY FROM HIS FATHER,
WHO WAS ALSO A DOCTOR.

AND AS THE COMEDIAN OF "AROUND THE WORLD IN 80 DAYS" REPLIED
WHEN ASKED IF HIS BOSS HAD ANYTHING TO DO WITH WOMEN, "I GUESS
HE MUST HAVE HAD A MOTHER", HERE IS THE FAMOUS MOTHER, MRS. GRACE.

SLIDE NO. 75.

DR. GRACE WAS UNIVERSALLY LOVED. HE DIED IN 1916, DURING
THE FIRST WORLD WAR, AND SUBSEQUENTLY IT WAS DECIDED TO PERPETUATE
HIS MEMORY

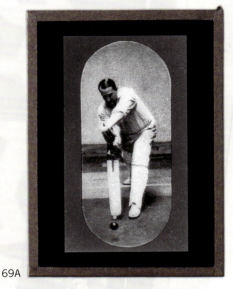
69A

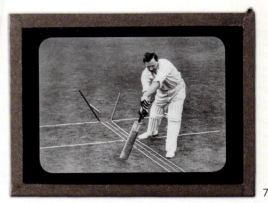
70

71

72

73

74

75

DONALD BRADMAN'S SLIDE COLLECTION

13.

SLIDE NO. 76.

THIS WAS DONE BY THE ERECTION OF WHAT ARE NOW KNOWN AS "THE GRACE GATES" AT LORDS. THEY CARRY THE SIMPLE INSCRIPTION "TO THE MEMORY OF THE GREAT CRICKETER".

SLIDE NO. 77.

I THOUGHT YOU MIGHT BE INTERESTED TO SEE A PHOTO OF THE BRADMAN OVAL AT BOWRAL. *as it was in my youth.* MY FATHER'S HOUSE IS IN THE BACKGROUND AND HE IS UMPIRING IN THE MATCH IN PROGRESS.

SLIDE NO. 78.

IT WAS A PRETTY LITTLE SPOT BUT HARDLY COMPARABLE WITH THE LOVELY WORCESTER GROUND IN ENGLAND, WHERE AUSTRALIAN TOURS COMMENCE AND WHERE I PLAYED MY FIRST MATCH ON ENGLISH SOIL. *~ 1930.*

SLIDE NO. 79.

PERHAPS IT IS ONLY FAIR TO ALSO SHOW YOU MY LAST MATCH ON ENGLISH SOIL. BOWLED HOLLIES FOR O, AT THE OVAL, 1948.

SLIDE NO. 79A.

ANOTHER UNFORTUNATE MEMORY. BOWLED BY BOWES FIRST BALL ON THE MELBOURNE CRICKET GROUND 1932/3. *

SLIDE NO. 80.

HERE YOU SEE ANOTHER OF ENGLAND'S MOST BEAUTIFUL GROUNDS, FENNERS AT CAMBRIDGE UNIVERSITY, WITH THE CATHEDRAL SPIRE, VERY SIMILAR TO ADELAIDE, IN THE BACKGROUND. ANOTHER MEMORY, I WAS ALSO BOWLED FIRST BALL FOR A DUCK THERE - BY A CHAP NAMED DAVIES. *

SLIDE NO. 81.

OF A VERY DIFFERENT CHARACTER IS THIS CRICKET GROUND AT KUALA LUMPUR, MALAYA.

I SUSPECT THOSE ARE NOT REALLY THE PLAYERS DRESSING ROOMS YOU CAN SEE. IF THEY WERE ...

SLIDE NO. 82.

I THINK THEY COULD AFFORD A BETTER HEAVY ROLLER THAN THIS.

AT LEAST IT IS AN IDEA FOR ~~ARTHUR LANGE AT THE ADELAIDE OVAL,~~ *curators everywhere* SHOULD ~~THE ELECTRIC~~ *their mechanical* ROLLER, EVER BREAK DOWN.

NOW I THINK YOU SHOULD BE INTERESTED IN SOME SLIDES OF FAMOUS PLAYERS

SLIDE NO. 83.

STARTING WITH THAT GRAND OLD MAN, THE ELDER STATESMAN OF M.C.C.

14.

TODAY, SIR PELHAM WARNER, COMMONLY KNOWN AS "PLUM".

HE WAS NOT A GRAND OLD MAN WHEN THIS PICTURE WAS TAKEN.

SLIDE NO. 84.

THEN COMES THE HON. SIR STANLEY JACKSON, WHAT A CAREER.
CAPTAIN OF ENGLAND, PRESIDENT OF M.C.C., MEMBER OF PARLIAMENT,
GOVERNOR OF BENGAL ~~AND HE EVEN~~ WON THE TOSS IN ALL 5 TESTS AGAINST
AUSTRALIA IN 1905. *

SLIDE NO. 85.

PERHAPS THE GREATEST ATHLETE, CRICKETER, SCHOLAR AND WRITER
OF HIS ERA, C.B. FRY. HIS RECORD OF 6 CONSECUTIVE CENTURIES IN
FIRST CLASS CRICKET, SCORED IN 1901, HAS NOT YET BEEN BROKEN.

SLIDE NO. 86.

JOHNNY TYLDESLEY - NOT TO BE CONFUSED WITH ERNEST TYLDESLEY,
WHO TOURED AUSTRALIA IN 1928/29. JOHNNY PLAYED BEFORE THE END
OF THE LAST CENTURY AND WAS ACCLAIMED ENGLAND'S GREATEST BATSMAN
ON A WET WICKET.

SLIDE NO. 87.

A MAN WELL KNOWN TO SOUTH AUSTRALIANS, NOT ONLY AS AN ENGLISH
INTERNATIONAL BUT BECAUSE HE CAME ~~HERE~~ to Adelaide AND COACHED ~~OUR~~ South Australian PLAYERS IN
THE 1920's - PATSY HENDREN.

PATSY ONCE DROPPED AN EASY CATCH IN THE OUTFIELD AND A
SPECTATOR YELLED OUT 'I COULD HAVE CAUGHT IT IN MY MOUTH' PATSY
HASTILY REPLIED 'IF I HAD A MOUTH AS BIG AS YOURS, SO COULD I'.

SLIDE NO. 88.

OF LATER VINTAGE AND LESSER HUMOR, DOUGLAS JARDINE. * YOU CAN
TELL BY LOOKING AT THE PICTURE THERE WASN'T MUCH COMPROMISE ABOUT
HIM.

SLIDE NO. 89.

THE ~~GREATEST INDIAN PLAYER OF ALL TIME~~ first of the great Indian players WAS RANJI AND HIS MOST
FAMOUS STROKE WAS THE LEG GLANCE WHICH YOU SEE HIM PLAYING.

SLIDE NO. 90.

AMONGST WEST INDIANS, ~~NO BATSMAN HAS A HIGHER REPUTATION THAN~~ many old timers think that as a batsman
GEORGE HEADLEY WHO TOURED AUSTRALIA IN THE 1930's, was the best.

SLIDE NO. 91.

BUT AS AN ALL ROUNDER, one of the most dynamic of the ~~PERHAPS THE GREATEST~~ WEST INDIANS WAS Learie
CONSTANTINE. Christened the spontaneous cricketer by John Arlott, ~~(I.E. BEFORE THE ADVENT OF GARY SOBERS,)~~
and created a furore in 1969

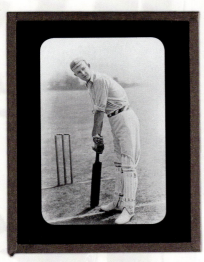
83

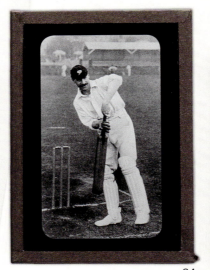
84

85

86

87

88

DONALD BRADMAN'S SLIDE COLLECTION

15.

SLIDE NO. 92.

THERE WAS NEVER A GREATER ~~ALL ROUND~~ FIELDSMAN, NOR A MORE *exciting*
~~DYNAMIC~~ PERSONALITY. EVEN THOUGH HIS TEST RECORD IN AUSTRALIA
WAS POOR, THE PUBLIC LOVED TO SEE HIM PLAY.

SLIDE NO. 93.

WE SHALL NEVER FORGET THE NEXT TWO.

FIRST - SIR JACK HOBBS - A MODEL AS A PLAYER AND AS A
GENTLEMAN AND ONE WHO DID SO MUCH TO UPLIFT HIS PROFESSION.

SLIDE NO. 94.

SECONDLY HIS DEBONAIR, DISTINGUISHED OPENING PARTNER, HERBERT
SUTCLIFFE. NO ONE EVER HAD A BETTER TEMPERAMENT.

SLIDE NO. 95.

NOW SOME FAMOUS CAPTAINS.

MONTY NOBLE, WHO PLAYED HIS BEST CRICKET DURING THE GOLDEN AGE
BUT WHO WAS STILL A FINE CRICKETER WHEN I PLAYED AGAINST HIM IN
THE 1920's.

SLIDE NO. 96.

WARWICK ARMSTRONG. HE WASN'T QUITE AS FAT AS THE ARTIST
SUGGESTS - BUT, AT 21 STONE, HE WASN'T FAR SHORT OF IT.

SLIDE NO. 97.

SIR LEONARD HUTTON, WHOSE PROWESS IS SO WELL KNOWN. ~~TO ALL OF YOU.~~

SLIDE NO. 98.

PETER MAY SHOWS THE ART OF PLAYING FORWARD AND DOES IT
BEAUTIFULLY.

SLIDE NO. 99.

TWO OF AUSTRALIA'S GREATEST LEFT HANDERS. FIRST JOE DARLING -
RENOWNED BATSMAN AND CAPTAIN.

SLIDE NO. 100.

SECONDLY CLEM HILL. CLEM MADE 99, 98 AND 97 IN 3 CONSECUTIVE
TEST MATCH ~~INNINGS~~ AGAINST ENGLAND.

SLIDE NO. 101.

ENGLAND'S LEFT HANDED COUNTERPARTS OF A MORE MODERN AGE. THE
GRACEFUL FRANK WOOLLEY.

89

90

91

92

93

94

DONALD BRADMAN'S SLIDE COLLECTION

38 THE BRADMAN MUSEUM'S WORLD OF CRICKET

16.

SLIDE NO. 102.

THE NOT SO GRACEFUL BUT THE IMPERTURBABLE MAURICE LEYLAND —
A REAL FIGHTER IF EVER THERE WAS ONE.

SLIDE NO. 103.

FOR GRACE AND ARTISTRY LET US LOOK AT 3 PLAYERS.

FIRST, VICTOR TRUMPER. HERE IS HIS STANCE AS A YOUNG MAN.

SLIDE NO. 104.

NOW LOOK AT HIM JUMPING OUT TO DRIVE. THE FORWARD SHOULDER
POSITION IN THIS SHOT IS BEAUTIFUL.

SLIDE NO. 105.

AGAIN JUMPING OUT TO DRIVE - SIDE-ON. THIS IS ONE OF THE MOST
FAMOUS OF ALL CRICKET PICTURES AND IT MAY BE FOUND IN ALMOST EVERY
MAJOR CRICKET PAVILION THROUGHOUT THE WORLD.

SLIDE NO. 106.

ARCHIE JACKSON. ~~REMEMBER THIS BOY'S~~ he made a WONDERFUL 164 AT ADELAIDE
IN 1929 in his first test. I BATTED WITH HIM. New Year THREE YEARS LATER I WAS ONE OF
THOSE WHO CARRIED HIM TO HIS LAST RESTING PLACE. IT ALL
HAPPENED BECAUSE HE PLACED HIS LOVE OF CRICKET BEFORE HIS HEALTH.

SLIDE NO. 107.

STAN McCABE. HIS 232 AT NOTTINGHAM IN THE FIRST TEST OF 1938
REMAINS THE GREATEST INNINGS I HAVE EVER SEEN. THAT DAY HE AND
FLEETWOOD-SMITH PUT ON 77 FOR THE LAST WICKET IN 28 MINUTES OF
WHICH FLEETWOOD MADE 5.

ENGLAND HAD 5 MEN ON THE BOUNDARY AND DID EVERYTHING THEY COULD
TO PREVENT McCABE GETTING THE STRIKE. HE WAS A GLORIOUS PLAYER.

SLIDE NO. 108.

CRICKET OWES A GREAT DEBT TO THE UMPIRES AND HERE YOU SEE THE
GREATEST ~~OF THEM ALL~~ I player under - FRANK CHESTER - A REAL ORNAMENT TO THE GAME.

SLIDE NO. 109.

DO BATSMAN EVER GET DISGUSTED WITH THEMSELVES WHEN THEY MAKE A
MISTAKE? HAVE A LOOK AT BILL EDRICH'S FACE in this picture AND YOU'LL KNOW THE
ANSWER.

SLIDE NO. 110.

SOME GREAT LEFT HAND BOWLERS.

102

103

104

105

106

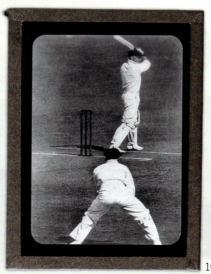

107

108

THE BRADMAN MUSEUM'S WORLD OF CRICKET

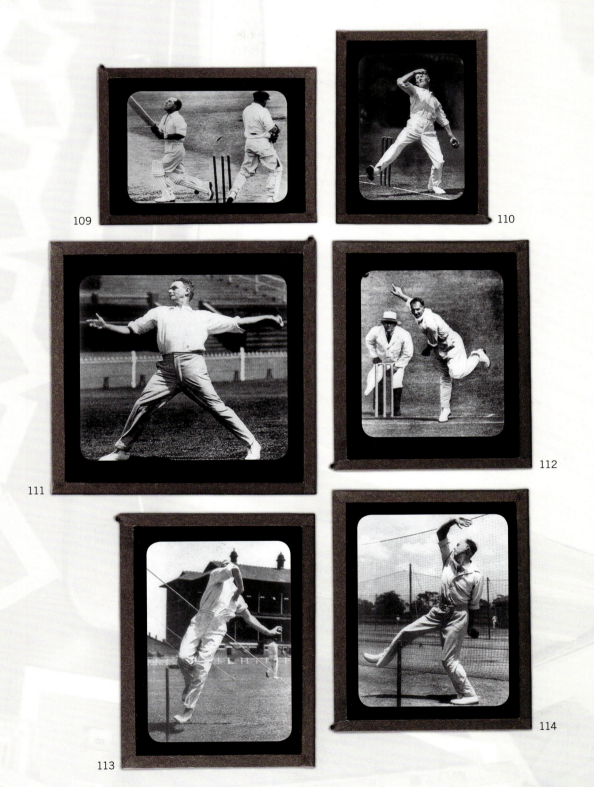

109
110
111
112
113
114

DONALD BRADMAN'S SLIDE COLLECTION

17.

"FARMER" JACK WHITE. IN THE ADELAIDE TEST OF 1929 HE BOWLED
125 OVERS AND TOOK 13 WICKETS - A TREMENDOUS PERFORMANCE.

SLIDE NO. 111.

BERT IRONMONGER. PICKED FOR HIS FIRST TEST AT THE AGE OF 41
AND PROBABLY THE GREATEST AUSTRALIAN BOWLER WHO NEVER WENT TO
ENGLAND.

SLIDE NO. 112.

THIS IS A BEAUTIFUL DELIVERY POSITION OF HEDLEY VERITY WHOSE
MARVELLOUS CAREER FOR YORKSHIRE AND ENGLAND ENDED SO SADLY WHEN
HE WAS KILLED AT THE WAR.

SLIDE NO. 113.

BILL JOHNSTON. I WANT YOU TO LOOK ~~CLOSELY~~ _carefully_ AT THESE TWO
SLIDES. IN THE FIRST ONE, NOTICE THE GAY CAREFREE ABANDON OF HIS
YOUTHFUL ACTION. NOW LOOK AT THE SECOND ONE ...

SLIDE NO. 114.

QUITE OBVIOUSLY HIS DELIVERY IS TIGHT - NOT FREE. IT IS ALL
BECAUSE HE HAS CHANGED HIS FOOT POSITION TO TRY AND PROTECT HIS
KNEE WHICH HAD DEVELOPED CARTILEGE TROUBLE AFTER AN INJURY IN
ENGLAND.

SLIDE NO. 115.

TWO OF AUSTRALIA'S FINEST GOOGLY BOWLERS - GRIMMETT AND MAILEY.

GRIMMETT'S ACTION IS THAT OF A MAN WHO IS CONCENTRATING ON
ACCURACY - ALMOST AS THOUGH HE DOESN'T WANT TO LET THE BALL GO AT
ALL.

SLIDE NO. 116.

ARTHUR MAILEY, ON THE OTHER HAND, SEEMS TO BE TOSSING IT UP
WITH THE LABEL - HIT ME IF YOU DARE - AND IF YOU CAN.

SLIDE NO. 117.

JIM LAKER. HIS 19 WICKETS IN THE TEST MATCH AT MANCHESTER IN
1956 IS THE GREATEST BOWLING PERFORMANCE IN ALL HISTORY AND I DON'T
THINK IT WILL EVER BE EQUALLED.

SLIDE NO. 118.

Possibly ~~PROBABLY~~ THE TWO GREATEST MEDIUM PACE BOWLERS OF ALL TIME WERE
TATE AND BEDSER. THEIR ACTIONS WERE NOT VERY SIMILAR TO WATCH ON
THE CRICKET FIELD BUT IN BASIC PRINCIPLES THEY WERE VERY MUCH ALIKE.

HERE IS BEDSER COMING INTO THE DELIVERY STRIDE ...

115

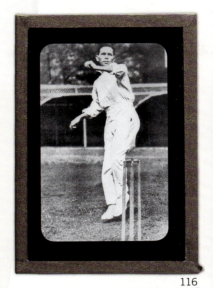
116

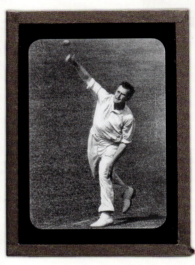
117

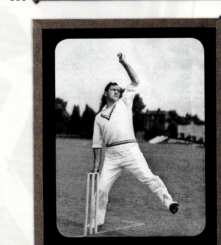
118

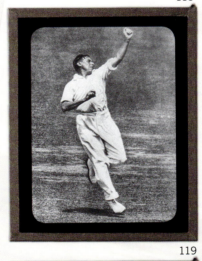
119

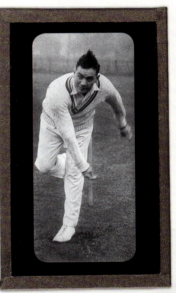
120

121

DONALD BRADMAN'S SLIDE COLLECTION

18.

SLIDE NO. 119.

MAURICE TATE IS SHOWN DOING THE SAME THING BUT THE PHOTO HAS BEEN TAKEN A FRACTION OF A SECOND EARLIER.

SLIDE NO. 120.

THERE IS A GREATER SIMILARITY BETWEEN THE NEXT TWO PICTURES. FIRST BEDSER AS HE DELIVERS THE BALL. YOU WILL FIND IT IS ALMOST IDENTICAL WITH THIS ...

SLIDE NO. 121.

AS TATE DELIVERS THE BALL.

WHAT A SUPERB POSITION THAT IS. YOU CAN'T FAULT IT.

SLIDE NO. 122.

IN THE FAST BOWLING LINE, LOOK AT SOUTH AUSTRALIA'S ERNIE JONES - THE FINE PHYSIQUE - THE GREAT CHEST AND BROAD SHOULDERS.

SLIDE NO. 123.

ABOUT THE SAME TIME ENGLAND HAD THE SWARTHY TOM RICHARDSON, THE BOWLER WITH THE WONDERFUL HEART AND INEXHAUSTIBLE STAMINA.

SLIDE NO. 124.

JACK GREGORY AT THE END OF HIS FAMOUS KANGAROO LEAP AND JUST BEFORE DELIVERY.

SLIDE NO. 125.

HAROLD LARWOOD. THE UNUSUAL HIGH FRONT LEG ACTION IS CAPTURED BY THE CAMERA BUT IT WAS NOT SO ~~BOVIOUS~~ *obvious* AS THAT ON THE FIELD OF PLAY BECAUSE OF THE RHYTHM OF HIS RUN UP AND FOLLOW THROUGH AT DELIVERY.

SLIDE NO. 126.

HERE IS AN EXTRAORDINARY PICTURE OF GUBBY ALLEN LITERALLY HURLING HIMSELF THROUGH THE AIR AS HE DELIVERS THE BALL.

SLIDE NO. 127.

New A LOVELY FULLY WOUND UP POSITION IS SHOWN BY RAY LINDWALL AS HE GATHERS HIMSELF TO EXERT FULL PRESSURE.

SLIDE NO. 128.

FREDDIE TRUMAN SHOWS HIS TREMENDOUS STRIDE AND THE FULL VIGOR OF HIS BOWLING. A MAN OF TREMENDOUS PHYSIQUE AND AMAZING STAMINA.

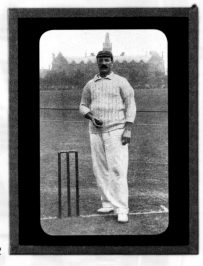
122

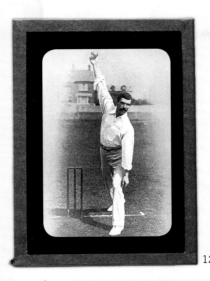
123

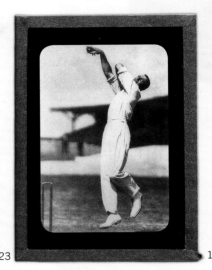
124

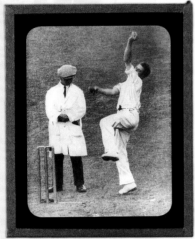
125

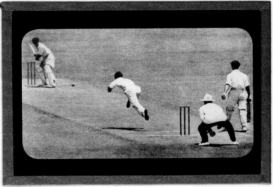
126

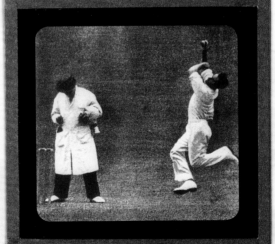
127

DONALD BRADMAN'S SLIDE COLLECTION

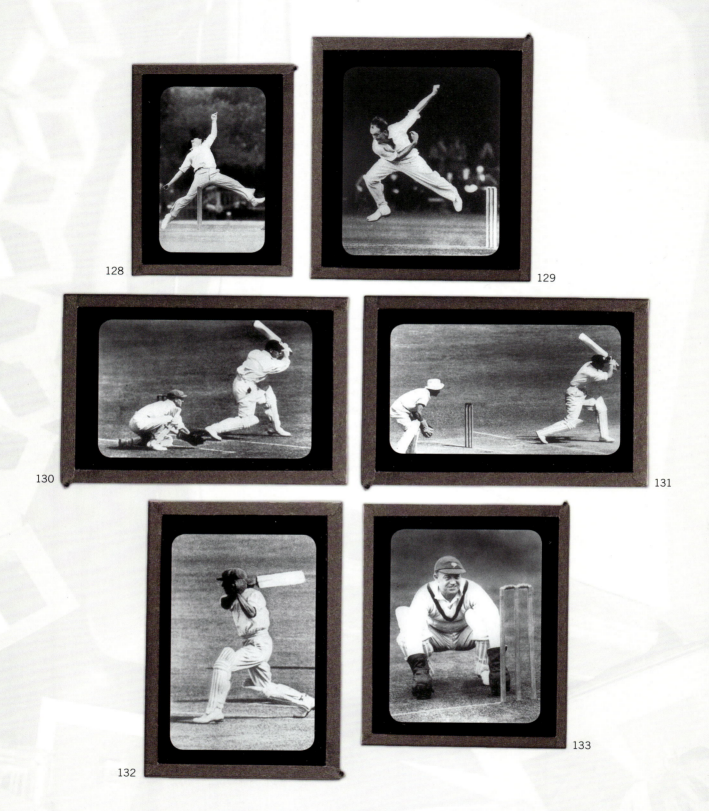

46 THE BRADMAN MUSEUM'S WORLD OF CRICKET

19.

SLIDE NO. 129.

THE FINEST PICTURE OF A FAST BOWLER I'VE EVER SEEN. FRANK
TYSON IN AN ASTOUNDING POSITION AFTER DELIVERING THE BALL. YOU
COULDN'T POSSIBLY GENERATE MORE POWER FROM THE HUMAN FRAME THAN THIS.

SLIDE NO. 130.

AS A CHANGE FROM BOWLING ACTIONS, HERE IS MY FAVOURITE BATTING
PHOTO. WALLY HAMMOND IN ALL HIS MAJESTY, EXECUTING A PERFECT
COVER DRIVE. THAT PICTURE IS MAGNIFICENT.

SLIDE NO. 131.

KEITH MILLER MAKING THE SAME STROKE. IT IS VERY GOOD BUT JUST
LACKS A LITTLE OF THE COMPACTNESS AND GRACE OF HAMMOND.

SLIDE NO. 132.

AND ONE OF MYSELF EXECUTING A DRIVE - TAKEN ~~30 YEARS AGO~~ *about 1930.*

IT CONTAINS PERHAPS A SHADE MORE VIGOR THAN THE OTHERS BUT IN
THOSE DAYS I HAD IT TO SPARE. ~~WISH I COULD SAY THE SAME TODAY.~~

SLIDE NO. 133.

I'VE INCLUDED THIS ONE OF ARTHUR WOOD, THE ENGLAND AND YORKSHIRE
WICKETKEEPER JUST TO TELL YOU A STORY.

ARTHUR WENT IN TO BAT FOR ENGLAND AT THE OVAL IN 1938 WITH THE
SCORE 770 FOR 6. HE MADE 53 AND GOT OUT WITH THE SCORE 876 FOR 7.

AS HE ENTERED THE PAVILION AN ADMIRER SHOUTED "WELL PLAYED ARTHUR"

ARTHUR LOOKED UP AND REPLIED "THANKS - I'M ALWAYS AT MY BEST IN
A CRISIS".

SLIDE NO. 134.

BACK TO BOWLERS. THE MAN WHOM OLD TIMERS RANK AS THE GREATEST
OF ALL - S.F. BARNES.

AGAINST SOUTH AFRICA IN 1913/14 HE TOOK 49 WICKETS IN THE FIRST
4 TESTS AND COULDN'T PLAY IN THE 5TH OWING TO ILLNESS. THIS
PERFORMANCE HAS NEVER BEEN APPROACHED BY ANYONE ELSE.

SLIDE NO. 135.

I NEVER SAW BARNES BOWL, BUT MY OWN CHOICE FOR THE GREATEST OF
ALL FALLS ON BILL O'REILLY.

THIS IS A FINE ACTION STUDY OF O'REILLY. POWER AND CONTROL
SIMPLY OOZE OUT OF THAT PICTURE.

20.

SLIDE NO. 136.

IN THIS NEXT STUDY OF O'REILLY CAN'T YOU FEEL THE TENACITY
AND FEROCITY OF THE FELLOW. BILL HAD THE LOT. *cricket — America*

~~SINCE 1895, IN SYDNEY FIRST GRADE CRICKET, ONLY 8 MEN HAVE WON
THE SEASON'S BOWLING AVERAGE WITH A BOWLING AVERAGE UNDER 10.
SEVEN OF THEM DID IT ONCE ONLY.
O'REILLY DID IT 12 TIMES IN 14 CONSECUTIVE YEARS. THAT WAS
THE MEASURE OF HIS SUPERIORITY OVER HIS COLLEAGUES.~~

THAT BRINGS ME TOWARDS THE CLOSE.

IN CASE YOU THINK CRICKET IS EASY JUST TAKE A LOOK AT THIS
~~SLIDE~~. *picture*

SLIDE F.

THAT SHOWS YOU HOW THE BATSMAN APPEARS TO THE BOWLER.

AND HOW DO YOU THINK THE BATSMEN FEEL ABOUT IT.

SLIDE G.

THIS IS THE ANSWER.

He look wonderful

AND FINALLY I AM INDEBTED TO MY FRIEND ARTHUR MAILEY, WHOSE
CARICATURES WERE JUST AS WONDERFUL AS HIS CRICKET, ~~FOR BRINGING
THIS ADDRESS TO A FITTING CONCLUSION.~~

~~SLIDE H.~~ *ringing down the curtain* *for*

matters of interest in the world of cricket.

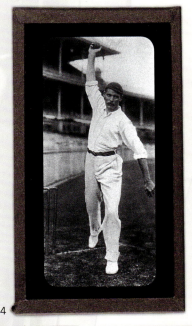
134

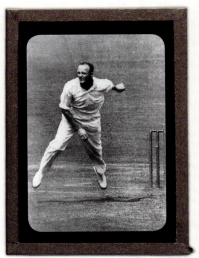
135

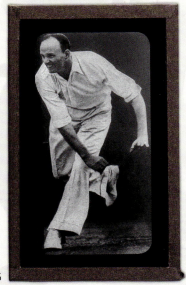
136

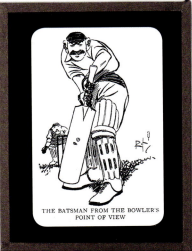
F

G

H

DONALD BRADMAN'S SLIDE COLLECTION

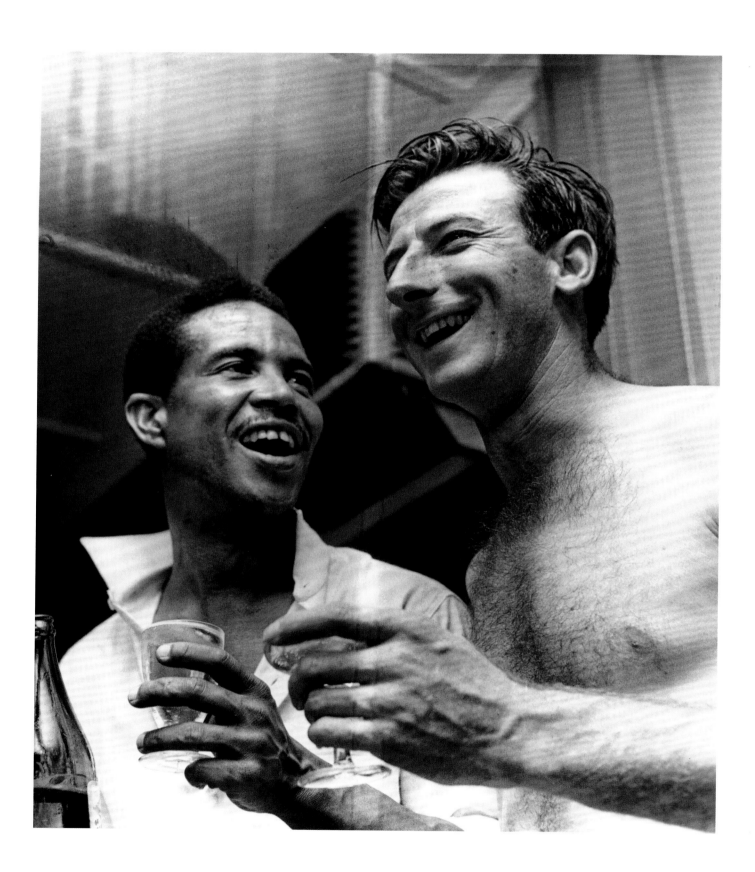

PART 2

THE BRUCE POSTLE COLLECTION

A NEW BEGINNING

DON BRADMAN'S RETIREMENT AS CRICKET'S PRE-EMINENT BATSMAN did nothing to diminish his aura or influence. After all, he had never confined his interest in the game to the techniques and practicalities of playing it. He was a fervent student of cricket history, who from the moment he was appointed secretary of Bowral Town Cricket Club a week after his seventeenth birthday had been fascinated by the mechanics and politics of administering the game. Bradman imposed his will as an administrator and legislator with the same sense of certainty and infallibility that characterised his batting.

Intrinsically modest, he was nevertheless aware that Australian cricket was bound to lose some lustre following his retirement after the undefeated 1948 tour of England by his legendary Invincibles. He had been a South Australian delegate to the then Australian Board of Control for International Cricket since the unusually young age of 37. He was acutely conscious of the challenges ahead.

Social scientists and cricket historians alike are given to portraying the 1950s as an uninspiring, unimaginative period separating the grim war years of the 1940s from the liberating, free-and-easy 1960s. Certainly the further the '50s progressed, the more turgid Test cricket became. Yet Bradman's charismatic successor, the impish Lindsay Hassett, made a spectacular start to the period by beating South Africa 4–0 and England and the West Indies 4–1. Particularly meritorious was the success against the 1951–52 West Indian tourists. Only fifteen months earlier John Goddard's calypso cricketers had startled the game's cognoscenti with a come-from-behind 3–1 victory in a four-Test series in England. Inspired by the genius deeds of spinners Sonny Ramadhin and Alf Valentine, West Indian cricket embedded itself in the consciousness of cricket followers the world over. Suddenly and thrillingly the calypso refrain about 'those little pals of mine, Ramadhin and Valentine' was heard far beyond the Caribbean archipelago. It was a lyric often reprised as the culture of the game spread and grew.

OPPOSITE: *Peerless all-rounder Garfield Sobers enjoys a drink with Australian captain Bill Lawry after leading the West Indies to victory in the First Test at Brisbane in December 1968. Lawry and his men quickly regained the initiative to win the series 3–1 and win back the Frank Worrell Trophy lost so dramatically in the Caribbean in 1965.*

Bradman's absence was loudly felt wherever the game was played. Hassett continued to lead many of the Invincibles, including the incomparable triumvirate of fast bowlers—Keith Miller, Ray Lindwall, Bill Johnston—and left-handed batsmen Arthur Morris and Neil Harvey. Not even their combined resources could prevent Ashes defeat in 1953, 1954–55 and 1956 casting a pall over Australian cricket, a condition that would be periodically and unsettlingly revisited during the tumultuous second half of the twentieth century.

Lamenting the 3–1 defeat in 1954–55 was fourteen-year-old Bruce Postle, who had the good fortune to witness Australia's solitary victory from the hill at the Gabba in Brisbane. He thrilled to the batting of Morris and Harvey, who each scored substantial centuries, but at the same time watched closely as his father Cliff photographed the match for Brisbane's *Courier-Mail* newspaper. Eight years later it would be 22-year-old

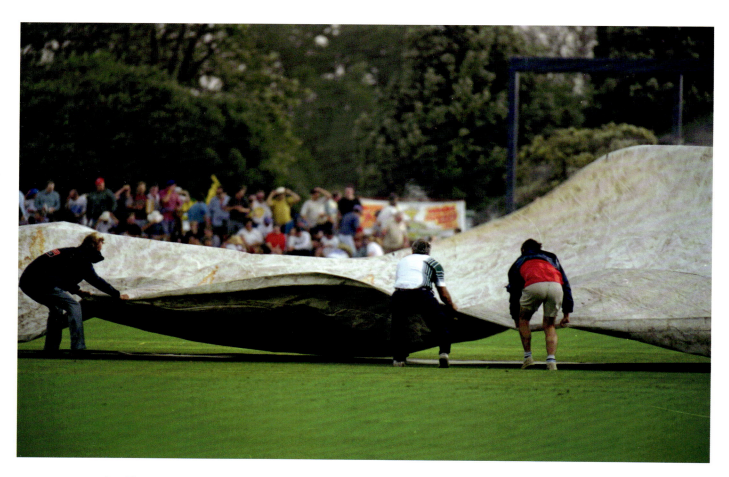

A sudden summer storm that taxed the resourcefulness of groundsmen at Adelaide Oval also brought the winds of change to Mark Taylor and his Australian team over the Australia Day holiday period in 1995. While Greg Blewett thrilled his home crowd by becoming the sixteenth Australian to score a hundred on debut there was no cause for celebration. The Australians frittered away a first innings advantage and England claimed their only victory for the series and their first for eleven Tests in Australia.

Bruce behind the lens at the Gabba for an Ashes Test, his career as one of the country's foremost photographers gathering momentum.

By the close of the 1950s Bradman could not mask his fear for Test cricket's immediate future. The game was being endured, not celebrated, and spectators longed for the kind of joyous cricket played by Australia in 1948 and the West Indies in 1950. Cricket since then had become a game of attrition, blighted by appallingly slow over-rates and controversies surrounding 'throwing' and 'dragging'. Crowd disturbances were a worry on the Indian subcontinent and in the Caribbean. Gerry Alexander, a brilliant West Indian captain and wicketkeeper-batsman, was so disenchanted he considered early retirement to his veterinary practice in Jamaica.

The negative mindsets and dreary fare were especially discouraging at a time when the game was endeavouring to rapidly broaden its horizons. Pakistan became the seventh full member of the Imperial Cricket Conference in 1952—just five years after its bloody partitioning from India—and hosted visits from New Zealand, Australia and the West Indies. Australia embarked on its first Test steps into India and the West Indies; India and Pakistan played home and away series; the West Indies reached New Zealand for the first time, and played home and away matches against India and Pakistan; New Zealand made their initial foray into South Africa.

Bradman, nearing the height of his powers as an administrator, was preparing for the first of two three-year terms as Australian board chairman. He was also nominal chairman of the national selection panel, on which he had served for all but a few months in 1952–53 since 1936–37. He represented Australia at the Imperial Cricket Conference meeting in London in 1960 when Test cricket's welfare and the curse of throwing topped the agenda. On his return to Australia, Bradman reiterated that if the throwing controversy was not controlled the 1961 Ashes tour of England could lead to 'the greatest catastrophe in the history of cricket. It is the most complex problem I have known in cricket because it is not a matter of fact but of opinion and interpretation. It is so involved that two men of equal goodwill and sincerity could take opposite views. We must find some answer which places due regard on the integrity, good faith and judgement of all countries.' At Bradman's insistence, the scourge was removed in the short term only to return in the most devastating manner before his death in 2001.

While the actions of Ian Meckiff (Australia), Geoff Griffin (South Africa) and Charlie Griffith (West Indies) in particular continued to be scrutinised by the media and public, Bradman again turned his attention to the moribund state of Test cricket. Displaying the entrepreneurial flair that would serve him well eleven years hence when compelled to organise a multicultural World XI, he was convinced that a series of exceptional enterprise and entertainment would reinvigorate Test cricket and re-engage spectators everywhere. The visit of the West Indies to Australia for the first time in nine years provided the perfect vehicle for such a celebration.

THE BRUCE POSTLE COLLECTION

Instinct told him that Richie Benaud and Frank Worrell were the class of men and calibre of player to implement his plan. But not even at his most optimistic could Bradman have hoped for such a thrilling and transformative contest—a benchmark for all series for the next 55 years, a 'very beautiful series of cricket', as West Indian batsman Peter Lashley called it. It began with the first tied match in 502 Tests, and ended with Bradman unilaterally creating the Frank Worrell Trophy for competition between the West Indies and Australia and commissioning a special tie tack for the tied Test players and umpires.

A crowd estimated at 500,000 lined Collins and Swanston streets in Melbourne to farewell the West Indians, who narrowly lost the series 2–1 but won hearts and admiration. The dark glasses worn by Worrell and his men were to hide not only the glare of the sun but the tears of pride at their wholehearted acceptance by the Australian people.

The true significance of the series lay far beyond the boundary. Worrell, who had spent much of the latter part of the 1950s at the University of Manchester, and was thus spared the tedium that had beset the game, was the first black man to lead the West Indies outside the Caribbean since their entry to Test cricket in 1928. His appointment was cheered to the echo throughout the cricket world, not least by his counterpart Richie Benaud, whose own leadership career had begun with him regaining the Ashes 4–0 in 1958–59 when the game was televised in Australia for the first time.

A journalist with an inquiring mind and a thirst for knowledge, Benaud relished the responsibility of captaincy and the opportunity to stamp his philosophy and personality on the Australian team. More than most he understood the social significance of Worrell's appointment and his own considerable responsibility in welcoming a predominantly black West Indian team to Australia, given the ugly contradiction of the existing White Australia Policy. Dr Barton Babbage, the dean of St Paul's Anglican Cathedral in Melbourne, seized on the extraordinary popularity of Worrell and his men to address wider and compelling issues in a sermon delivered during the thrilling fifth and final Test:

It is a sobering and humbling thought that the West Indians whom Australia welcomes as cricketers would not be welcome as citizens. Their skin is the wrong colour. They may play with us, but they may not stay with us. It may be that the game of cricket will pave the way for more generous national policies. If only we could cultivate the spirit of cricket in all our dealings, one with the other. It is not far from the spirit of Christ.

Benaud had already demonstrated his worldliness and preparedness to think laterally. He'd written to Prime Minister Robert Menzies, a passionate cricket follower, seeking

a briefing from the external affairs minister, Richard Casey, ahead of Australia's first full tour of Pakistan and India—an exhausting three-month, eight-Test campaign in 1959–60.

Mentored and inspired by Keith Miller, Benaud led with boldness, enterprise and flexibility. His attacking instincts earned him the respect and admiration of his charges and won him considerable popularity among spectators. In dress and demeanour, he brought a new flamboyance and professionalism to the captaincy, and as a consequence of his membership of the fourth estate there was a fresh openness to dealings with the media.

While he had a comfortable rapport with Bradman, he was as uneasy with the game's conservative and myopic administration as it was with his progressive thinking and assertive captaincy. Even supportive critics were unsure how to judge such unconventional and liberating leadership as Benaud's. Johnnie Moyes, who played sixteen first-class matches for South Australia and Victoria before embarking on a successful career as a sports editor, commentator and author, observed:

At the start he [Benaud] was overflowing with exuberance. If a wicket fell there was much rushing about, with players hugging one another as at a young people's picnic after the finish of the egg-and-spoon race. Sometimes it seemed rather like gloating at the downfall of an honourable foe, and it was too lacking in dignity for an Australian team. One could understand, if not endorse, this outward and visible sign of inward jubilation.

Yet Moyes also felt that Benaud, in instituting team meetings and engendering a strong sense of unity, had 'waged unceasing war against stodge' and thereby 'recovered Australia's cricketing soul'. And it was Moyes who best encapsulated the feeling of the cricket community that unforgettable December day in Brisbane in 1960 when a Test match was tied.

Benaud came through the gate on to the field of honour to shake Worrell by the hand and we saw the two captains who had conspired together to make cricket a game once again; two captains who spurned the idea of playing for a draw [and] who now rejoiced, I am sure, that they had breathed new life into the dead bones of a game which had been starved to death by indecisive batting, lack of inspiration in bowling, dullness and lack of adventure in leadership. We thanked them, some of us silently, as we looked down from the broadcasting box, and some with cheers as they stood in front of the dressing rooms to pay their allegiance to those who had caused their hearts to leap in loyalty.

THE BRUCE POSTLE COLLECTION

The true and lasting significance of that inaugural series for the elegant Frank Worrell Trophy, which incorporates a tied Test ball as its centrepiece, became apparent when Bradman oversaw the presentation ceremony before a vast crowd at the Melbourne Cricket Ground on 15 February 1961. 'You've all,' said Bradman, 'heard so much about the great revival that has taken place in cricket, and for that we thank our West Indian guests who have come here, and they have made it possible and they have given us some superb cricket. But I would also like to say that I think Richie and his boys have been equally responsible and have played their full part.' Jack Fingleton, a former teammate of Bradman's, wrote in the *Wisden Cricketers' Almanack* of 1961:

I have high hopes that the wind of change which Benaud and Worrell so bravely inspired in Brisbane will blow on to all cricketing countries and disperse that mean, niggardly outlook on Tests which says they must be won at all costs and, if they cannot be won, they must never be lost. In Brisbane, at a time when many were lamenting that the game was dying, cricket was never more alive in its challenge, in its brilliance, in its down-to-earth honesty and the link it forged between men of different countries and different colours of skin.

Benaud enhanced his reputation as a captain by retaining the Ashes in England in 1961. Future captain and obdurate opening batsman Bill Lawry began his distinguished international career; athletic paceman Graham 'Garth' McKenzie joined him a Test later; Benaud's daring bowling around the wicket in Manchester for the priceless wickets of Ted Dexter, Peter May and the startling analysis of 5 for 12 instantly entered the lore of the game.

Having overseen Australia's rise from mediocrity to excellence, Benaud relinquished the captaincy after a tumultuous First Test with South Africa in Brisbane in 1963. That was the game that saw left-arm fast bowler Ian Meckiff finally thrown out because of his contentious action. Benaud denied colluding with Bradman and umpire Colin Egar to make an example of the controversial Meckiff, and made no apology for not bowling Meckiff in front of the other umpire Lou Rowan.

Benaud handed the reins to Bob Simpson and set about broadening his career as an insightful and thought-provoking commentator, analyst and writer. Simpson was destined to have a profound influence on Australian cricket in various capacities for much of the next 25 years. And Benaud, always intent on championing the cause of players, remained a revered figure in Australia, England and far beyond well into his ninth decade.

BRUCE POSTLE

SPORT HAS BEEN A LIFE FORCE OF THE NATION, its most famous images transcending time and fashion to sear themselves in people's minds—and Bruce Postle was assured of lasting renown the moment he captured horse trainer Tommy Woodcock lying in a stall beside his much-loved charge Reckless on the eve of the 1977 Melbourne Cup.

The sporting contest has always enthralled Postle, providing him with some of his most memorable moments and images. But he has also long been celebrated for his versatility. In a decorated 27-year career with *The Age* newspaper in Melbourne, Postle's uncanny eye for a page-one picture ensured he was assigned to cover the most notable people and events. His stunning up-close portrait of Sammy Davis Jnr, a cigarette in hand, was commended by the great American entertainer himself. A signed copy of the portrait is among Postle's most prized possessions.

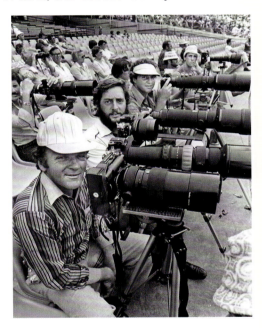

Snapper's gallery: (left to right) Bruce Postle (The Age), Colin Bull (The Sun) and Bobby Pearce (The Sydney Morning Herald) on duty at the Second Test, between Australia and England, at the SCG in January 1980. (Patrick Eagar)

His love of photography, of the power and timelessness of an image, was instilled in him by his father, Cliff, who had a heady reputation as a photographer at Brisbane's *Courier-Mail*. It was with his father's Graflex that Postle took his first picture, aged seven. By the time he was ten he was sitting alongside his father at Sheffield Shield and Test matches at the famous old Woolloongabba ground.

Postle began at *Queensland Country Life* before gravitating to the *Courier-Mail* armed with an antique Speed Graphic 5x4 camera. It was a painfully slow business, the flashbulb and film plate needing to be changed after each shot. 'That said,' Postle once explained, 'it was as good as a press pass. Walk up with that and you could get in just about anywhere.'

A capable minor league and social cricketer who learned to bowl fast on the full-length pitch pegged out on the family's two suburban blocks in the Brisbane suburb of Hendra, he revelled in being posted to Sheffield Shield cricket and, in time, to Test matches. In January 1966 he had the joy of covering the Shield match at the MCG in which his hero, Queensland fast bowler Peter Allan, took all ten Victorian wickets.

A warm, easygoing personality who quickly earned the respect of the sporting community, Postle was one of few photographers given regular access to the dressing room, where he captured many candid and whimsical moments. But his most compelling cricket images transpired on the field—Rick McCosker leaving the MCG after batting with a broken jaw in the Centenary Test of 1977 and England fast bowler John Snow being accosted by a spectator at the SCG in 1971.

The winner of numerous awards, including a prestigious Walkley, Postle turned the best of his library of more than 60,000 pictures into an acclaimed book, *The Image Maker*, published in 2011.

THE BRUCE POSTLE COLLECTION

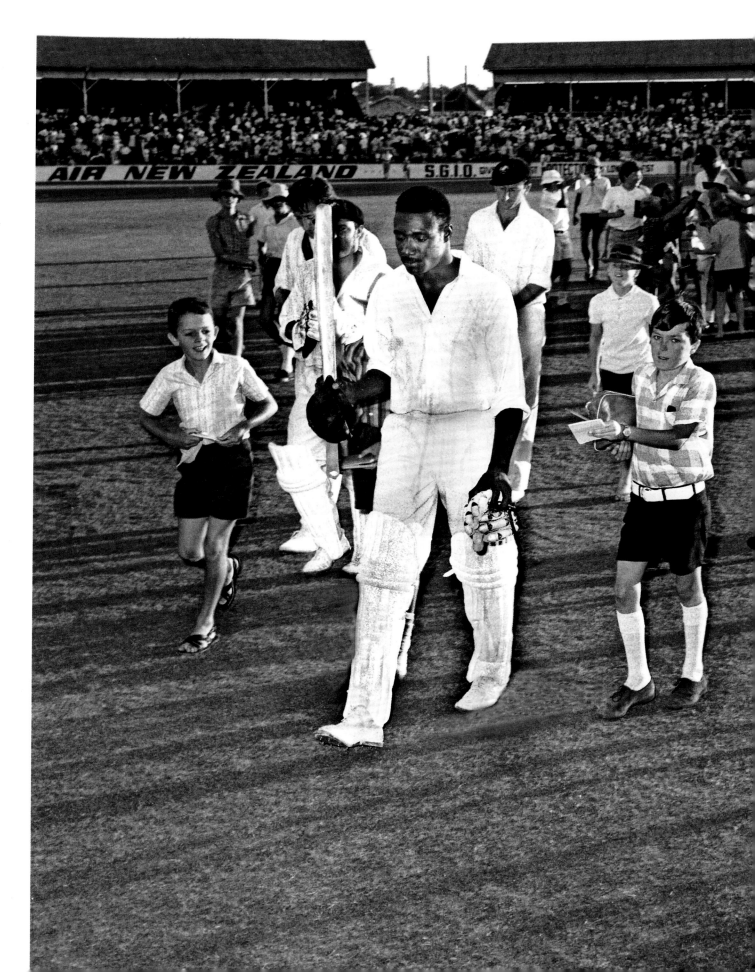

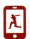

Clive Lloyd's unique relationship with Australian crowds began at Brisbane in 1968 when he scored his third hundred in just his ninth Test, his first against Australia. Anointed 'Supercat' because of his speed and feline movements in the field, he scored 129 with eighteen boundaries and a six in 210 minutes to ensure a West Indies victory by 125 runs. On his last visit to the Gabba sixteen years later he scored his nineteenth and final Test match hundred batting at seven. A celebrated and long-serving captain renowned for developing one of the most powerful teams in the annals of the game, he was made an honorary officer of the Order of Australia and was twice decorated by the government of his native Guyana.

Enigmatic and often controversial England fast bowler John Snow in a relaxed mood coaching schoolboys on King Island after inspiring England to victory in the 1970–71 Ashes series, the longest rubber in Test history. The son of a Sussex vicar, he took 31 of his 202 Test wickets at an imposing 22.83 in the series. Snow was also a published poet, his first volume, Contrasts, *appearing in 1971.*

On 15 February 1971, the rest day of the six-day Seventh Ashes Test, Bruce Postle cajoled England wicketkeeper Alan Knott to visit Plunkett Street Primary School at Woolloomooloo, Sydney, to pose with local children. It became one of Postle's favourite photographs. Much to the chagrin of the boys, it was eight-year-old Melita Pullicino who got the chance to bat. Knott, one of the game's most distinguished glovemen, completed a record 24 dismissals for the series—including four catches and two stumpings in this Test.

Australian number nine Terry Jenner ducks into a bouncer from John Snow on the second day of the seventh Test match of the 1970–71 Ashes series. A section of the crowd was incensed by the incident and Snow, who had been officially warned against excessive use of the short ball, was aggressively accosted by a spectator on the fence and cans were thrown onto the ground. Outraged by such unruly behaviour, England captain Ray Illingworth led his men off the field but returned soon after when warned by the umpires that England was in danger of forfeiting the match. Jenner retired hurt but returned to the fray to score 30.

In this image, unusual in that it shows all eleven members of the fielding team, Dennis Lillee is in action to opening batsman John Edrich in the first over of the Seventh Ashes Test at the SCG in February 1971. Ian Chappell emulated his predecessors Percy McDonnell, George Giffen and Bob Simpson by inviting the opposition to bat in his first Test as captain. The boldness that was to characterise his leadership seemed to pay handsomely when Australia established a first innings advantage of 60. However, England rallied in the second innings to triumph by 62 runs.

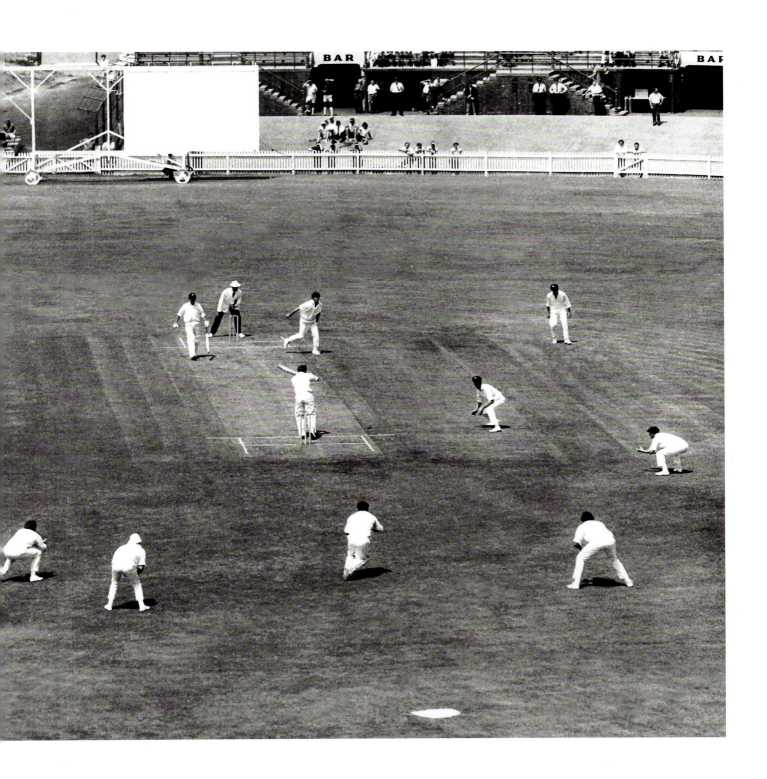

THE BRUCE POSTLE COLLECTION

England fast bowler John Snow sunbakes at a Sydney beach in 1971. Even when catnapping he is being watched closely by his grateful skipper, Ray Illingworth. Snow's new ball partner Peter Lever (right) seems to be meditating.

OPPOSITE: *Doug Walters, a gifted batsman known as much for his antics off the field as his brilliance on it, strikes a familiar pose with a full hand and a beer at the ready. An inveterate gambler and a wonderful raconteur he was known to leave a hand of cards and a lighted cigarette when required to bat. Leaning over his shoulder is fast bowler Graham McKenzie who answered to the nickname of Garth after a comic strip hero of the time.*

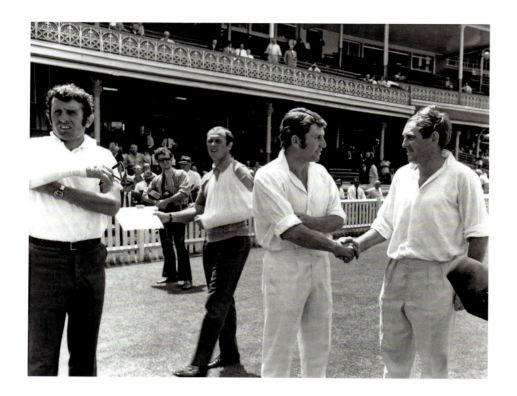

Contrasting emotions after the Seventh Ashes Test, 1970–71. New Australian captain Ian Chappell congratulates his counterpart Ray Illingworth on becoming the first England captain to regain the Ashes in Australia since Douglas Jardine in the infamous Bodyline summer of 1932–33. John Snow (left) nurses a fractured finger and Geoff Boycott a broken arm at the end of the gruelling four-month tour.

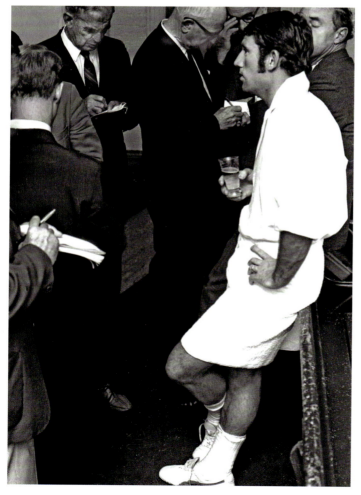

Never one to stand on ceremony, Ian Chappell, wearing a towelling bathrobe, fields questions from journalists during his first Test as Australia's 34th captain. Always a respecter of the media, he became an accomplished writer and commentator after retiring as a player.

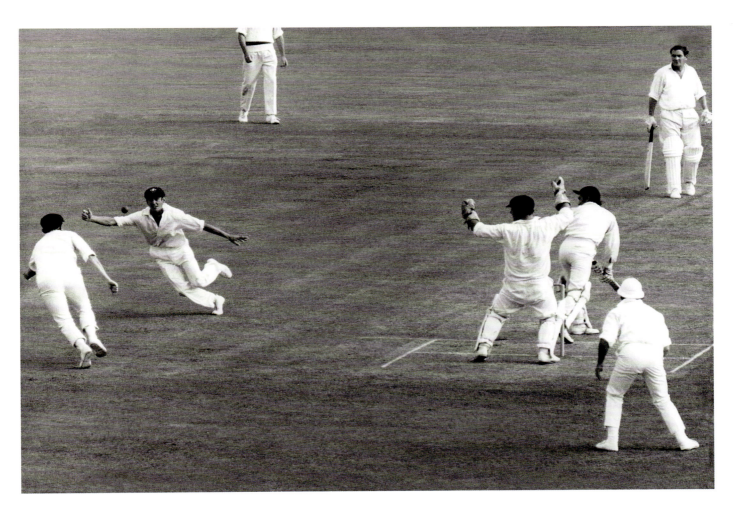

It was not only the pace of Dennis Lillee and Jeff Thomson that so unsettled England's batsmen in Australia in 1974–75. Lean off-spinner Ashley Mallett bowled with considerable guile to claim seventeen wickets at a miserly 19.94 in five Test matches. Here he draws an error from England wicketkeeper-batsman Alan Knott during the Fourth Test at the SCG. Ian Redpath (second from left) reacts fractionally quicker than Jeff Thomson (left) and completes a fine catch to dismiss Knott, top-scorer with 82 in England's first innings, for ten. Australia won the match by 171 runs and the series 4–1.

THE BRUCE POSTLE COLLECTION

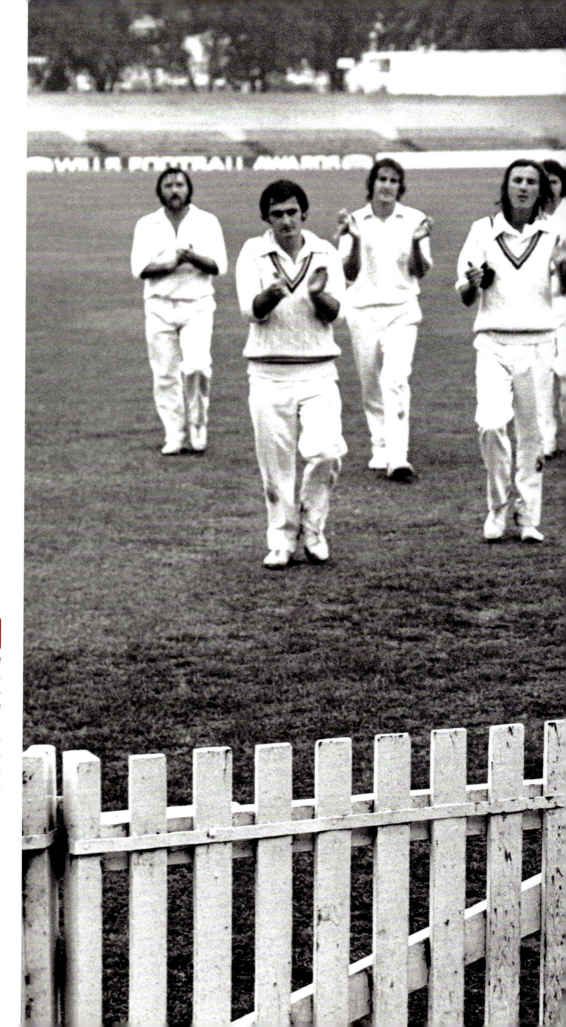

He was Australia's 32nd captain but Bill Lawry is predominantly identified by friend and foe as an unabashed and unapologetic Victorian. A fine and courageous opening batsman but a stubbornly conservative leader, here he is photographed leaving the Junction Oval at St Kilda, Melbourne, after his last competitive game of cricket at the age of 38 in March 1975. Lawry was appointed captain–coach of St Kilda in 1972 after a long and distinguished club career with Northcote.

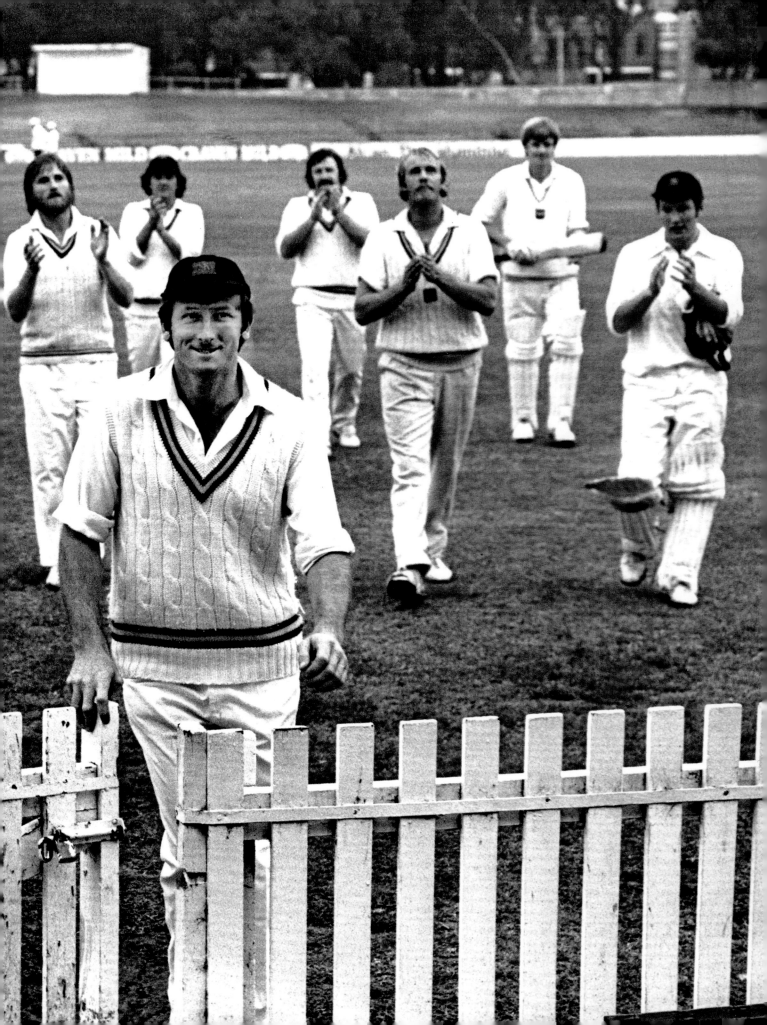

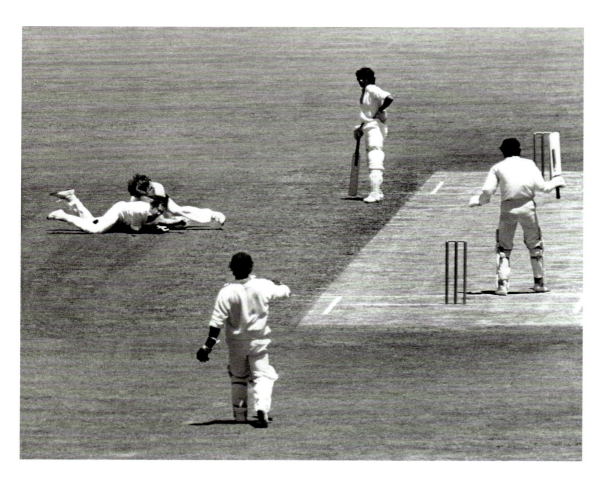

Jeff Thomson dislocated his right shoulder in a shocking collision with teammate Alan Turner in the First Test with Pakistan at Adelaide Oval in December 1976. Turner, at short leg, was rendered unconscious when Thomson cannoned into him while attempting to catch masterful Pakistani batsman Zaheer Abbas off his own bowling. Umpire Max O'Connell said the sound of the accident was redolent of a pistol shot.

RIGHT: *With a characteristic mix of guile and gumption, Bruce Postle inveigled himself into the hospital to get this news picture of the wounded bowler.*

OPPOSITE: *By 1976–77 a rhyming couplet was embedded in Australian cricket lore: 'Ashes to ashes, dust to dust, if Thomson don't get ya, Lillee must.' With Thomson unable to take any further part in the series with Pakistan, Lillee assumed sole responsibility for the Australian attack and finished with 21 wickets at 25.71 in the drawn three-match series. This photograph shows Lillee at the point of delivery in the Second Test in Melbourne, where he returned the stunning match figures of 10–135.*

THE BRADMAN MUSEUM'S WORLD OF CRICKET

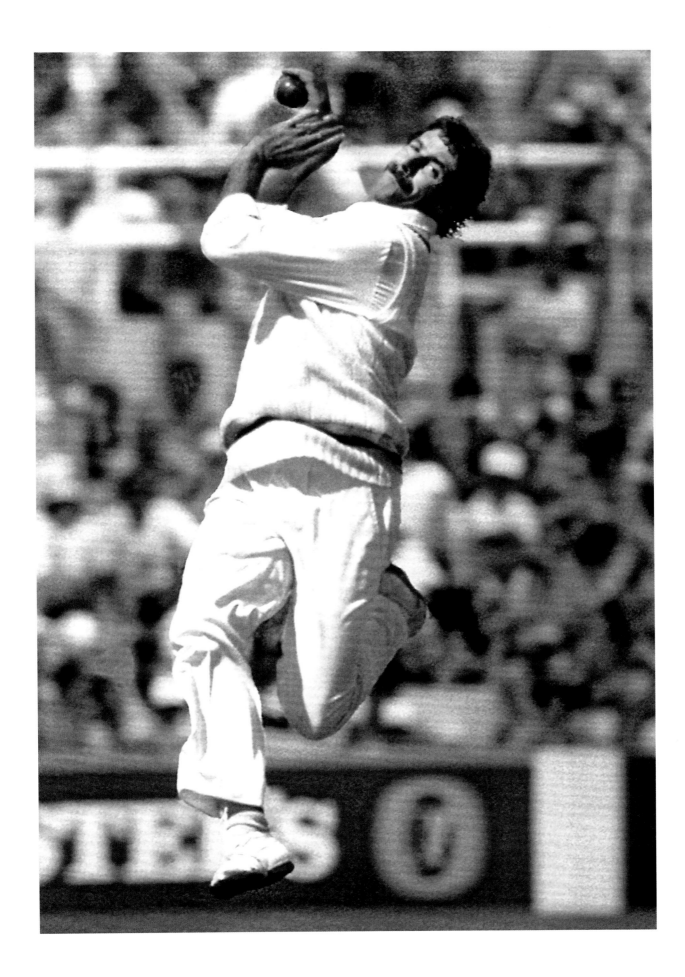

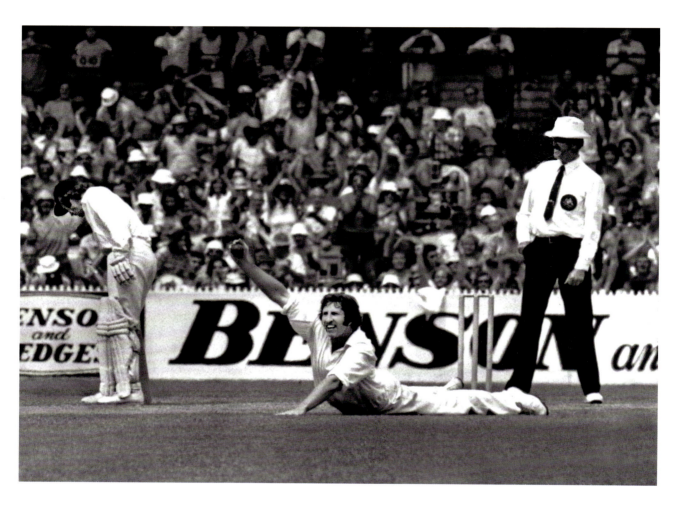

The incorrigible Max Walker, prostrate and optimistic in a Sheffield Shield match for Victoria against South Australia in 1976 (above) and in action at the height of a 34-Test match career which earned him 138 wickets at 27.47 (right). An extrovert showman and storyteller, 'Tangles' developed a wide following through his product endorsements and television advertisements.

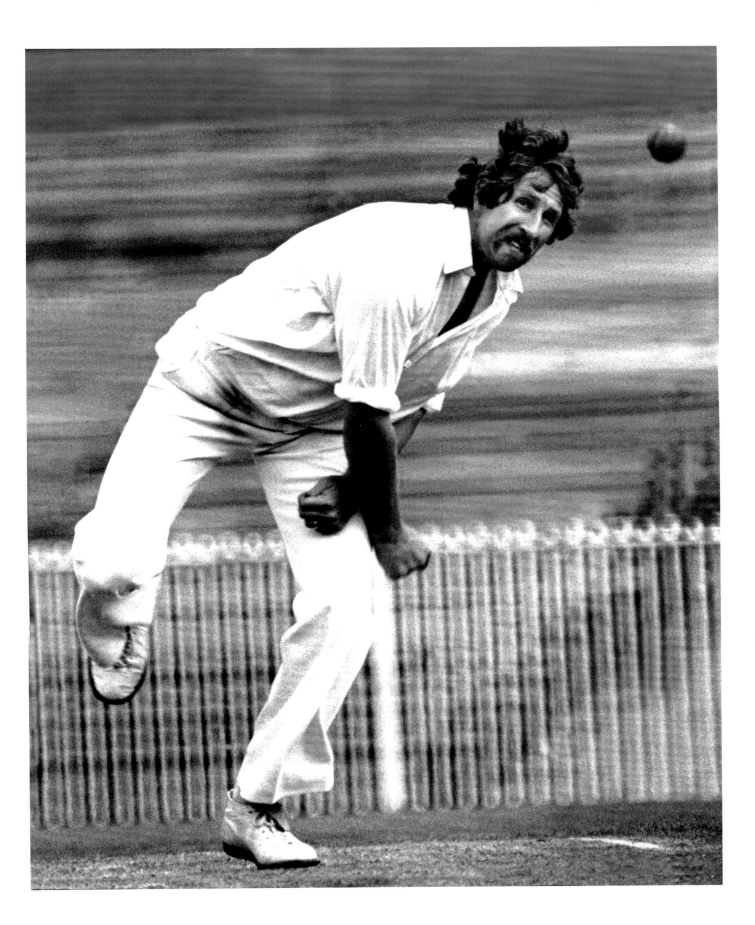

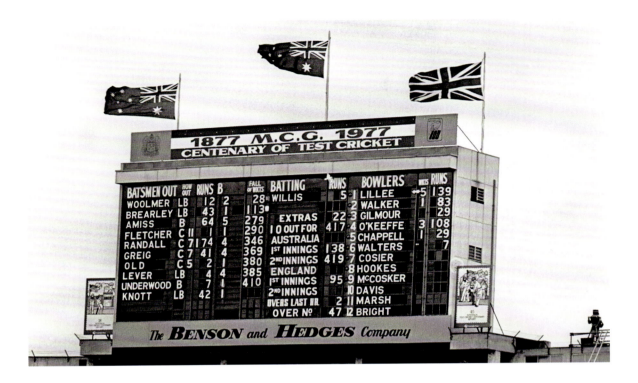

Australia won the Centenary Test (12–17 March 1977) at the MCG by 45 runs after Rick McCosker, batting at number ten with centurion Rod Marsh, added a precious 54 runs for the ninth wicket. In the First Test (15–19 March 1877), Australia also won by 45 runs— a striking coincidence.

RIGHT: *In just his fifth Test match, impish England batsman Derek Randall batted for seven hours and 26 minutes for a thrilling 174 as England gallantly but vainly amassed a record fourth innings total of 417. That he was named Man of the Match ahead of all-conquering Dennis Lillee was testament to the magnitude of his innings.*

OPPOSITE: *Battered, broken but unbowed, Rick McCosker leaves the crease in the Centenary Test, his broken and swollen jaw swathed in a bandage. McCosker had listened to much of the match on radio from his hospital bed before returning to the fray and again confronting the cause of the damage, England fast bowler Bob Willis.*

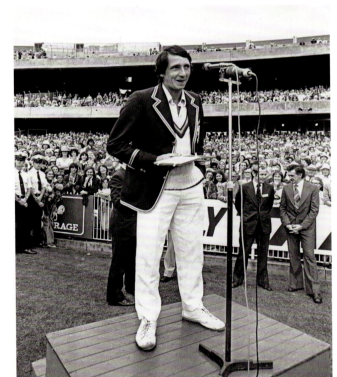

THE BRUCE POSTLE COLLECTION

'Lillee, Lillee, Lillee': incomparable fast bowler Dennis Lillee is carried aloft by his captain Greg Chappell and Gary Cosier after returning the match figures of 11–165 and inspiring Australia to a historic victory in the Centenary Test. His teammates Kerry O'Keeffe and Max Walker (right foreground) are swamped by a horde of Lillee's admirers.

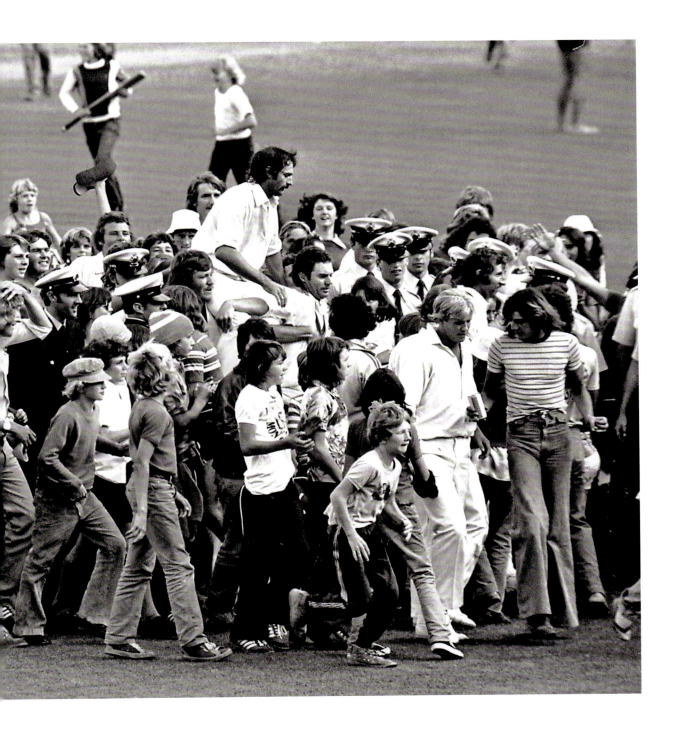

THE BRUCE POSTLE COLLECTION

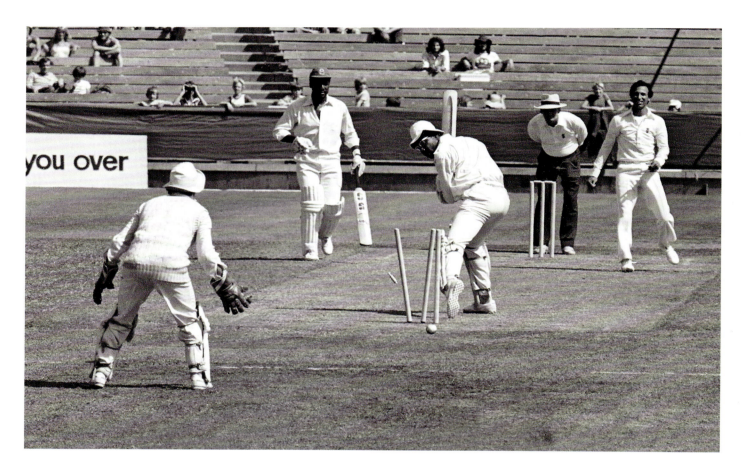

Exhilarating Pakistani all-rounder Asif Iqbal occasionally deputised for Tony Greig as captain of the World XI in the first series of World Series Cricket in 1978–79. Here he cannot resist a smile as he bowls West Indies captain Clive Lloyd in a day–night match at Waverley in Melbourne. Asif, who led Pakistan at the World Cup in 1979 and then to India for a six-Test series, in time became an influential figure in the establishment of international cricket at Sharjah in the United Arab Emirates.

OPPOSITE: *Few elite batsmen have played off their hip with the power and panache of West Indian Gordon Greenidge. Here he has the temerity to despatch behind square leg a short delivery from Dennis Lillee in the first over of the Second Test match at the MCG in December 1979. With Desmond Haynes, Greenidge formed one of the most accomplished opening partnerships in the annals of the game.*

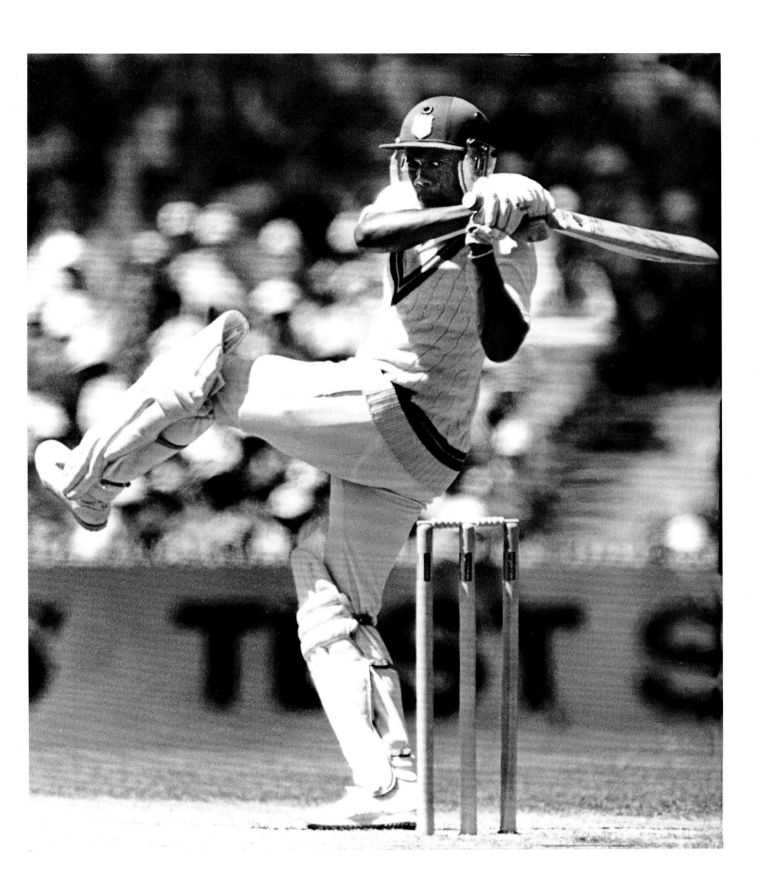

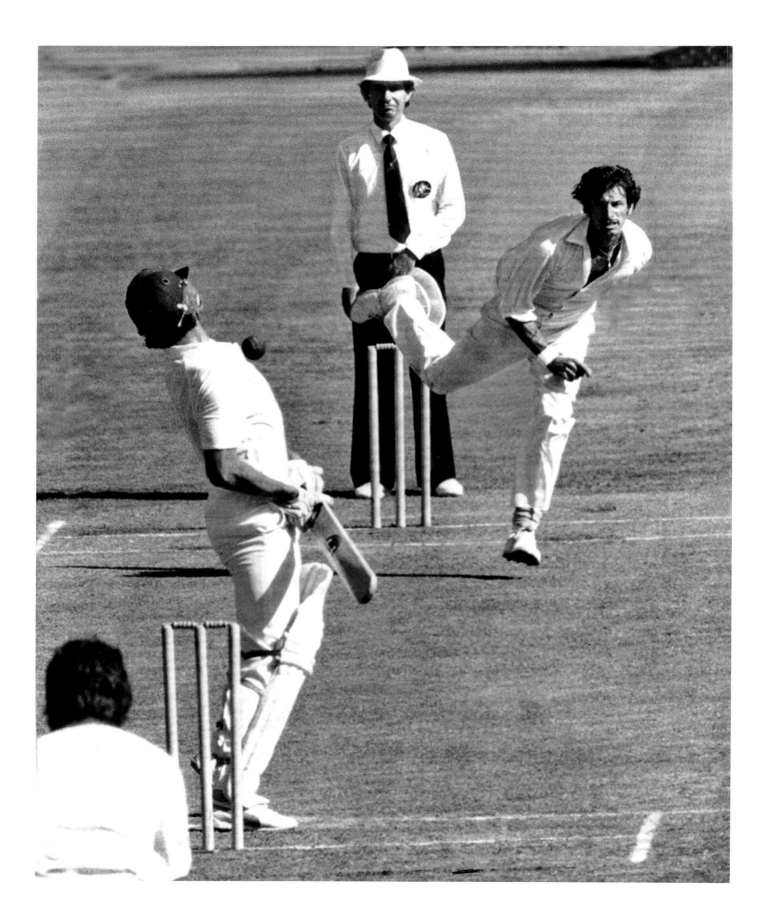

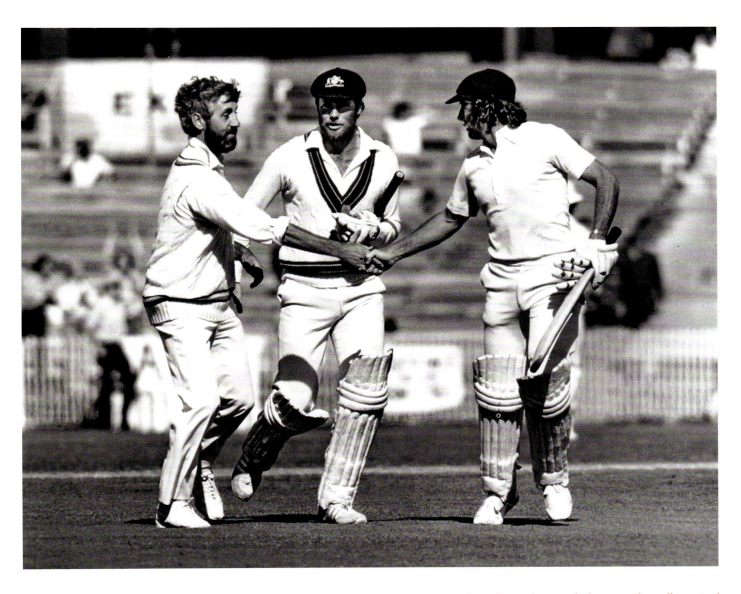

England captain Mike Brearley congratulates Ian Chappell on a distinguished career. Chappell remained unbeaten on 40 in his 136th innings in his 75th and final Test match, at the MCG on 6 February 1980. Looking on is Chappell's brother Greg, who captained Australia to an emphatic 3–0 series victory and topped the averages with 317 runs at 79.25. The previous season, at the height of the World Series Cricket revolution, Brearley led England to a 5–1 Ashes success. The Ashes were not at stake in 1979–80.

OPPOSITE: *Fearsome New Zealand fast bowler Richard Hadlee dares to intimidate his Australian counterpart Dennis Lillee with a bouncer during the Third Test at Melbourne in 1980–81. Hadlee had less fear of retaliation than many of his fast bowling cohorts; he complemented his 431 wickets at 22.29 with 3124 Test runs at 27.16 with two centuries. Hadlee was knighted for his services to cricket in 1990.*

THE BRUCE POSTLE COLLECTION

To his astonishment, master batsman Allan Border needed to reappraise his ability as a very occasional left-arm finger spinner after taking 11–96—a record match analysis for an Australian captain—against the West Indies at Sydney in January 1989. He took sixteen wickets in his first 100 Tests and completed his 156-Test career with 39 wickets at 39.10.

OPPOSITE: *Sri Lankan Asanka Gurusinha takes flight as David Boon plays with characteristic power through point during the First Test with Australia at the Gabba, Brisbane, in December 1989. This was the first occasion Sri Lanka was afforded more than a solitary Test match in Australia.*

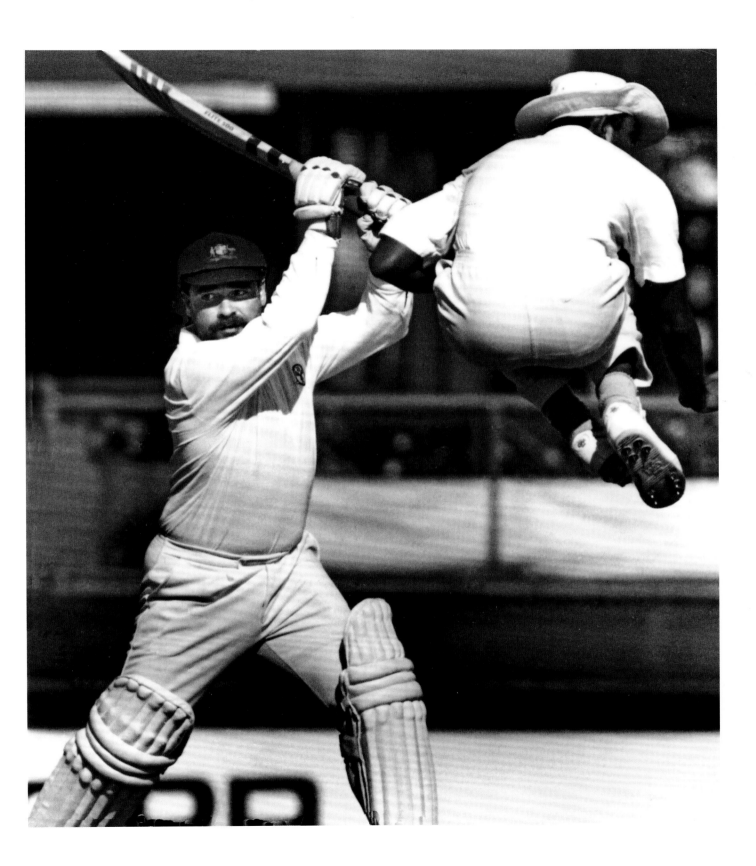

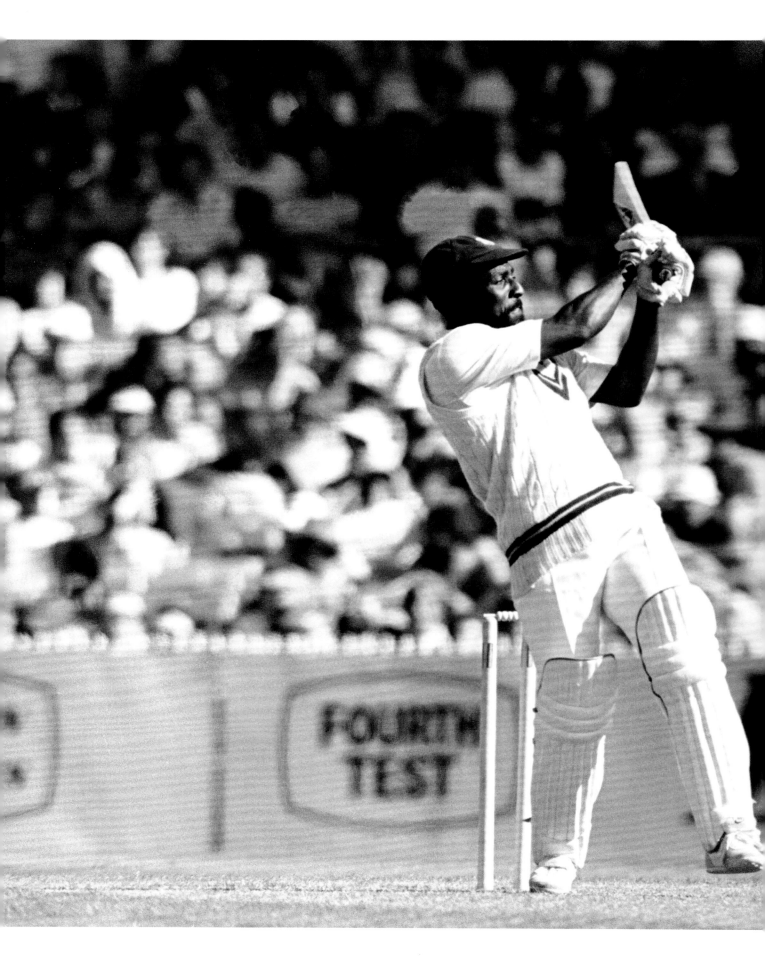

Viv Richards, judged by Wisden Cricketers' Almanack *to be one of the five greatest cricketers of the twentieth century, pulls with customary power and flair through mid-wicket during his vintage 208 against Australia at the MCG in Christmas week 1984. Richards' third double century, which included 22 boundaries and three sixes in six hours and fourteen minutes, was the first for the West Indies in Australia.*

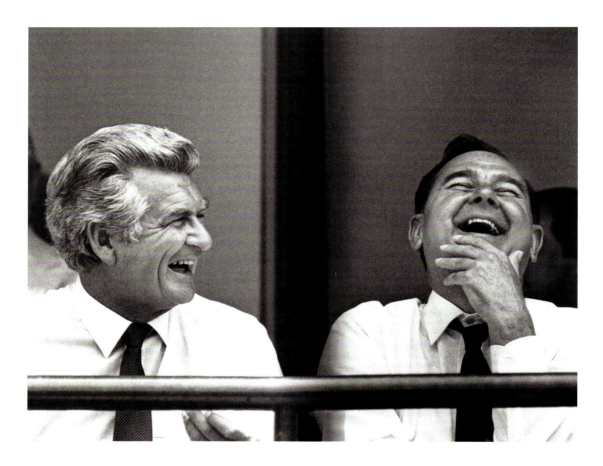

Ardent cricket lover Bob Hawke acted swiftly to reinstate the Prime Minister's XI after coming to office in 1983. Instituted by the longest-serving prime minister, Sir Robert Menzies, in 1950, Hawke welcomed Clive Lloyd's celebrated West Indian team to Manuka Oval in January 1984 during their visit for World Series Cup matches. An honoured guest in the VIP enclosure was former England captain Lord Colin Cowdrey of Tonbridge. Twenty-five years earlier Cowdrey scored 101 to lead England to victory over Menzies' XI in the corresponding match.

OPPOSITE: *Off-beat all-rounder Greg Matthews leaps into the arms of madcap fast bowler Merv Hughes, himself adept at invading the personal space of teammates in moments of celebration. Often their wacky antics deflected attention from outstanding achievements in the middle. Gregarious Dean Jones (left) and wicketkeeper Ian Healy share the excitement.*

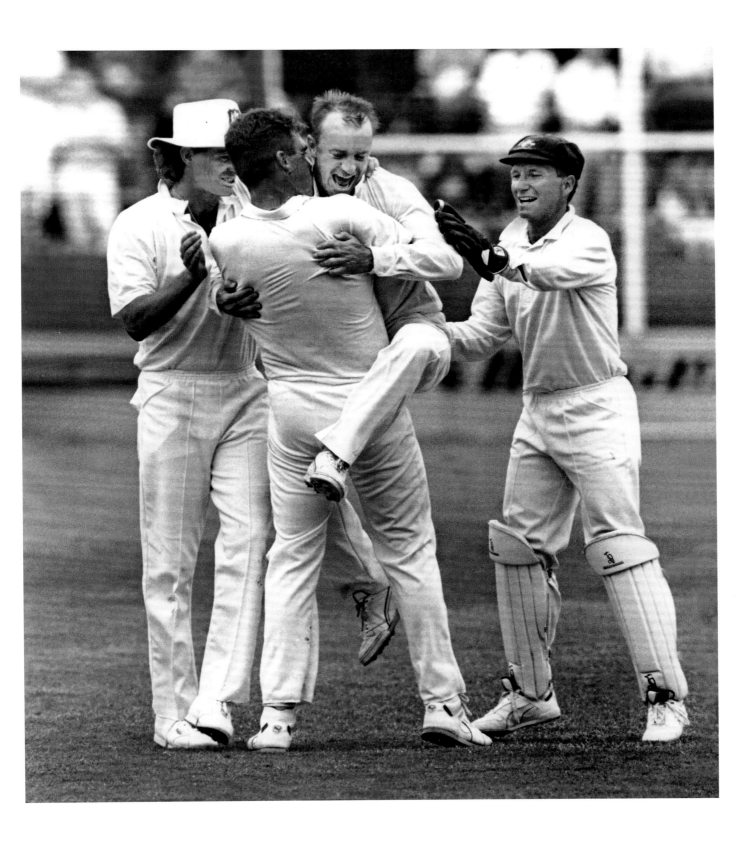

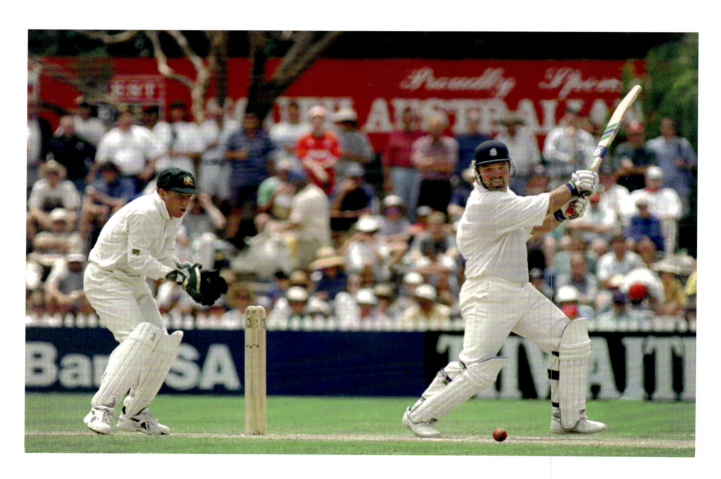

Mike Gatting's penchant for a feed and a beer endeared him to Australian crowds. As England captain he had the distinction of retaining the Ashes in Australia in 1986–87 and was at the helm for the Bicentenary Test at Sydney in 1988. Here he plays ahead of point while constructing his tenth hundred—his first for seven and a half years—in his penultimate Test, at Adelaide in January 1995. Ian Healy is at the ready.

A predilection for runs and a beer earned David Boon cult status in Australian cricket and beyond. Here a well-oiled Adelaide Oval crowd shows its affection. A decade after his retirement a beer manufacturer patented the talking 'Boony doll', complete with luxuriant moustache, to promote their product and sponsorship of the limited-over game in Australia.

THE BRUCE POSTLE COLLECTION

In 1984 the first of the spectacular lighting towers was the newest structure at the MCG. In 2014 it was the oldest, bar some boundary fencing that has been conscientiously preserved since 1884. To keep the peace with union officials and for the modest outlay of $40, Bruce Postle set his camera and issued precise instructions to the dogman who took this remarkable image from the arm of a crane positioned behind the Great Southern Stand (opened in 1936). The quaint members' pavilion (1928) is flanked by the 1956 Olympic Stand (right) and the Ponsford Stand (1967) displaying an electronic scoreboard.

At the feet of a colossus: dignitaries gather at the unveiling of an imposing statue of Sir Donald Bradman at the MCG in September 2002. Bradman's son, John, is second from right.

To the unbridled delight of English supporters marching under the flag of the Barmy Army at Adelaide Oval in January 1995, zany slow bowler Phil Tufnell has his moment centre stage, feet up! Often mocked for his poor fielding, Tufnell took a brilliant tumbling catch in the deep to dismiss flamboyant Australian opener Michael Slater. The dismissal precipitated a collapse, with Australia squandering a first innings lead of 66 and England winning by 106 runs.

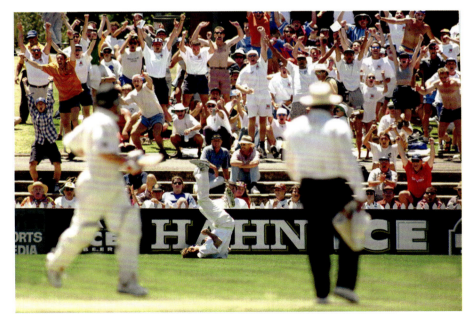

THE BRUCE POSTLE COLLECTION

*Call him what you will—Smokin'
Joe, Master Blaster, Black Bradman—
Viv Richards was arguably the most
devastating and thrilling batsman of
his generation. Knighted by his native
Antiguan government in 1999, Richards
said: 'I was proud to be associated with
the great name of Sir Donald Bradman,
a figure who was revered. I'm very
privileged if someone mentions Vivian
Richards, wow, the black Bradman!
Totally happy with that!'*

*FOLLOWING PAGE: On assignment and
nearing the Victorian town of Bungaree in
1985, Bruce Postle came upon ten members
of the Steenhuis family playing in a
paddock just off the main road. This classic
image eloquently showcases the glorious
game in the unique Australian landscape.*

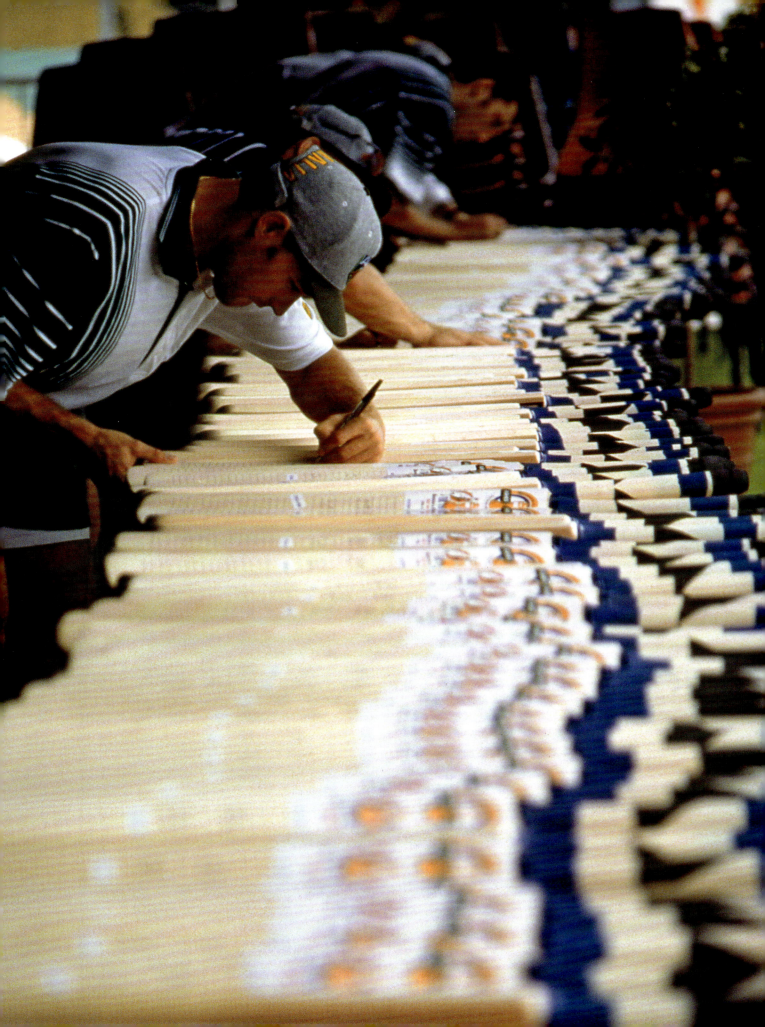

PART 3

THE VIVIAN JENKINS COLLECTION

EYEWITNESS TO REVOLUTION

CRICKET WAS UNPREPARED FOR THE 1970s. The game's intransigent governors, overcome by upheavals in the wider community, ceded authority and control to entrepreneurs. Exclusiveness gave way to inclusiveness. Elite players no longer played serf to their masters in oak-panelled corridors of power. Within a decade the most conservative and constricted of popular sports was changed deeply. 'Over the years,' Ian Chappell observed, 'the Australian Cricket Board hoped they'd never get a whole lot of militants at one time. I'm afraid they just ran out of luck in the '70s.'

The generation of cricketers born after World War II—the baby boomers—had come of age during the social and sexual revolution of the 1960s. In the minds of the game's Establishment they were unkempt, bolshie and impertinent. They demanded a voice in the game and their appeals to be heard went unheeded. The most conspicuous among them was Chappell, who had risen to the Australian captaincy in February 1971, a hard-headed, hard-swearing leader who inspired loyalty, courage and devotion from his men and was destined to lock horns with Bradman, his nemesis. Next to the often irascible fast bowler Dennis Lillee, Chappell was a prime mover of the World Series Cricket movement that was destined to transform the game from 1977.

A more empathetic and accessible authority would have foreseen the impending conflict. Top players were battling to prosper on subsistence pay and a modest laundry allowance while trying to hold down a job outside cricket. Chappell had been deputy to autocratic skipper Bill Lawry on an ill-conceived visit to Sri Lanka, India and South Africa in 1969–70, which drove yet another wedge between leading players and their overlords. That the governing body countenanced such a foolhardy undertaking was a sign of its insularity and naivety. From the moment Lawry, exhausted after a five-month tour, signed a letter tabling a litany of complaints, his captaincy was doomed—and so it came to pass, though not until after Australia's

OPPOSITE: The proliferation of the limited-over forms of the game from the 1990s on has ensured merchandising and marketing became cornerstones of professional cricket. Australian batsman Michael Bevan, who forged his identity in the one-day arena, is shown signing scores of bats for sponsors, marketers and publicists.

second shellacking in three years in South Africa was followed by the loss of a home Ashes series for the first time in sixteen years.

Compounding this unsettling opening to the 1970s was the controversy surrounding South Africa's proposed five-Test tour of Australia scheduled for the 1971–72 summer. An orchestrated international move against the iniquitous, racist government of the old South Africa had become irresistible, and Bradman, while it distressed him to do so, cancelled the tour. He was approaching the end of his second term as board chairman. Australian cricket, try as it might, could no longer distance itself from the harsh realities of the cricket world.

In the short term Ian Chappell set aside his displeasure with the game's tight-fisted governors and set about changing the mentality and methodology of his ambitious young team. A creditable 2–1 loss to a Rest of the World side, hurriedly cobbled together to replace the South Africans, and a gallant 2–2 draw in England—swing bowler Bob Massie taking eight wickets in each innings of his Test debut at Lord's, MC, one more than he'd take for the rest of his Test life—earned Chappell impressive notices as a leader. Spirits in the Australian cricket public lifted.

But by the time of England's 1974–75 return visit Chappell was again thinking as much like a shop steward as his country's captain. His epiphany came in the middle of the Melbourne Cricket Ground on the last day of 1974 when he heard over the public address system that the aggregate crowd had been 250,750 and the gate receipts $251,771. Total player payments for the Australians were $2400—$200 each. The injustice of this infuriated Lillee, and Chappell immediately agitated on behalf of his men, securing them a $200 bonus for each Test they played in the series. The mandarins believed their gesture to be magnanimous. This incensed the players.

Chappell was determined to improve pay and conditions before handing the leadership to his brother Greg. Twice he addressed full gatherings of the board delegates. He also sought a meeting with Bob Hawke, trade unionist and renowned cricket lover, who was destined for the country's prime ministership in 1983.

A student of cricket history, Chappell sensed substantive changes were afoot that would make new and varied demands of players everywhere. He had been a member of the team that played the first limited-overs international against England on 5 January 1971. That match was arranged on the fly following a Test match washout. He was aware of the popularity of the shorter-form competitions introduced in England in 1963 as an antidote to falling county and Test attendances. The three 55-over matches appended to the Ashes schedule in 1972 had not enthused him, but nor was he surprised.

Soon Chappell and his contemporaries learned they would need to give this compressed version of the game greater respect. Confirmation of the emerging power, commercial clout and general appeal of limited-overs cricket came when the

inaugural women's World Cup was held in England, two years before the first men's one-day jamboree in 1975. Remarkably—given their initial indifference—Chappell's Australians exceeded expectations by reaching the final, which was narrowly and thrillingly won by a vibrant West Indian team at Lord's.

The potential of the limited-overs game to engage spectators seeking fast-paced entertainment was undeniable. At the same time the revival of Australia's fortunes under Chappell, and the emergence of Lillee, Greg Chappell, Rod Marsh and Jeff Thomson, ensured a heightened level of interest in the traditional game. And it was rich and varied fare that was on offer. In the four summers since the Rest of the World visit of 1971–72, Pakistan, New Zealand, England and the West Indies had all toured Australia. Pakistan's visit was their first in eight summers and the West Indies were returning after a seven-year absence; New Zealand, embarrassingly for Australia, had never played Tests in Australia before. The initial match between the Australasian neighbours happened 27 years earlier in Wellington and was only granted Test status retrospectively. The disregard for New Zealand has long been a stain on Australian cricket's record.

Greg Chappell took the helm in 1975–76. That summer's 5–1 rout of the West Indies by Lillee, Thomson and their assistants Gary Gilmour and Max Walker had a profound impact on the way Test cricket would be played throughout the world for the next fifteen years. It came just five months after the West Indies' World Cup triumph. Their devastated captain Clive Lloyd pledged that never again while he was in charge would West Indian cricket be so humbled. He noted that every West Indian had 'at some time or other felt the pain of a cricket ball sent down at great speed thudding into their bodies. The players are determined never to let it happen again.'

Unashamedly Lloyd adopted the Australian methodology, employing a plethora of fine fast bowlers to exact revenge and so develop one of the most imposing teams in the game's annals. Five times in eight seasons they would play Tests against the Australians, winning four series and drawing the other, as one of cricket's greatest dynasties gathered momentum and attracted controversy. Meanwhile exposure to the world's leading cricketers at such concentrated intervals had revealed to Ian Chappell and Lillee that in their dissatisfaction with pay rates, conditions and the high-handedness of their masters, the Australians were not alone. The winds of change were gathering velocity.

June 1976 brought an extraordinary confluence of events that in essence led to the game being propelled from the nineteenth to the 21st century. As Chappell, Lillee and their cohorts became increasingly loud in their militancy, Bradman and his fellow delegates declined a sizeable offer from media magnate Kerry Packer to televise Australian cricket. Rather than award the broadcast rights to Packer's commercial Nine Network, the board decided to remain with their existing broadcaster, the then Australian Broadcasting Commission, for a substantially smaller fee.

Incensed at being given short shrift by the local game's haughty government, Packer was untroubled in convincing Richie Benaud, arguably cricket's foremost analyst and commentator, and England's captain of the day Tony Greig of the merits of forming a breakaway World Series Cricket movement, a concept first considered by Packer after entreaties on behalf of Lillee and Chappell. Simultaneously Hans Ebeling, a 71-year-old vice-president of the Melbourne Cricket Club and noted respecter of cricket history, was putting before the committee the concept of an event to mark the centenary of the first ever Test match of March 1877. Ebeling, who himself made a solitary appearance for Australia as an opening bowler at The Oval in 1934, envisaged every living cricketer who'd ever played an Ashes Test match gathering at the MCG.

So it was that at the very moment the Establishment celebrated the values, traditions and glory of Test cricket, the revolutionaries were being conscripted for the barricades.

Only in the days and months that followed was this paradox fully revealed. Indeed Greig and Lillee were key players in that celebratory Centenary Test, and Benaud and Ian Chappell dissected proceedings from the vantage point assigned to the 0–10 television network. Unbeknownst to even the most savvy and well-informed folk in cricket, clandestine meetings took place and discreet targetings unfolded in the dressing rooms and labyrinthine corridors of the MCG, and in the suites and passageways of the nearby Hilton Hotel where both teams were staying. And there were mumbled and telling conversations in Yarra Park, located between the people's ground and the hotel.

It says much for the players' pride and sense of patriotism that they managed such conflicting emotions to produce an epic match for which they were each paid a meagre $400. (A statement released by Bob Parish, chairman of the Australian Cricket Board, on 16 September 1977 claimed every player received $2277 for the match. The players have no recollection of such a figure reaching their bank accounts, believing it most likely to be the aggregate sum set aside for player payments.) Inspired by Lillee, who captured 11 for 165 and was chaired off the ground to thunderous applause, Australia won by 45 runs—the exact margin, astonishingly, as 100 years earlier.

Just as remarkably, not one confidence or promise was broken, and another 53 days would go by before an unsuspecting world, on 9 May 1977, formally learned of World Series Cricket. Only then was the extent of the Melbourne masquerade revealed. The entire Australian team, with the exception of batsman Gary Cosier, and three members of the England XI had made a commitment to what a shell-shocked Establishment immediately dismissed as 'Packer's circus'.

The attendant court actions and broken friendships polarised cricket communities everywhere, as Packer lured players from across the world. Despite the luminaries he attracted, World Series Cricket failed to fill seats in 1977–78, a season when the orthodox Australian XI under the leadership of reborn Bob Simpson won an enthralling series with India. The following summer Graham Yallop took over the traditional

102 THE BRADMAN MUSEUM'S WORLD OF CRICKET

Without understating the colossal contribution of fast bowlers to Australian cricket, 'Bring on the Leg Spinner' has long been a familiar refrain of spectators throughout the country. Australia has been wonderfully served by the masters of the arcane art and this homespun sign was hoisted to demand the appearance of charismatic and controversial Shane Warne. Warne proudly served his distinguished predecessors, Arthur Mailey, Clarrie Grimmett, Bill O'Reilly, Richie Benaud and company, to become the nation's highest wicket-taker in Test matches.

team, which was ridiculed 5–1 by England, and Packer's World Series—bringing night cricket, and all its pizzazz, to the Sydney Cricket Ground—was an unqualified success.

In a matter of months the often staid, colourless game of Empire had time-travelled. Nothing seemed the same. The philosophy of cricket changed both on and off the field of play. So did its complexion. So did its standards and values. So did its language. Flannels were discarded for what some said were coloured pyjamas. The game was played at night with a white ball to unfamiliar laws and there were markings on the ground. Television and radio appreciation of the game was different, its reportage too.

With a numbing swiftness, the game belonged not to parochial administrators but to publicists, promoters and marketers, as sports lovers responded in impressive numbers to catchy jingles and patriotic anthems. The newness was intoxicating. The game and its finest exponents were absorbed into popular culture as never before. Cricketers who had been branded 'Ugly Australians' in 1974 and roundly condemned for introducing sledging to a genteel pastime became heroes, role models, to often unruly and exhibitionist crowds. Colour TV, introduced in 1975, underscored and

amplified the game's transformation. It was to such a kaleidoscopic backdrop that Viv Jenkins took a telephone call in November 1977 from one of Packer's most trusted lieutenants, Lynton Taylor, offering him the position of official photographer to World Series Cricket.

A successful newspaper and magazine photographer, Jenkins had to make the transition from multiple fields of endeavour to a single subject: cricket. It demanded lightning reflexes, the patience of Job, and a preparedness to hump 25 kilograms of equipment to his workplace, which shifted on a daily basis. He had the priceless opportunity to intimately document the most remarkable period in Australian cricket history, and he did so with a freshness, daring and modernity that perfectly complemented his subject matter. The most affable of men, he immediately gained the trust and respect of his subjects—a fact reaffirmed years later when Richie Benaud and Ian Chappell provided laudatory forewords to his books *Fields of Glory* and *The Baggy Green: World Series to World Champions.*

Benaud and Bradman did not speak to each other during the two-year schism. Throughout cricket, there was deep bitterness and lasting resentments, much like the summer of 1932–33 when an England captain in a harlequin cap, Douglas Jardine, calculatedly went outside the spirit of the game to bring down Bradman.

Come 1979 the warring parties found common ground, and a conspicuously humbler Australian Cricket Board welcomed back to the fold the country's finest cricketers. Packer's Nine Network won the broadcast rights. Jenkins was appointed the board's official photographer. He faithfully recorded the triumphs and travails of Australian cricket until 1996–97. Following his death at 74, in 2009, his widow Jan donated his photographs to the Bradman Museum and International Cricket Hall of Fame, of which she is an ardent supporter. Jenkins' legacy is a comprehensive and compelling archive of the revolutionaries, and then some.

VIVIAN JENKINS

AN ENTHUSIASTIC TEENAGER, unafraid of hard and menial tasks, Viv Jenkins left the verdant and singing valleys of his father's land, Wales, to make his life in Australia, where he landed a job as copyboy on *The Sydney Morning Herald* before gravitating to the photographic department.

After a stint at *The Age* in Melbourne he returned to Sydney as an Australian Consolidated Press staff photographer. He was soon shooting sport and fashion for *The Daily* and *Sunday Telegraph*, *The Australian Women's Weekly* and *Cleo* magazine. At the direction of founding editor Ita Buttrose, he photographed actor Jack Thompson in 1972—*Cleo*'s first nude 'Playmate of the Month' male centrefold.

The following year the England cricket team was famously led by a Welshman, Tony Lewis, and Jenkins decided to broaden his horizons and seek professional experience overseas. Four years later he was invited back and accepted the prestigious position of official photographer for Kerry Packer's World Series Cricket movement.

For the next twenty years this affable and witty raconteur was a constant presence at cricket grounds throughout Australia and numbered some of the game's greatest players among his friends and acquaintances. When the World Series revolution ended in 1979 he became official photographer for the Australian Cricket Board while working under the auspices of Packer's marketing arm, PBL.

Viv Jenkins (right) and good friend and colleague Patrick Eagar skylarking with their national flagettes at a function hosted by the UK Sport's Journalist Association to mark Eagar's 40-year service as one of cricket's elite photographers.

Jenkins' thoughtful, flawless work earned him the admiration of players and officials. He was feted by his contemporaries as the first photographer in Australia to capture the game using colour film. In the quest for the perfect shot, he rarely relied on a camera's motor drive. Patiently he'd watch each ball through the lens, taking an image only when he sensed something significant happening—what he termed a 'peak action'. 'If it's not possible to concentrate, it's not possible to photograph cricket,' he told his many acolytes and protégés. 'Simple as that. In addition to being very lucky, it helps if you have above-average reflexes, the ability to concentrate for hours, and the ability to relax and allow the tension to ease whenever the pressure becomes hard to handle.'

Winner of the Kodak/Adidas Sports Colour Picture of the Year in 1990, he was appointed official photographer to the 1992 World Cup, the first time the blue-riband event was held in Australasia. He retired at the end of the 1996–97 Australian season. Jenkins particularly enjoyed working at the charming Adelaide Oval, long before its dramatic 21st-century transformation into a modern stadium.

THE VIVIAN JENKINS COLLECTION

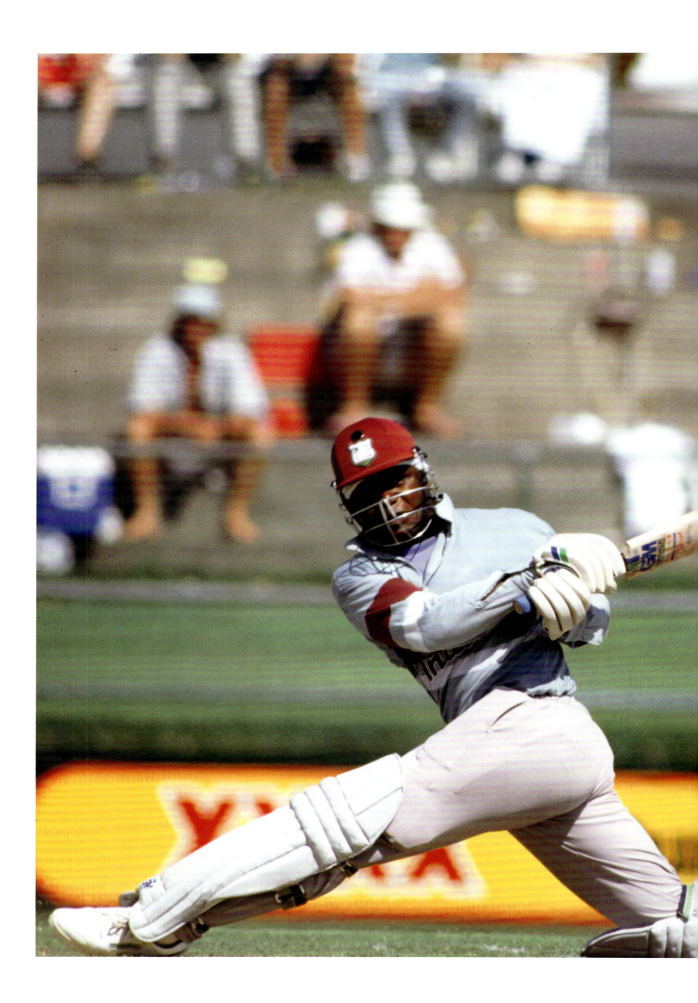

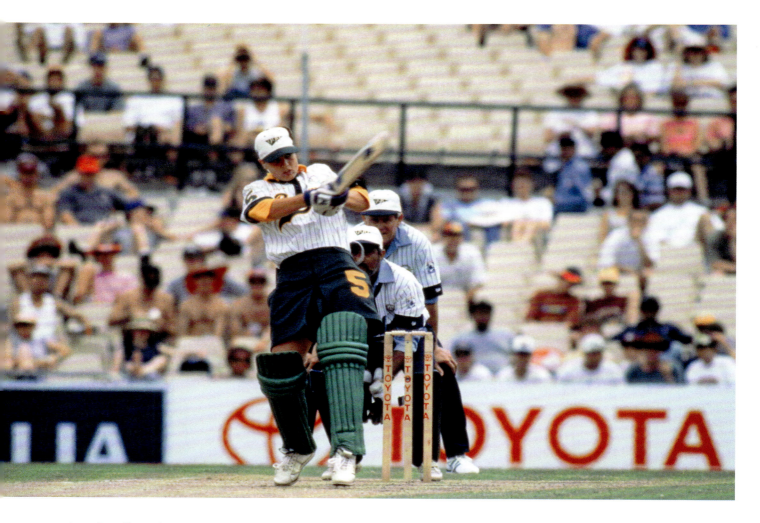

Australian all-rounder Zoe Goss earned instant celebrity when she dismissed the peerless Brian Lara twice with the same delivery while playing for the Bradman XI against a World XI at the SCG in 1994. To her delight she had Lara both caught and stumped by former Australian wicketkeeper Steve Rixon. She also batted ably for 29 in an innings that included this full-blooded pull.

OPPOSITE: *Genius leg-spinner Shane Warne poses for an official photograph in the striped team blazer favoured by the elite of Australian cricket for more than a decade from the mid-1990s. The move to haute couture was driven by Ian Healy, the country's longest-serving wicketkeeper, and Errol Alcott, who served scores of Australian players as physiotherapist, counsellor and surrogate father.*

PREVIOUS PAGE: *Incomparable West Indian batsman Desmond Haynes always batted and fielded with a joie de vivre affirming his personal motto of 'Live, Love, Laugh'. A vibrant and universally admired character, for some years he wore his pet expression hanging from a gold neck chain. He amassed 7487 runs at 42.29 with eighteen hundreds in 116 Tests from 1977 to 1993 and, with his earnest teammate Gordon Greenidge, established one of the most consistent and successful opening partnerships in the history of the game.*

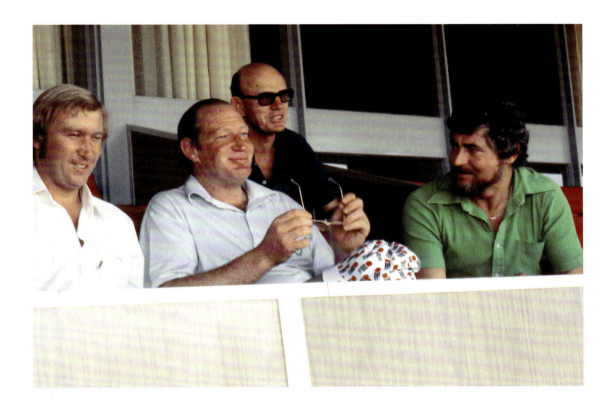

*So polarising was the World Series Cricket upheaval that media mogul Kerry Packer (second from left) could be prickly when dealing with Australia's established cricket writers. On this occasion, however, he seems relaxed in the company of (from left) Peter McFarline (*The Age, Melbourne*), Dick Tucker (the defunct* Daily Mirror, Sydney*) and Brian Mossop (*The Sydney Morning Herald*).*

OPPOSITE: *Enigmatic Australian batsman Michael Bevan waits to be presented with the Man of the Match award after a startling all-round performance against the West Indies at Adelaide over the Australia Day holiday period of 1997. Surprisingly chosen principally as a slow bowler to support Shane Warne, he returned the match figures of 10–113 with his left-arm wrist spin to complement his innings of 85. A cricketer of brooding intensity he played eighteen Tests but is best remembered for his feats in the limited-overs game.*

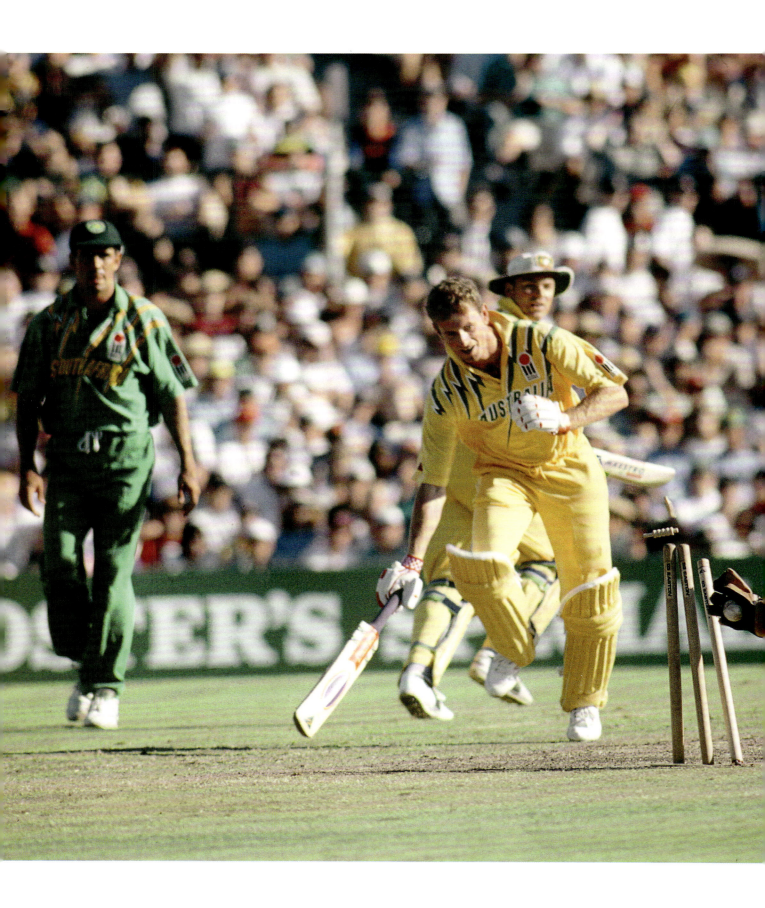

Wicketkeeper David Richardson lunges to run out Australian bowler Paul Reiffel in the third and deciding match of the one-day World Series finals at Sydney during South Africa's first visit to Australia for 30 years in 1993–94. Hansie Cronje (left), deputising as captain for the injured Kepler Wessels, and Shane Warne are witnesses. Both Richardson and Reiffel were destined to serve the International Cricket Council after their playing careers had ended—Richardson as chief executive and Reiffel as a Test match umpire.

THE VIVIAN JENKINS COLLECTION

This is one of the very few catches to elude David Boon at short leg during his magnificent 107-Test career. Much loved by crowds everywhere, the chunky batsman possessed exceptional judgement and lightning reflexes, and complemented his 7422 runs at 43.65 with 99 catches. He famously made a brilliant interception to give Shane Warne his Test match hat-trick against England in Melbourne in 1994–95.

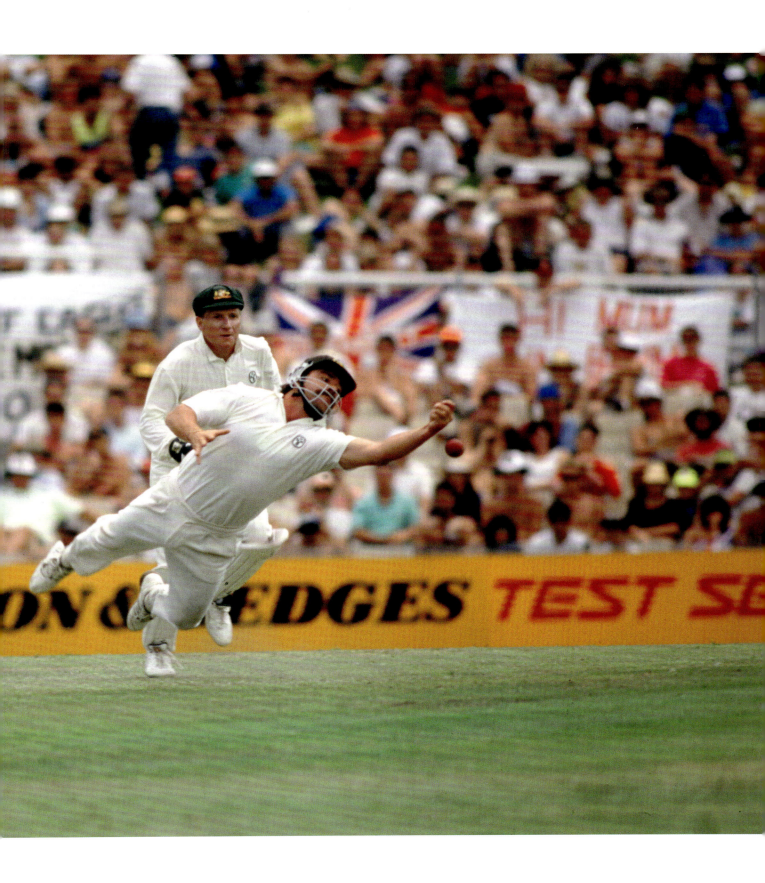

THE VIVIAN JENKINS COLLECTION

Historically cricket has forged a strong bond between the disparate sovereign nations that comprise the Caribbean archipelago. In the quest for a coalition as demanded by the great captains Sir Frank Worrell and Clive Lloyd, West Indies teams play under this special flag draped around the shoulders of Antiguan Richie Richardson (left) and Trinidadian Brian Lara. Richardson was knighted by the Antiguan government for his services to cricket in 2014.

Iman Khan, the 'Lion of Pakistan', led his nation to triumph in the World Cup before a crowd of nearly 90,000 at the MCG in March 1992. He described the success over England as 'the most fulfilling and satisfying cricket moment of my life'. One of the greatest all-rounders in history, he was the highest scorer in the final, with 72, and had the joy of taking the final wicket to secure the victory by 22 runs. Renowned for his extensive charity work, Imran is the leader of the Tehreek-e-Insaf political party, which is committed to restoring Pakistan's political and economic sovereignty.

THE VIVIAN JENKINS COLLECTION

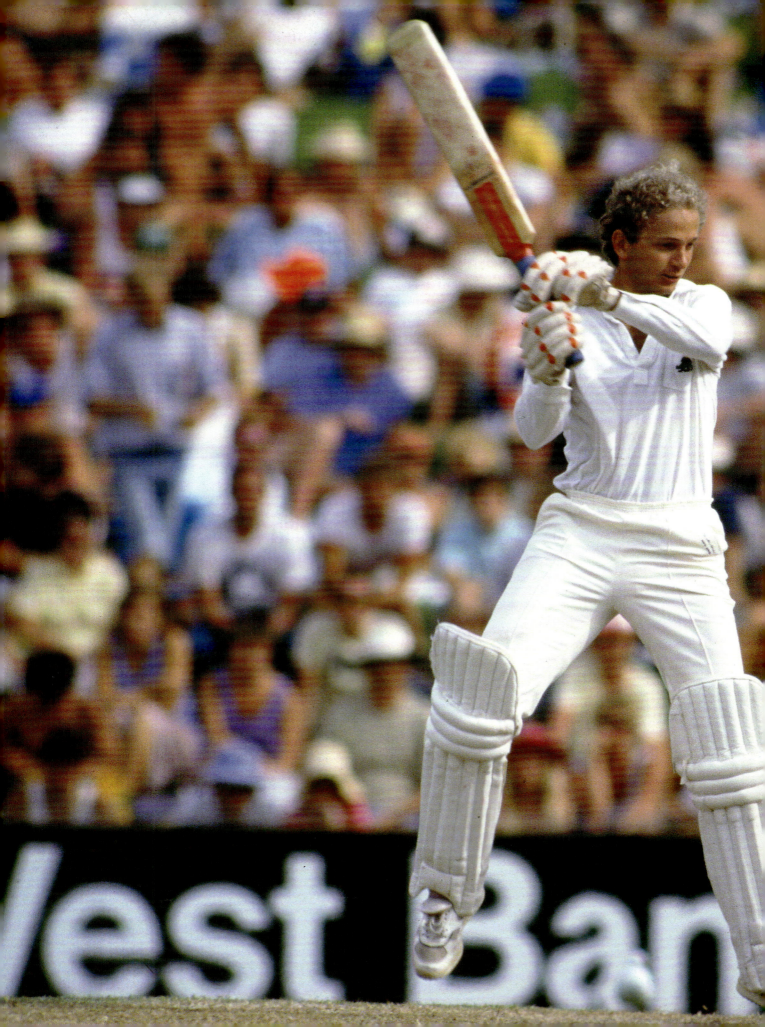

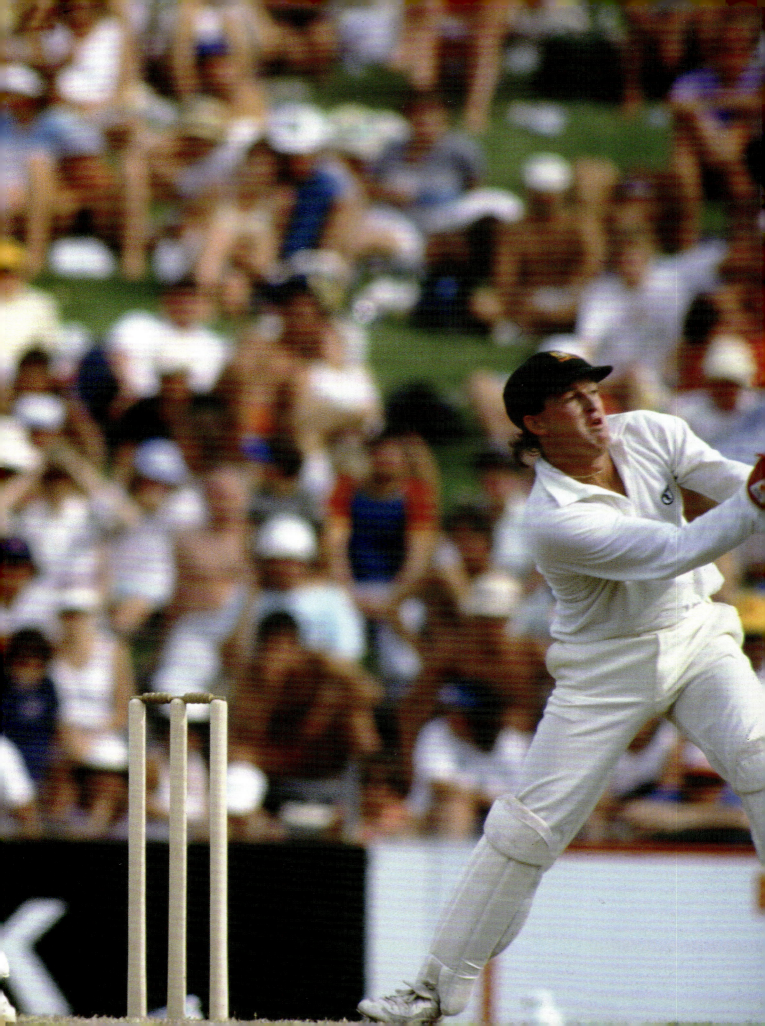

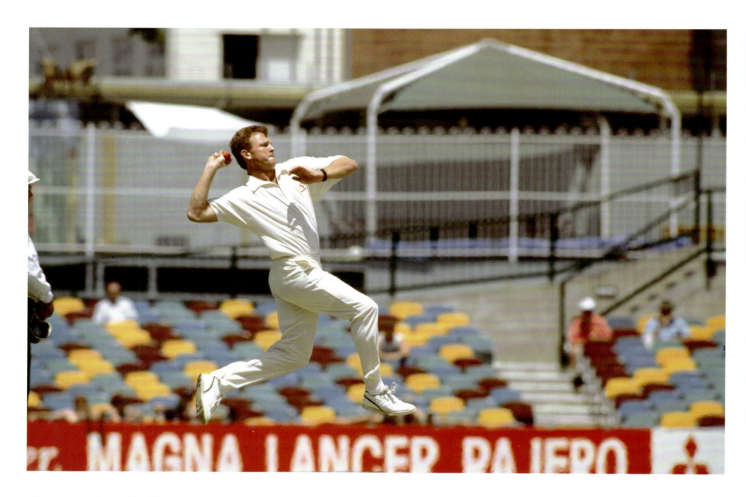

These images beautifully illustrate the poise and power of fast bowlers Craig McDermott (above) and Sir Richard Hadlee (opposite) in their delivery stride. The contribution of McDermott, who was summoned at the age of nineteen by anxious selectors when Australian cricket was at its nadir in 1984, has been seriously under-rated. In 71 Tests over eleven years he formed the backbone of the attack and took 291 wickets at 28.63.

Hadlee was a master practitioner and one of the most cerebral of all new ball bowlers. His 431 wickets at 22.29 represented 34.34 per cent of New Zealand's wickets throughout his career, which spanned 1972–1990. Only Sri Lanka's Muttiah Muralitharan and England's Sydney F. Barnes took a greater percentage of their team's wickets—38.64 and 38.25 respectively.

PREVIOUS PAGE: *It is often said lefthandedness is associated with genius and there was no more gifted stroke player than England's David Gower. He was an exquisite timer of the ball but could exasperate his legion of fans with his laid-back approach and often inexplicable lapses in concentration. One of few English captains to be openly admired in Australia he amassed 8231 runs at 44.25 with eighteen hundreds in 117 Test matches. He retired in 1992 and with characteristic ease became a popular and widely respected television commentator and presenter.*

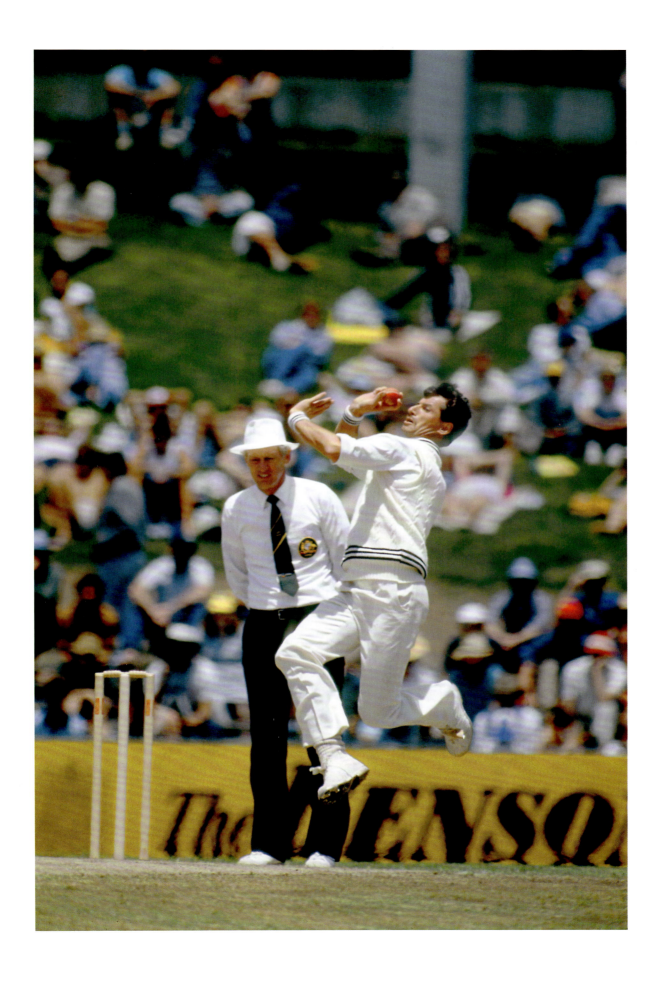

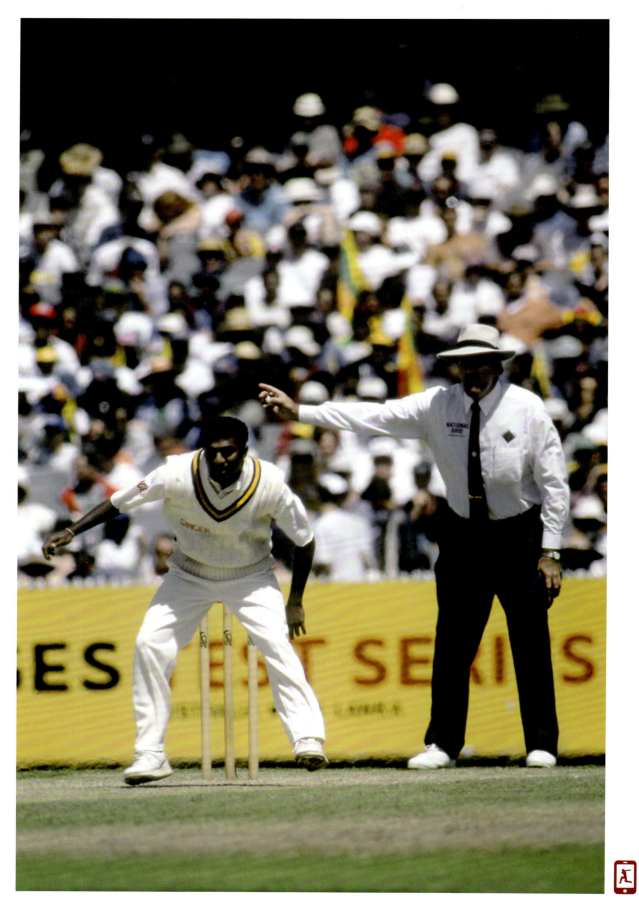

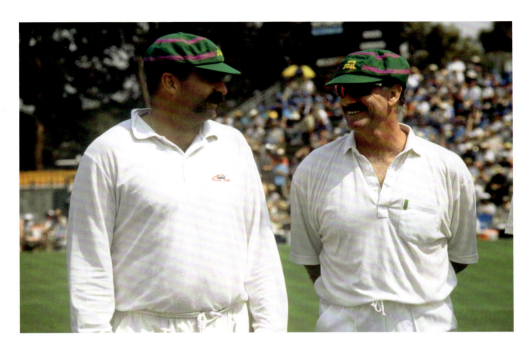

Top: *Merv Hughes (left) and Dennis Lillee chew the fat before a festival match at Lilac Hill outside Perth. At the initiation of the Midland–Guildford Cricket Club and former Australian player Keith Slater, Lilac Hill hosted international teams at the start of their Australian tour for twenty years from 1990.*

Above: *Richie Benaud and his wife Daphne have long taken a close interest in horse racing. Benaud is not a punter but follows the form avidly and thrills to the spectacle of the sport of Kings.*

Opposite: *Umpire Darrell Hair caused a furore when from the bowler's end he called Sri Lankan Muttiah Muralitharan seven times in three overs for throwing before a crowd of 55,239 in the Second Test with Australia at the MCG on Boxing Day 1995. A unique spinner, Murali polarised the cricket community and brought about change to the law governing the legitimacy of a bowling action. For a time he was asked not to bowl his renowned doosra as it exceeded the fifteen-degree tolerance measure.*

THE VIVIAN JENKINS COLLECTION

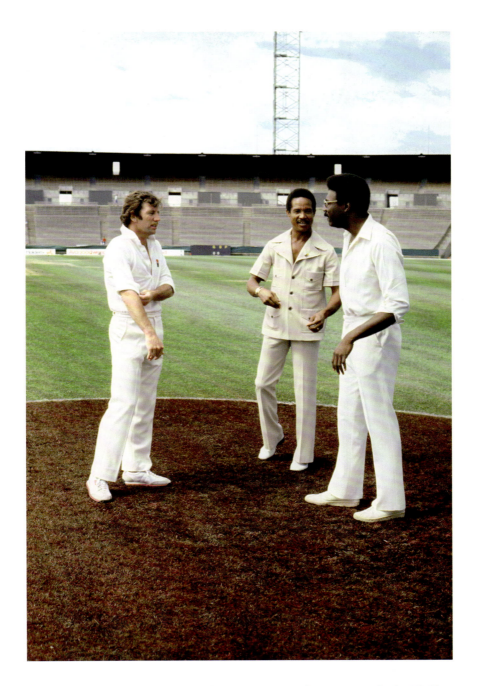

Safari-suited Sir Garfield Sobers acted as a statesman and commentator for the World Series Cricket movement when matches began with empty stadiums in the summer of 1977–78. Here he is seen with Australian captain Ian Chappell and the West Indian captain Clive Lloyd.

OPPOSITE: *Groundstaff with brooms, the ubiquitous hessian bags and a hand roller tend to the pitch at the cricket stadium at Sharjah, one of the seven sheikhdoms that make up the United Arab Emirates. Australia first played at the ground under Allan Border in the four-nation Rothmans Trophy in March 1985. The stadium was built by wealthy businessman and entrepreneur Abdul Rahman Bukhatir, who fell in love with cricket while studying in Pakistan.*

THE VIVIAN JENKINS COLLECTION

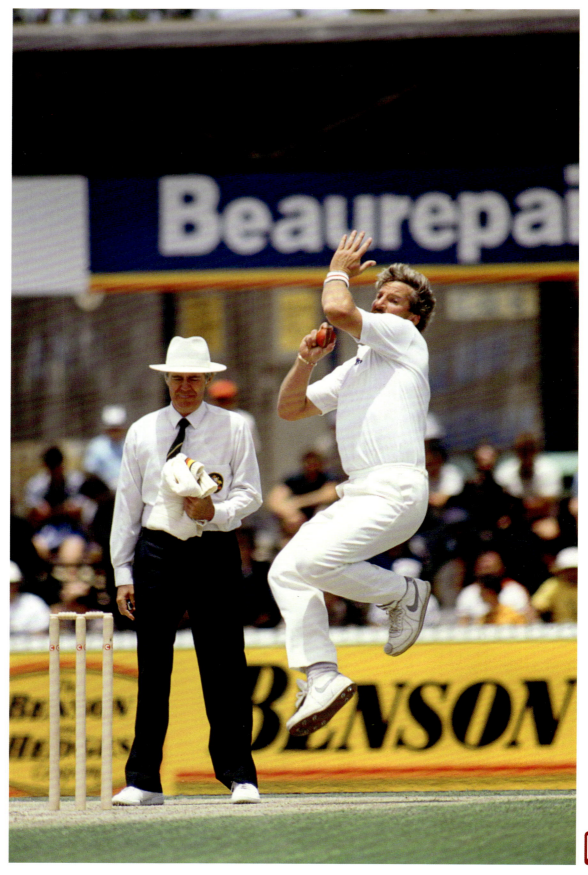

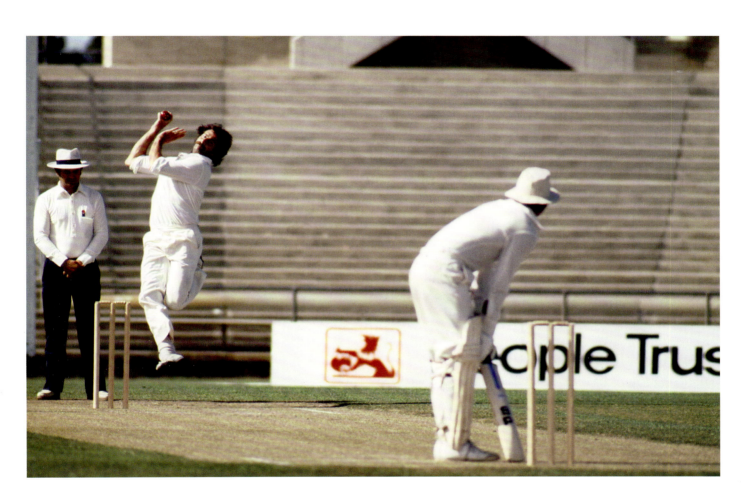

In March 1977 Dennis Lillee was cheered by tens of thousands as he inspired Australia to an unforgettable victory in the Centenary Test match at the MCG. Barely nine months later, at Waverley Park in the outer eastern suburbs of Melbourne, not a soul was in place to chant his name as the great fast bowler plied his trade with customary commitment in an early World Series Cricket match.

OPPOSITE: Ian Botham bestrode the game like a colossus in the 1980s and vied with Richard Hadlee, Imran Khan and Kapil Dev to be considered the foremost all-rounder of the time. An aggressive, uncompromising player he imposed himself on proceedings with the power of his body and personality. He was at his awesome peak in 1981 when he singlehandedly changed the course of a series now commonly known as 'Botham's Ashes'.

THE VIVIAN JENKINS COLLECTION

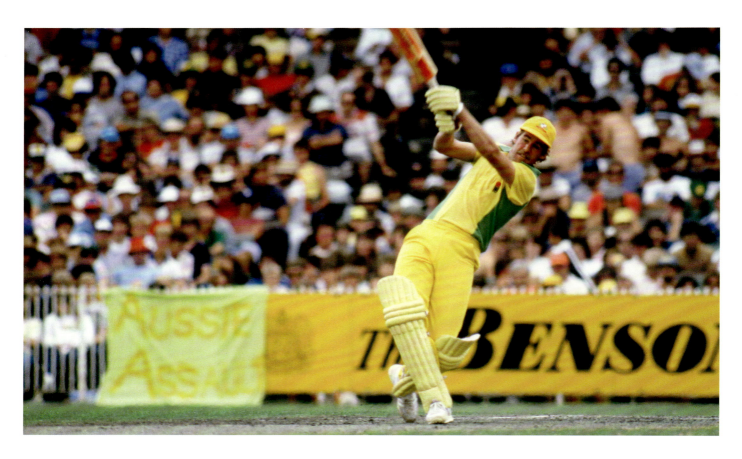

Power and panache: on song, David Hookes was irrepressible, irresistible. Supremely confident of his prodigious natural ability, he played with a flair that instantly endeared him to Australian crowds. Ultimately he did not fulfil such rich promise and played just 23 Test matches in eight years. Tragically killed by a bouncer's gratuitous punch, at the age of 48 he had the distinction of acting as Australia's captain against ultimate winner India in the 1983 World Cup in England.

Tony Crafter, who was Australia's longest-serving Test match umpire when he retired in 1992 after 33 matches, demonstrates the signal employed to send a batsman on his way. He courageously separated firebrands Javed Miandad and Dennis Lillee in their infamous contretemps at Perth in 1981. In this photograph, an image of Australian fast bowler Craig McDermott has been projected onto his chest.

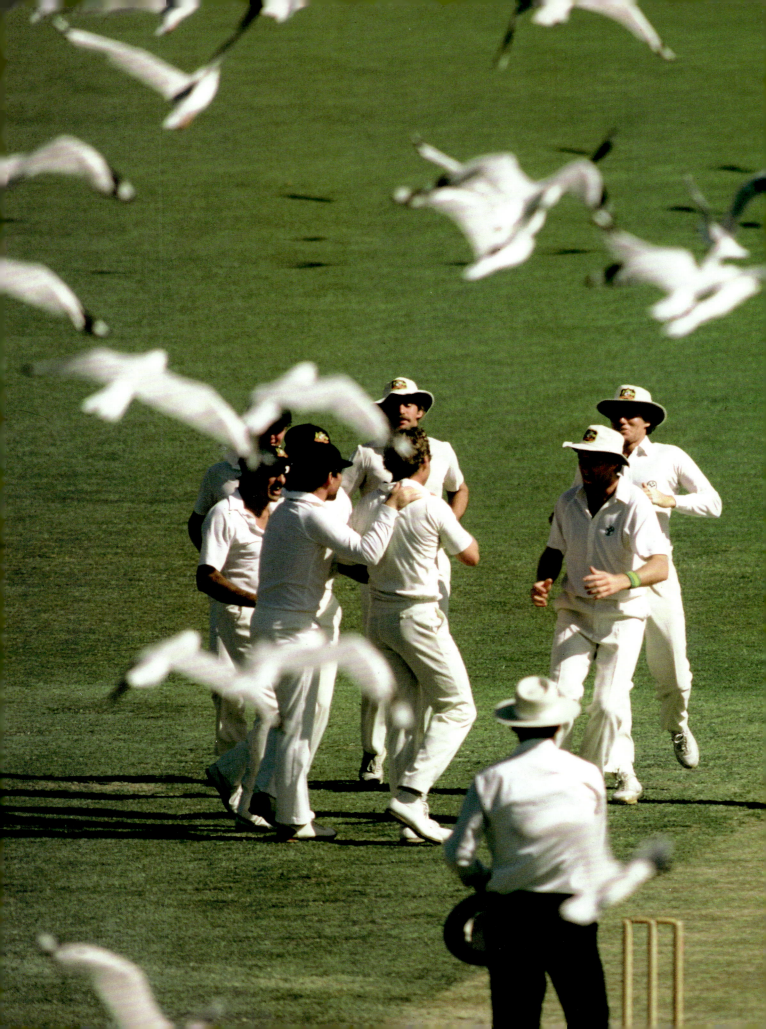

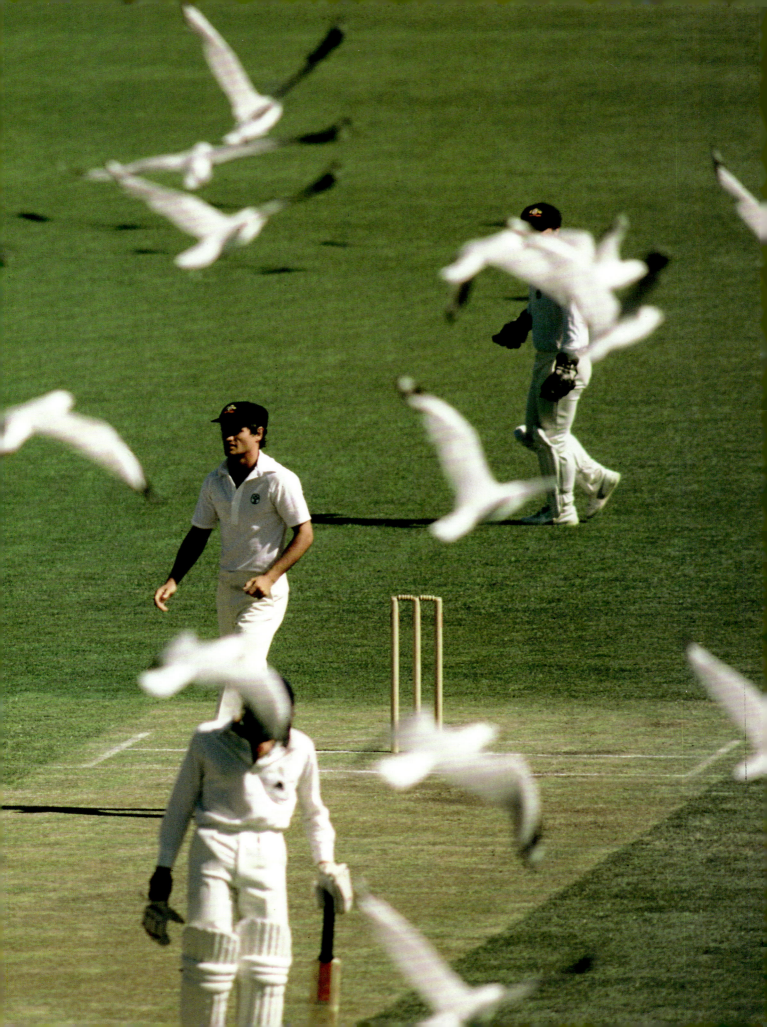

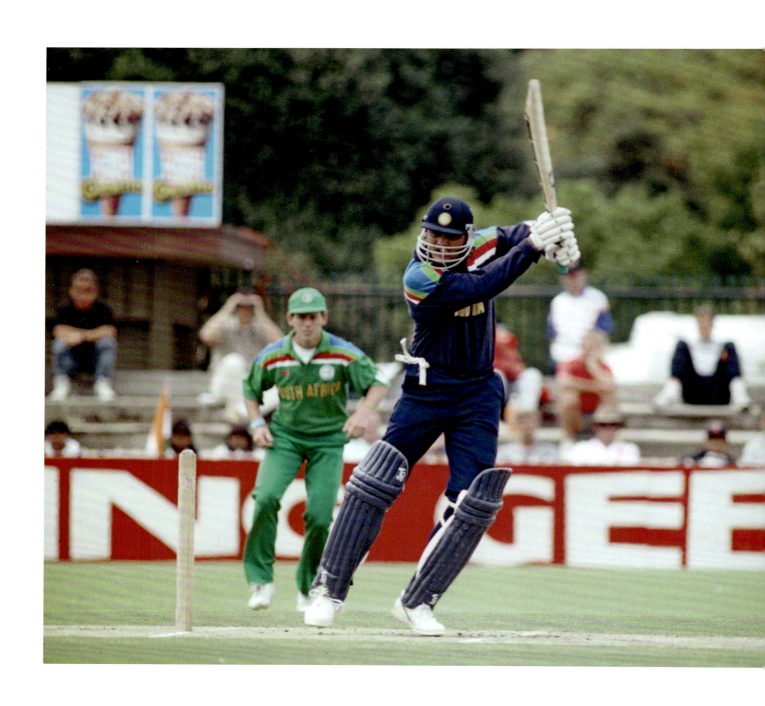

Judging by his demeanour, distinguished Australian captain Mark Taylor has given twelfth man Tim May (right) more than sweat-soaked batting gloves to return to the dressing room. As always, David Boon (left) is inscrutable.

It has been said of Mohammad Azharuddin that he was a Michelangelo in the midst of housepainters. The epitome of wristy players from the subcontinent, this former Indian captain and master batsman was adored by devotees everywhere throughout his 99-Test career. Here he plays with characteristic poise through point. For more than ten years he has lived with the stain of match-fixing and continues to fight the life ban meted out by the Indian cricket authorities.

PREVIOUS PAGE: Australian tearaway Rodney Hogg was known to ruffle feathers during his 38-Test career from 1978 to 1984. Here on his adopted home turf at Adelaide Oval, he claims one of his three wickets in an emphatic eight-wicket victory over England in December 1982, and upsets the composure of the seagulls that habitually gather at the beautiful ground.

THE VIVIAN JENKINS COLLECTION

The unauthorised biography of New Zealand's master batsman Martin Crowe is titled Tortured Genius. *A man of considerable complexity, Crowe was the steely backbone of his country's batting for fourteen years, gathering 5444 runs at 45.36 with seventeen centuries. An affable man, he captained with great intellect but at times an unsettling intensity.*

Consummate Indian all-rounder and captain Kapil Dev playing with characteristic fluency behind square leg. Despite being condemned to bowl on pitches tailored to the needs of feted slow men he became his country's greatest fast bowler, taking 434 wickets at 29.64 in a fifteen-year career. He was voted India's Cricketer of the Twentieth Century ahead of Sunil Gavaskar and Sachin Tendulkar.

THE VIVIAN JENKINS COLLECTION

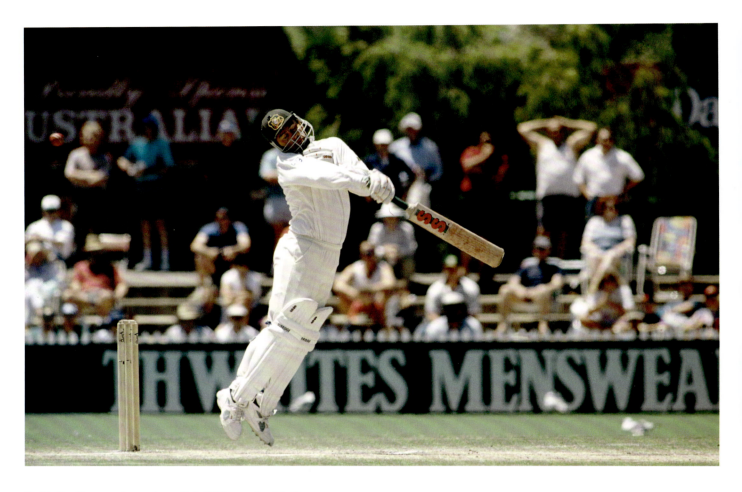

In his first home series as Australia's 39th captain, Mark Taylor is confronted by a wicked steepling delivery from England paceman Devon Malcolm in the Fourth Test match at Adelaide Oval. Malcolm returned match figures of 7–117 to spearhead England's solitary success for the 1994–95 Ashes series.

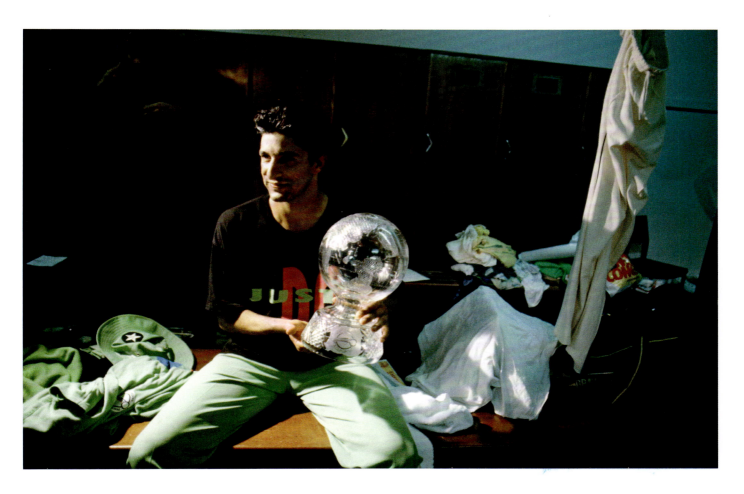

He's got the whole world in his hands. Arguably the greatest of all left-arm fast bowlers, Wasim Akram poses with the World Cup after Pakistan's 22-run triumph against England before a crowd of 87,182 at the MCG in March 1992. Wasim, who was run out for 33 and dismissed Ian Botham for a duck in taking 3–49 from his ten overs, was named Man of the Match.

THE VIVIAN JENKINS COLLECTION

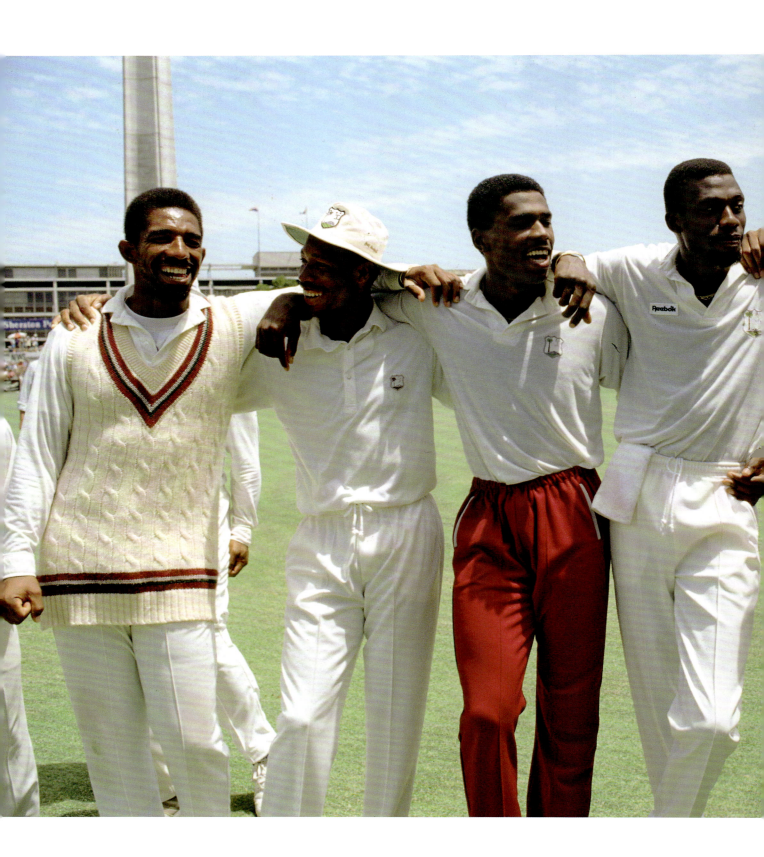

Opening partners and bosom mates David Boon (left) and Geoff Marsh poolside in Sharjah in the United Arab Emirates in 1990. Australia reached the final of the Austral-Asia Cup but was defeated by Pakistan.

Australia lost the last Test against the West Indies in 1992–93 by an innings and 25 runs in just fourteen hours and four minutes—the quickest finish to a Test in Australia since 1931–32. Rejoicing in the moment from left: Phil Simmons (top scorer for the match with 80), Anthony Cummins (match figures of 1–55 on debut), Ian Bishop (8–57), Curtly Ambrose (9–79), Courtney Walsh (1–91) and Patrick Patterson, who attended to dressing room duties.

THE VIVIAN JENKINS COLLECTION

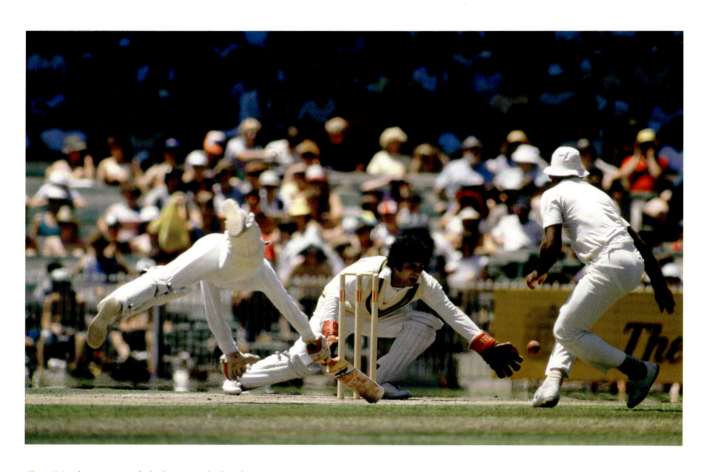

Greg Matthews accomplished a great deal in his 33 Test matches between 1983 and 1992 but not often in a conventional or predictable manner. Here, with bat outstretched, he propels himself to safety in his debut against Pakistan at the Boxing Day Test at Melbourne in 1983. Batting at eight, he made 75 to complement his four wickets, including the prize scalp of Zaheer Abbas. The wicketkeeper is the very accomplished Wasim Bari.

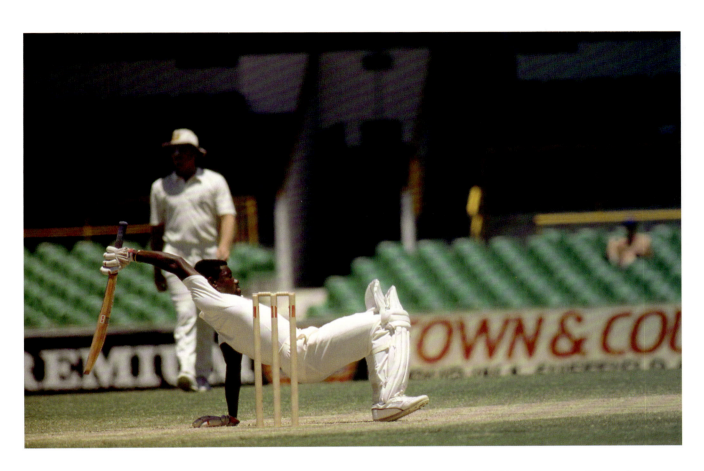

Like Viv Richards, his predecessor as West Indies captain, Richie Richardson eschewed the use of a helmet even against the most fearsome bowlers. Here he is without even his signature maroon broad-brim hat as he takes evasive action.

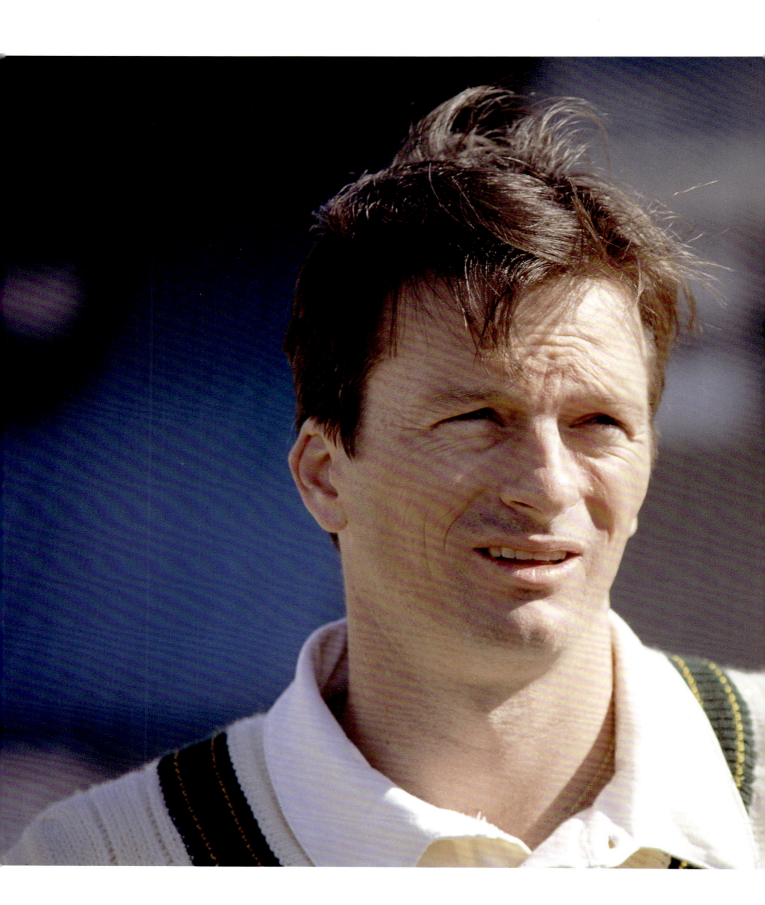

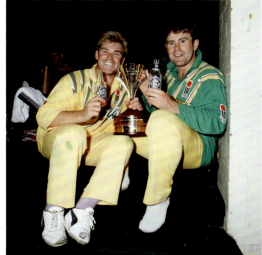

Top: *The spoils of victory: Shane Warne (left) and his proud captain Mark Taylor toast yet another success in the World Series Cup.*

Above: *Unlike his predecessor, Bob Hawke, and successor, John Howard, Australia's 24th Prime Minister Paul Keating (right) had little interest in cricket. But on the hustings he was happy to pose with a personalised one-day shirt with Australian Cricket Board chairman Alan Crompton (left) and chief executive officer Graham Halbish.*

Urgently summoned to the team as a twenty year old in 1985, Steve Waugh had a tough initiation into Test cricket as Australian cricket struggled with the destabilisation caused by the rebel tours of South Africa. But within two years he had played in the famous tied Test match at Chennai and earned the sobriquet 'Iceman' for his key role in Australia's World Cup triumph as 16–1 outsiders in Kolkata.

THE VIVIAN JENKINS COLLECTION

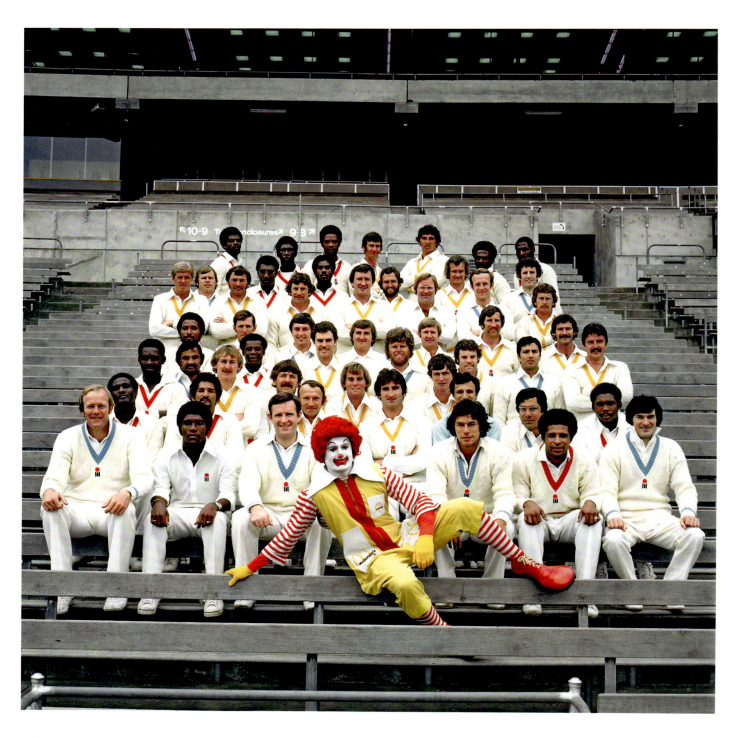

The summer of 1977–78 and the dawning of a new professional age: many of the world's foremost cricketers don World Series Cricket apparel for a promotional and marketing shoot and share the spotlight with Ronald McDonald, the mascot for the ubiquitous fast-food restaurant chain.

Hirsute and much loved Rod 'Bacchus' Marsh, another of the people's cricketers during the transformative 1970s, enjoys modelling the latest World Series one-day outfit. The first Australian wicketkeeper to score a Test century, Marsh became an international coach and in 2014 was appointed chairman of the Australian selection panel.

THE VIVIAN JENKINS COLLECTION

PART 4

THE PHILIP BROWN COLLECTION

CONSEQUENCES OF REVOLUTION

REVOLUTION BEGETS REVOLUTION. The free thought and daring that spawned World Series Cricket became an intrinsic characteristic of the game into the 21st century, as the new horizon glimpsed at the close of the 1970s proved to be a brave and substantially bigger world that looked beyond England for inspiration and direction.

The game of the British Empire now belonged to two of the defunct Empire's one-time colonies, Australia and India, while being conducted from another, the International Cricket Council having relocated from London to the United Arab Emirates in 2005. Cricket, with dizzying speed, was being transformed into an often brassy multimillion-dollar entertainment industry, eventually drawing comparisons with the film capitals of Hollywood and, more pertinently, Bollywood. In Australia, on the Indian subcontinent, and for a time in the Caribbean, the game was embedded in popular culture.

It was a boisterous new world where boundaries of fairness, discipline, good taste and tact were pushed like never before, and the fabled 'spirit of the game' needed to become law. One-time autocratic governors were compelled to cede greater control to players and their formalised associations, and to speak openly of the importance of inclusiveness. A new egalitarianism was in place.

OPPOSITE: *David Warner has defied the odds, and his critics, to gravitate to Test cricket from the frenetic Twenty20 arena. Here he makes a joyous leap to celebrate his century against England in Perth in December 2013. He made five centuries in eight Tests against England and South Africa in fifteen weeks in 2013–14.*

Riches were on offer from television rights and sponsorship money. The pesky player managers, marketers, publicists, consultants, spin doctors, counsellors, business advisers and gofers who inhabited this world often cared little for the game's rich history or customs. Opportunistic players, too, buoyed by the money available, disregarded allegiances and so polarised their fans, while avaricious officials paid lip-service to Test cricket's primacy amid a sweeping proliferation of limited-overs internationals and Twenty20 matches. These cash cows engaged new audiences, allowing cricket to develop and spread among the ICC's 37 associate and 59 affiliate members, while simultaneously exposing the game to dark and dangerous forces.

Illegal gambling—the menace that encourages match and spot fixing—grew rife. Cricket's perceived purity and innocence was lost, the corrupt behaviour of South Africa's Hansie Cronje, India's Mohammad Azharuddin and Pakistanis Salim Malik and Salman Butt bringing shame upon their countries and the previously sacrosanct office of captain. The ICC invested millions in anti-corruption and integrity units. But its fast-increasing constituency across many ethnic and cultural borders, and the resultant plethora of competitions, sorely taxed its resources, if not its will.

It can be persuasively argued that, aside from the World Series phenomenon, the two moments to have the most profound impact on the way cricket is now played, watched, managed, marketed and broadcast were major events involving India and staged 24 years apart: their stunning defeat of the West Indies in the 1983 World Cup final in England, and their triumph over Pakistan in the inaugural World Twenty20 final in Johannesburg in 2007.

A nation, the vast Indian diaspora, was captivated. It was the power and reach of television that sparked the revolution. In a trice, the customary pursuit of the wealthy and the privileged became a game of the people, played not only on the maidans of the sprawling cities but in villages, on beaches, outside temples: anywhere and everywhere.

Confirmation that the one-day game was destined to supplant first class and Test cricket in the hearts and minds of Indians came within a year of all-rounder Kapil Dev holding aloft the World Cup at Lord's. To celebrate the golden jubilee of India's first-class competition, the Ranji Trophy, Australia visited India and played five limited-overs matches. The die was cast.

India and Pakistan then set aside deep enmities to jointly host the 1987 World Cup under the banner 'Cricket for Peace', the first time the event had been held outside England, and another emphatic confirmation of the new order. A dwindling number of traditionalists spoke with affection about the past—about the graciousness and courage of the Nawab of Pataudi, and the genius of a quintet of slow bowlers—but in truth the country was smitten by Kapil and his fellow warriors and the magic of instant cricket. Only the arrival of Sachin Tendulkar, arguably the greatest batsman since Don Bradman, saved Test cricket in India from obscurity, perhaps obsolescence.

Come 2007, when pundits everywhere bemoaned the tedium of the 50-over game's middle overs and were predicting its speedy demise, M.S. Dhoni, a one-time railway platform announcer and ticket-seller, led India to success in the first World Twenty20. India had entered the tournament having played only one Twenty20 international, and with its mandarins publicly railing against the concept of such an abbreviated game being played at the international level.

At the same time entrepreneurs, business moguls and Bollywood stars were offering unheard-of sums of money to players and officials for the first edition of the Indian

Premier League (IPL) and the short-lived Indian Cricket League (ICL), and all of India, and particularly the forever burgeoning wealthy and middle classes, adopted another consuming passion. Knowledge of cricket and its rich history was optional. Essentially the IPL was a ballsy, song-and-dance Twenty20 entertainment for the rich, famous, influential and their acolytes.

Be that as it may, the IPL was a qualified success. Into the 2010s Indian cricket was estimated to generate more than 70 per cent of the game's revenue. Although its television ratings had fallen markedly and devalued the Twenty20 brand by 2013, Indian cricket remained fabulously wealthy and intimidatingly powerful. And it was at this point, being a strident critic of the ICC, and having been largely at the mercy of England and Australia since the awarding of Test status in 1926, that the Board of Control for Cricket in India ruthlessly wielded its influence. By 2014 it had inveigled

Spitting fire in the colours of Kent, Antiguan-born Robbie Joseph strikes an intimidating pose as he bellows his delight at trapping Essex's middle-order batsman Ravi Bopara leg before wicket for seven in the final of the 50-over Friends Provident Trophy at Lord's in August 2008. By the end of the day it was Bopara who was beaming, his two wickets from eight overs helping Essex to victory by five wickets.

THE PHILIP BROWN COLLECTION

Cricket Australia and the England and Wales Cricket Board into a contentious cartel that in all but name acted as the game's controlling body.

Not since the ICC's founder members—England, Australia, South Africa—retained veto over all resolutions between 1909 and 1993 had such power resided in so few hands. Fear of India withdrawing from the ICC and impoverishing the game compelled the alliance, which threatened to disenfranchise the game's minnows. It was a humbling concession by the overlords of Australian cricket, who until the BCCI's flaunting of its status as world cricket behemoth were generally seen to run the most powerful and progressive administration in the game. Certainly they were the envy of their counterparts when the teams of Mark Taylor, Steve Waugh and Ricky Ponting bestrode the cricket world during the 1990s and into the 2000s.

Before then, through the disorderly and disillusioning days of the 1980s, Australian cricket reached its nadir. Attempts to re-establish stability and charter a path forward were frustrated by captaincy crises involving Bob Simpson and Graham Yallop, alternate incumbents Greg Chappell and Kim Hughes, and later Allan Border, then finally shattered in 1985 when the disaffected joined the mercenaries in the iniquitous old South Africa. For the second time in seven years Australian cricket was divided, with two national teams—the sanctioned and the unsanctioned—competing for the attention and loyalty of supporters. That little if anything was known of the musings of the defectors to apartheid South Africa was an indictment of the then Australian Cricket Board. It indicated a them-and-us mentality prevailed, despite the solemn pledges made when hatchets were buried in 1979.

Yet Border, the 38th and most reluctant Australian captain, was destined to ultimately rank beside Richie Benaud and Ian Chappell as the most significant figure in Australian cricket since Sir Donald Bradman. Throughout the conflicted 1980s he was the embodiment of Australian cricket. In essence he *was* Australian cricket, and some of his achievements were Bradmanesque.

He had the wholehearted backing of coach Simpson, who for the second time in nine years answered an anguished call for help, and Lawrie Sawle, a scholarly selector and career educationist. Gradually, as captain, Border developed self-confidence and nous. Australia's stocks, by increments, improved. Cricket historians invariably point to the Ashes triumph of 1989 as the moment of rebirth. But the foundations were laid in India two years earlier when Border and his gallant followers, who had begun as 16–1 outsiders, beat England by seven runs in the World Cup final in Kolkata. By strong example, on and off the ground, Border encouraged the eradication of the ignorance, paranoia and cultural elitism that had often beset Australian teams on the subcontinent.

Given the chaotic state of Australian cricket at the height of his career, Border at times justified the harsh 'Captain Grumpy' epithet bestowed on him. He was, however, always loved, the 'people's cricketer', a man greatly admired throughout the cricket

world for his courage and grim determination to revive Australian cricket. That he led his country in 93 successive Test matches and played 153 of his 156 Tests consecutively are among the game's most remarkable statistics.

Border inspired a generation of players and profoundly influenced the thinking of his immediate successors, Mark Taylor and Steve Waugh, who between them led Australia in 107 Tests over nine years. They in turn set the standard for Ricky Ponting, who was in charge on 77 occasions, and Michael Clarke. Five captains in 30 years was a spectacular antidote to the instability and uncertainty that racked Australian cricket throughout the turbulent 1970s and '80s.

The 4–0 Ashes success in England in 1989 brought more than salvation and peace of mind for Border. It heralded the start of an era that gave a grateful cricket world the genius of Shane Warne, Mark Waugh, Adam Gilchrist and Glenn McGrath. In 1995 Taylor's heroes, as they became, inflicted on the West Indies their first series defeat in fifteen years. Then to underscore their mastery and supremacy Australian teams twice, under Steve Waugh and Ponting, won a startling sixteen consecutive Test matches.

At times the euphoria was tempered by criticism of the methods employed, especially those of Waugh, who unashamedly introduced the words 'mental disintegration' to the game's lexicon. At times the behaviour of the more provocative players revived unwanted memories of the 'Ugly Australians' of the 1970s. Certainly the game lived up to the adage of the great English writer and broadcaster John Arlott: that cricket is always a microcosm of society. The game, no doubt, reflected the increased aggression, abrasiveness—even violence—of a fast-paced and more judgemental community.

Greg Chappell compelled his brother Trevor to cheat by bowling underarm in a limited-overs game against New Zealand; Pakistan's Javed Miandad threatened to use his bat to strike Dennis Lillee, who'd kicked him; Jamaican Michael Holding and England's Chris Broad petulantly demolished stumps; Barbadian paceman Sylvester Clarke threw a brick into a crowd in Pakistan; Colin Croft made contact with a New Zealand umpire; Indian captain Sunil Gavaskar and Sri Lanka's Arjuna Ranatunga staged partial walk-offs in Australia; Michael Atherton of England used dust secreted in his pants pocket to tamper with the condition of a ball in a Test match; Sri Lankan Muttiah Muralitharan, the game's greatest wicket-taker, and Henry Olonga, the first black man to play for Zimbabwe, were two culprits requiring rehabilitation for cricket's most heinous crime—throwing. Codes of behaviour were enshrined in cricket law and match referees were appointed and given power to fine and suspend players for a range of infringements.

But for all the controversy, unseemly behaviour and varying interpretations of the spirit of the game, there was excitement and innovation—none more telling than the introduction of neutral umpires. Given the game's uneasily disguised prejudices and sniggering, it was significant that the Pakistan authorities appointed English umpires

John Hampshire and John Holder to stand in the home series with India in 1989–90, the same series a sixteen-year-old prodigy named Sachin Tendulkar made his debut. Australian authorities discarded the luxurious Test match rest day and reverted to the six-ball over they had abandoned for the eight-ball over in 1936–37. While periodically there was fear that Test cricket would be subsumed by the insidious rise of the shorter games, Test status was accorded to newcomers Sri Lanka (1981), Zimbabwe (1992) and Bangladesh (2000). Australia, England, South Africa and India all spent time on top of the ratings and a staggering 45 new Test grounds were commissioned between Bellerive Oval in Hobart in December 1989 and the Khulna Divisional Stadium in Bangladesh in November 2012.

And the names of some of the greatest of all cricketers have been perpetuated in the naming of Test trophies. India and Australia have vied for the Border–Gavaskar Trophy since 1996–97, South Africa and the West Indies for the Sir Vivian Richards Trophy since 2000–01, England and South Africa for the Basil D'Oliveira Trophy since 2004–05, and the names Warne and Muralitharan are now inscribed on the prize on offer for Tests between Australia and Sri Lanka. Since 2007 India's Test matches in England have been played for the Pataudi Trophy.

It has always been a compelling strength of the ancient game that it can change to suit the moods and mores of society at any given time. Like Viv Jenkins and Bruce Postle before him, Philip Brown has dedicated his professional life to capturing priceless photographs of cricket and cricketers—timeless images that will live in the memory of those who cherish the glorious game.

PHILIP BROWN

NOWADAYS HE SMILES AT THE THOUGHT, but not even when offered a fee for his sporting images did Philip Brown initially consider photography as a career.

As a young man growing up in Canberra, photography was purely a hobby and he was excited, flattered and grateful if his handiwork generated any income, whether it came in rolls of film or hard cash. But experience in a camera store and a timely decision to embark on media and communications studies put him on course for a professional life as one of the world's foremost cricket photographers.

He had a productive trip to the Edinburgh Commonwealth Games in 1986, and a photo published in *Time* magazine, after which he moved to Sydney and worked for various newspapers, shooting weekend matches for *Rugby League Week*. His decision to relocate to London and his outstanding coverage of Allan Border's triumphant Ashes tour of 1989 established his reputation in cricket. And while digital technology and a raft of other technological advances have dramatically changed the mechanics of his work over the past 25 years, he has lost neither his joy for the task nor his eye for an exceptional image.

Brown's love of photography is rivalled only by his love of sport. He has published major volumes on both cricket and rugby, and his work appears regularly in newspapers, magazines, books and collections, including *Wisden Cricketers' Almanack*. He covers cricket in all its forms throughout the world, and nominates Lord's in London and Newlands in Cape Town as the two grounds where he feels most comfortable and connected. 'Every time I go to Lord's it feels like going home, and there is something magical about Newlands under Table Mountain. Somehow your eye always moves up to the mountain.'

After sixteen years mainly servicing London's *Daily Telegraph*, he has broadened his freelance network over the past decade. He has earned the trust of elite players around the world. Brown considers himself fortunate that his time in the game has coincided with some of the most photogenic of all cricketers. He singles out Shane Warne, explosive England stars Andrew Flintoff and Kevin Pietersen, and West Indian maestro Brian Lara as his most fascinating and satisfying subjects. Indeed he still marvels at the number of orders he needed to fill when Flintoff was at the peak of his considerable powers.

Snapper being snapped, and by young England batsman Joe Root, no less. All-rounder Tim Bresnan (left) and skipper Alistair Cook flank Philip Brown as the England team celebrate their Ashes triumph at The Oval in 2013.

While Brown is grateful for the improvements digital photography has brought to his profession, he reflects with affection on the days he used to worry about stock and the number of shots he could responsibly capture in a day's play.

Long renowned for staring down batsmen, exuberant Australian fast bowler Merv Hughes uses the technique to try to intercept a disruptive mutt before a ball has been bowled in the Third Test with England at Trent Bridge in 1993. Back on his feet, Hughes took 5–92 in England's first innings of the only undecided match of the series.

OPPOSITE: *Essex medium–fast bowler Neil Williams in action—life imitating art— against Warwickshire at Edgbaston, Birmingham, in September 1996 only days after England and Pakistan had done battle in a Texaco Trophy match before this massive hoarding. Williams, who played one Test for England, died from pneumonia three weeks after having a stroke in 2006. He was 43.*

Popular England fast bowler Darren Gough has not lost his head, although it seems this is what his West Indian counterpart Curtly Ambrose had in mind in the Second Test at Lord's in June 1995. Gough is one of only twelve Englishman to have taken a hat-trick—against Australia at Sydney in 1999.

Shane Warne is as wide-eyed and open-mouthed as Mike Gatting was two months earlier when he received the fabled 'ball of the century' at Old Trafford, Manchester, on 4 June 1993. Here at Edgbaston, Warne bowled 49 overs to take the second of his 37 hauls of five or more wickets in an innings, and his first against England.

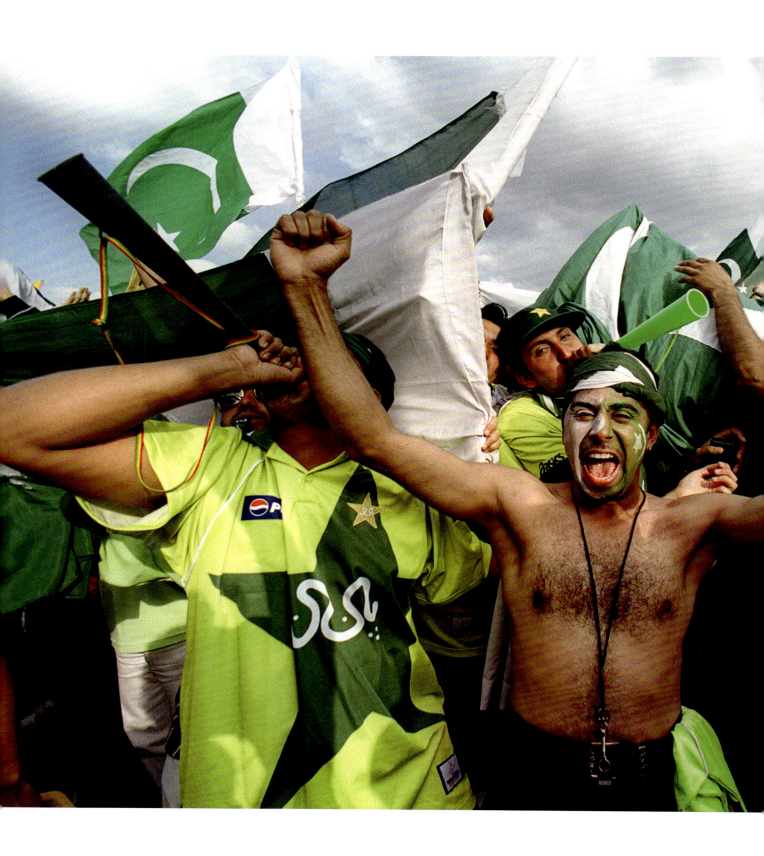

Melon heads and proud of it: patriotic young South Africans spell out their affection for the national cricket team at beautiful Newlands in Cape Town. Table Mountain is the imposing backcloth.

As a consequence of the partitioning of Pakistan from India in 1947, matches between the two countries are events of astonishing intensity, emotion and tension whether they are played on the Indian subcontinent, in the Arabian Desert or far beyond. These Pakistan supporters maintain a brave face despite the disappointment of a 47-run loss to India at Old Trafford, Manchester, in the 1999 World Cup.

THE PHILIP BROWN COLLECTION

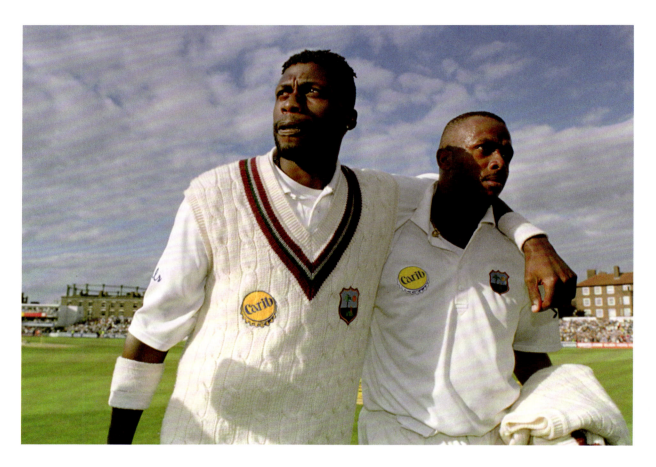

Next to peerless Malcolm Marshall, Curtly Ambrose (left) and Courtney Walsh have claims to be considered the greatest of the many great West Indian fast bowlers. Between them they played 230 Tests and captured 924 wickets. At the conclusion of The Wisden Trophy Series at The Oval in London in September 2000, they left a Test match ground together for the last time and to a standing ovation. In 2014 Ambrose was knighted by the Antiguan government for services to cricket.

OPPOSITE: *Pigeons take flight as Andrew Flintoff takes a sharp run during an innings of 137 for Lancashire against Surrey at The Oval in May 2002. A charismatic all-rounder who habitually imposed himself on proceedings, his deeds could lift the spirits of his teammates as well as the crowds who cheered him to the echo.*

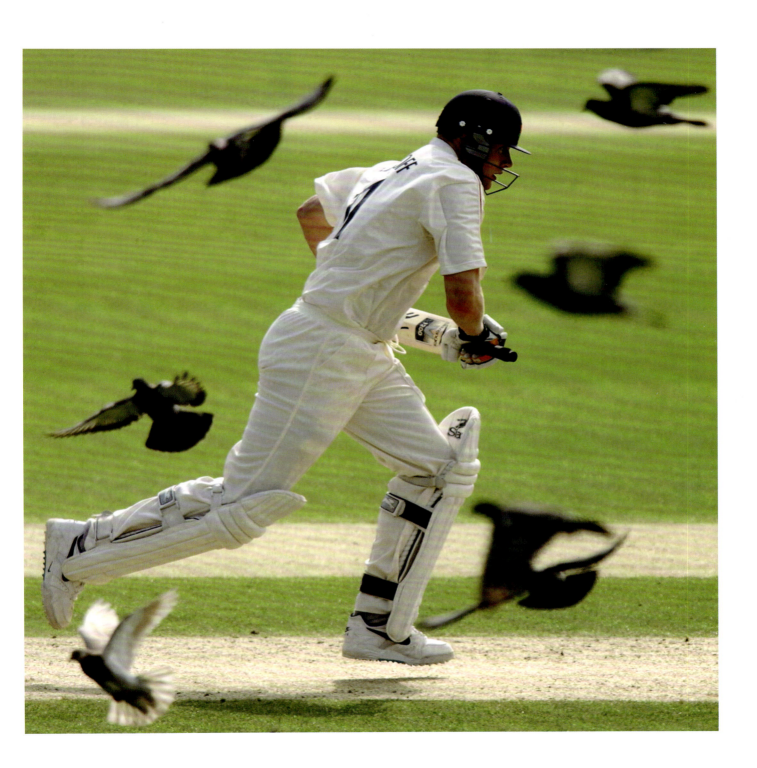

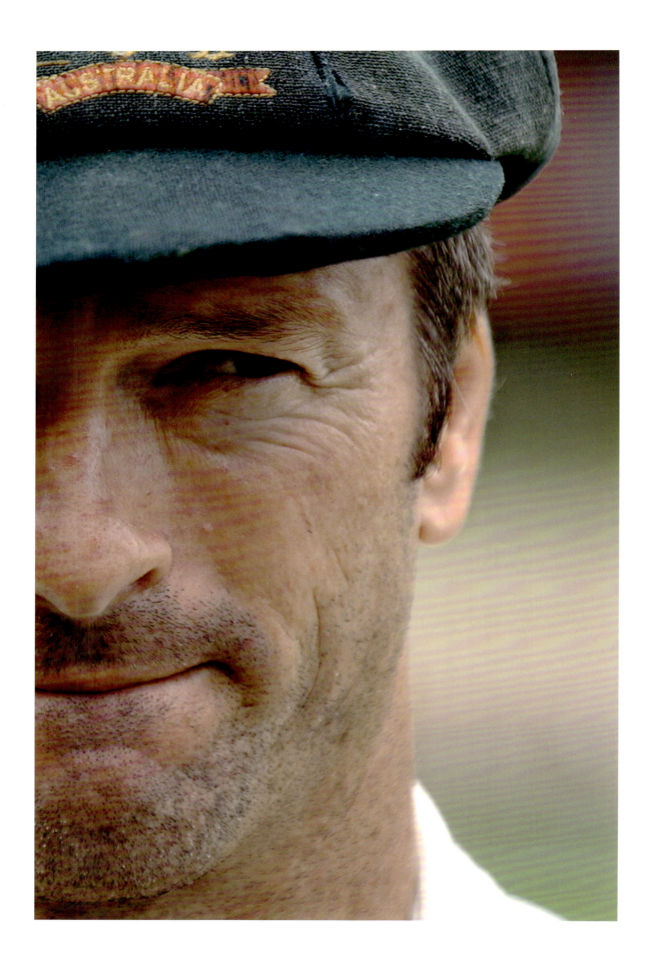

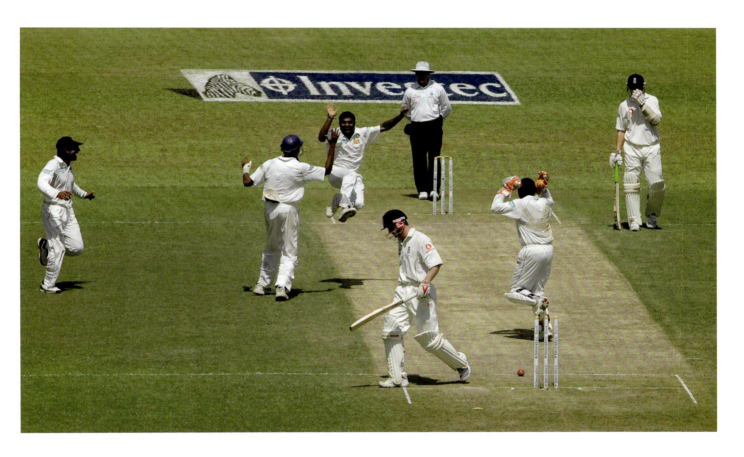

Sri Lankan spinner Muttiah Muralitharan dismisses England batsman Paul Collingwood to become Test cricket's highest wicket-taker at the Asgiriya Stadium, Kandy, in December 2007. His clever deception of Collingwood took him past Shane Warne, who ended his glittering career with 708 wickets at 25.41. When he retired in 2010 Muralitharan had taken his aggregate of wickets to 800 at 22.72.

OPPOSITE: *Statistically Australia's finest captain, with 41 victories (and nine losses) from 57 matches, Steve Waugh is numbered among the most influential figures in the annals of Australian cricket. Known for his mental toughness and introducing 'mental disintegration' to the language of the game, he placed great store in the game's history and initiated important customs and ceremonies which continue to be observed. Here he waits on Adelaide Oval to meet the media after Australia's defeat of England in November 2002.*

THE PHILIP BROWN COLLECTION

This young scoreboard attendant was in the throes of officially registering Sri Lankan Tillakaratne Dilshan's dashing hundred against England at the Asgiriya Stadium at Kandy in 2003 when Dilshan was stumped by Chris Read off the bowling of off-spinner Gareth Batty. Until then, Dilshan had played with characteristic flair, keeping the scoreboard kids gainfully employed.

The universal language of cricket is now being spoken by young Maasai warriors from the Laikipia region of Kenya. Intent on using cricket as a vehicle to promote healthy living and spread awareness of HIV/AIDS, the Maasai Cricket Warriors reached the spiritual home of the ancient game in August 2013. Here Sonyanga Ole Ngais sets himself for a catch before the 'last man stands' cricket tournament at Dulwich sportsground in south London. Kenya has been an Associate Member of the International Cricket Council since 1981.

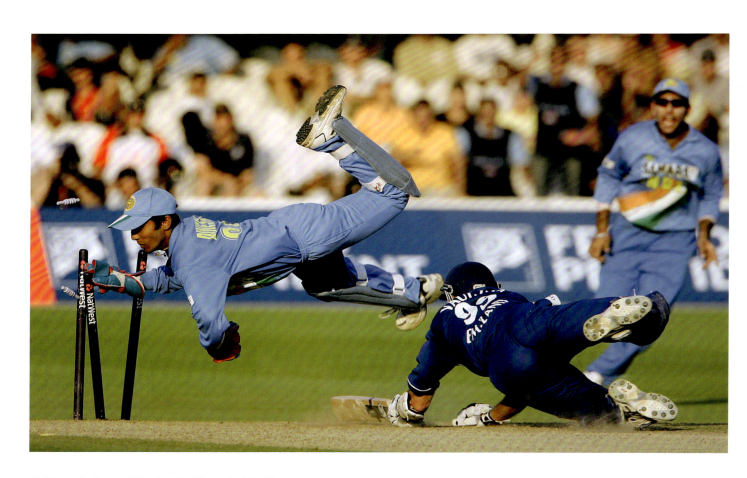

Indian wicketkeeper Dinesh Karthik marks his debut in the one-day international arena with this spectacular if unconventional stumping of England captain Michael Vaughan off the bowling of Harbhajan Singh at Lord's in 2004. India won this third NatWest Challenge match by 23 runs but lost the two previous matches at Nottingham and The Oval by seven wickets and 70 runs respectively.

There is no more idyllic setting for a game of beach cricket than the welcoming Caribbean island nation of Barbados, which has produced a disproportionately high number of the game's greatest cricketers. Understandably Philip Brown has a special fondness for this beautifully framed image of a young boy batting at Batts Rock beach in April 2007.

FOLLOWING PAGE: *England all-rounder Paul Collingwood takes evasive action as forceful Sri Lankan batsman Tillakaratne Dilshan unleashes one of his signature square drives in the Second Test with England at Kandy in December 2003. On aggregate, Dilshan was the highest scorer for the match with innings of 63 and 100. England narrowly saved this match but was defeated by an innings in the final Test in Colombo to lose the three-match series 1–0.*

THE PHILIP BROWN COLLECTION

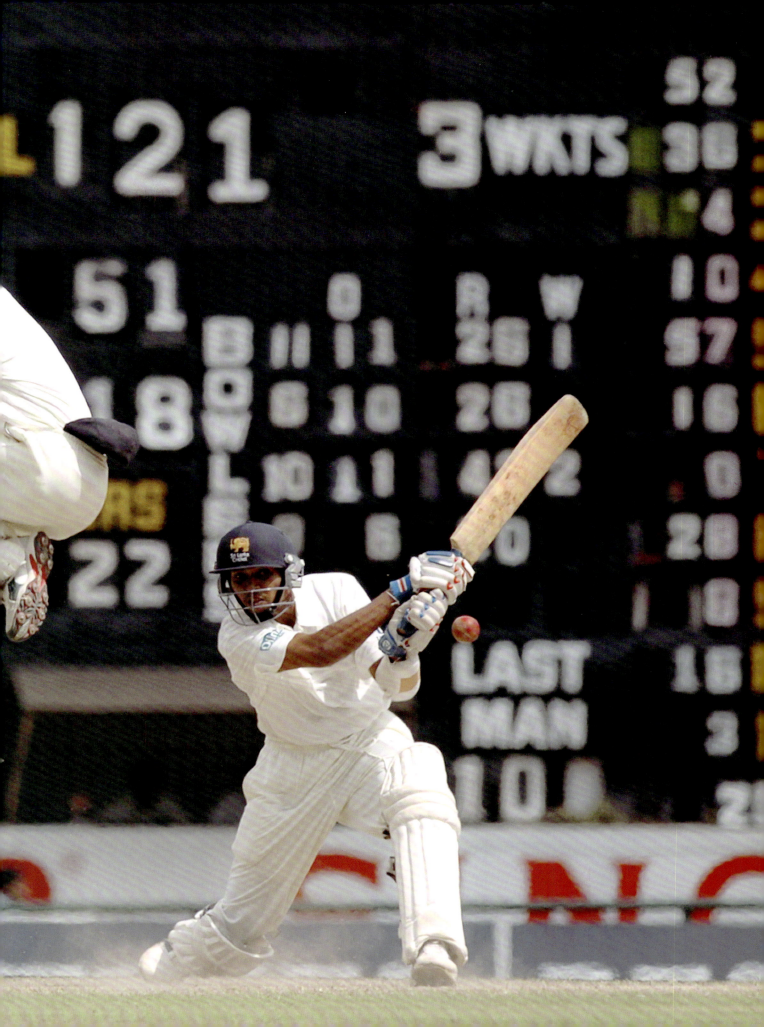

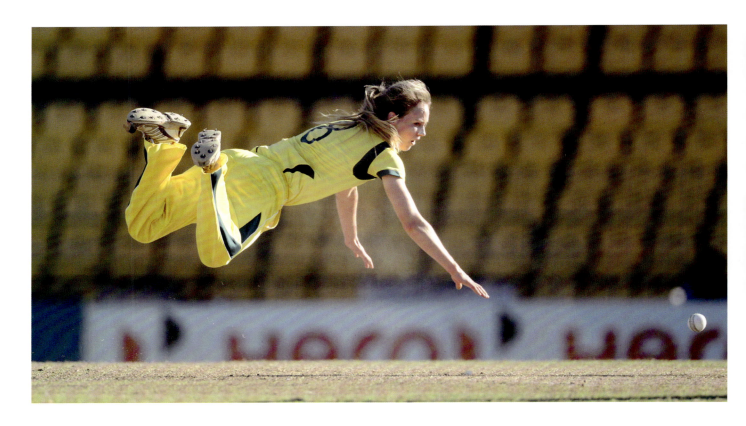

Australian fast bowler Ellyse Perry displays her exceptional athleticism when fielding to her bowling in the semi-final of the women's Twenty20 at the Premadasa Stadium in Colombo in 2012. In her follow-through she leapt to alter the trajectory of the ball and in a flash parried it onto the stumps to run out West Indian batsman Shemaine Campbelle who was backing-up.

Opposite: *Bangladeshi paceman Tapash Kumar raises his finger as though to pre-empt the umpire to award him a leg before wicket decision against Australian captain Ricky Ponting in a NatWest Series match at Cardiff in June 2005. He was refused this appeal but the very next ball he trapped Ponting in line for just one as Australia was sensationally defeated by five wickets. The Wisden Cricketers' Almanack described the result as the greatest upset in 2250 one-day internationals.*

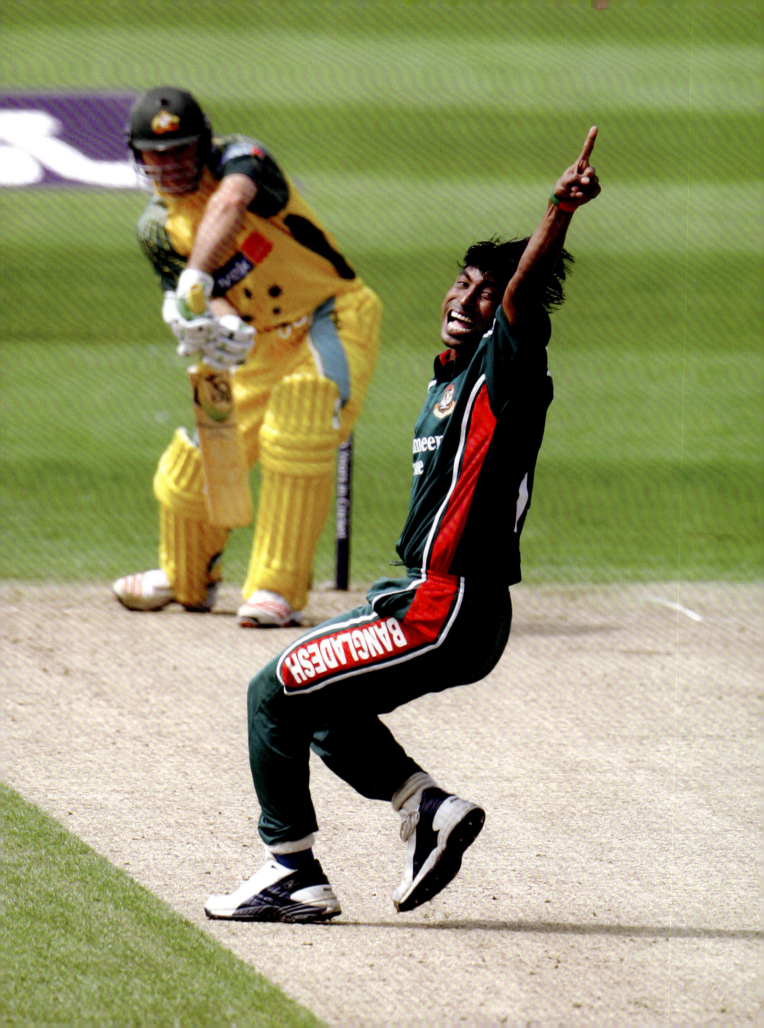

This is a delightful 2006 portrait of the most elaborately named of all elite cricketers. Warnakulasuriya Patabendige Ushaantha Joseph Chaminda Vaas bowled with distinction for Sri Lanka in 111 Test matches over fifteen years from 1994. An affable man with a fondness for music, this genuinely fast left-arm paceman claimed 355 wickets at 29.58 and sits alongside Australia's legendary Dennis Lillee on the list of the game's greatest wicket takers.

A signwriter at the Wankhede Stadium in Mumbai meticulously prepares the name plates to be posted on scoreboards in the third India–England Test match in March 2006. England won their first Test match in India for 21 years to level the three-match series.

The honey-coloured Gateway of India in Sachin Tendulkar's beloved home city of Mumbai makes an imposing backcloth as the Indian maestro proudly holds aloft the World Cup in April 2011. To the unbridled delight of more than a billion people, India defeated Sri Lanka by six wickets in a fascinating final and Tendulkar tasted victory for the first time in a record-equalling sixth and final appearance at the blue-riband event.

OPPOSITE: *Andrew Flintoff's anguished expression at Adelaide Oval tells the sorry tale of England's Ashes campaign in Australia in 2006–07. Flintoff lives with the ignominy of having captained a side that was whitewashed. J.W.H.T. ('Johnny Won't Hit Today') Douglas in 1920–21 and Alistair Cook in 2013–14 suffered a similar fate.*

FOLLOWING PAGE: *Michael Vaughan's England team congregate on the Basin Reserve in Wellington for the ritual team talk before play on the fourth day of the Second Test with New Zealand in March 2008. The following day England achieved their first overseas victory for two years to level the series.*

THE PHILIP BROWN COLLECTION

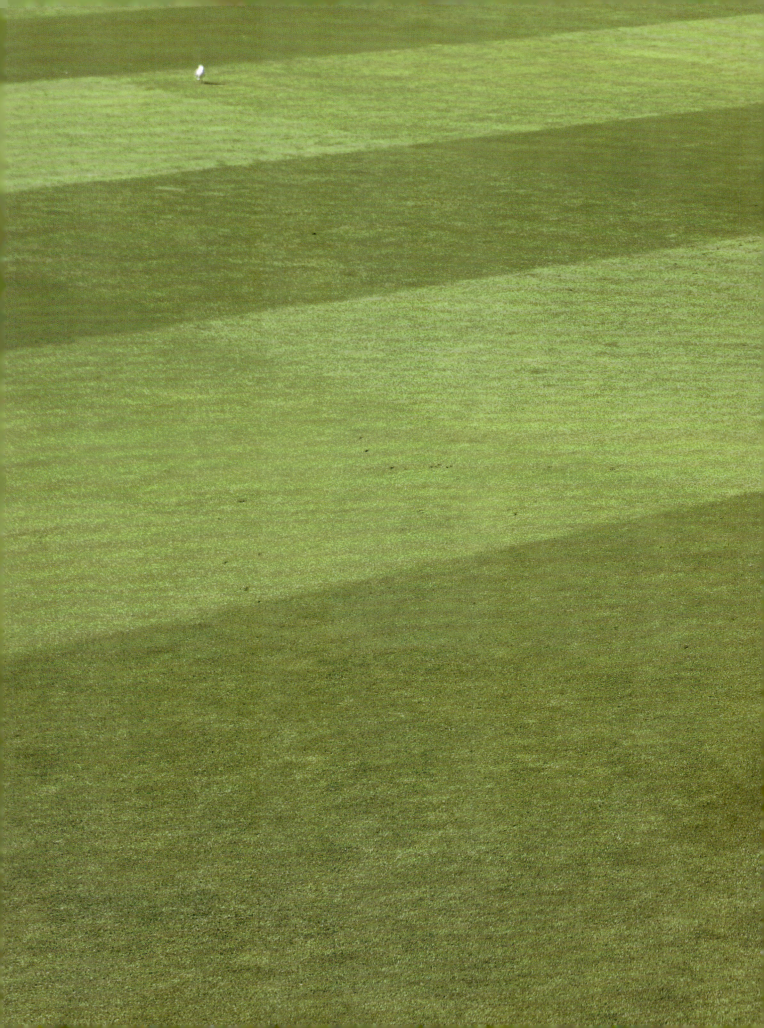

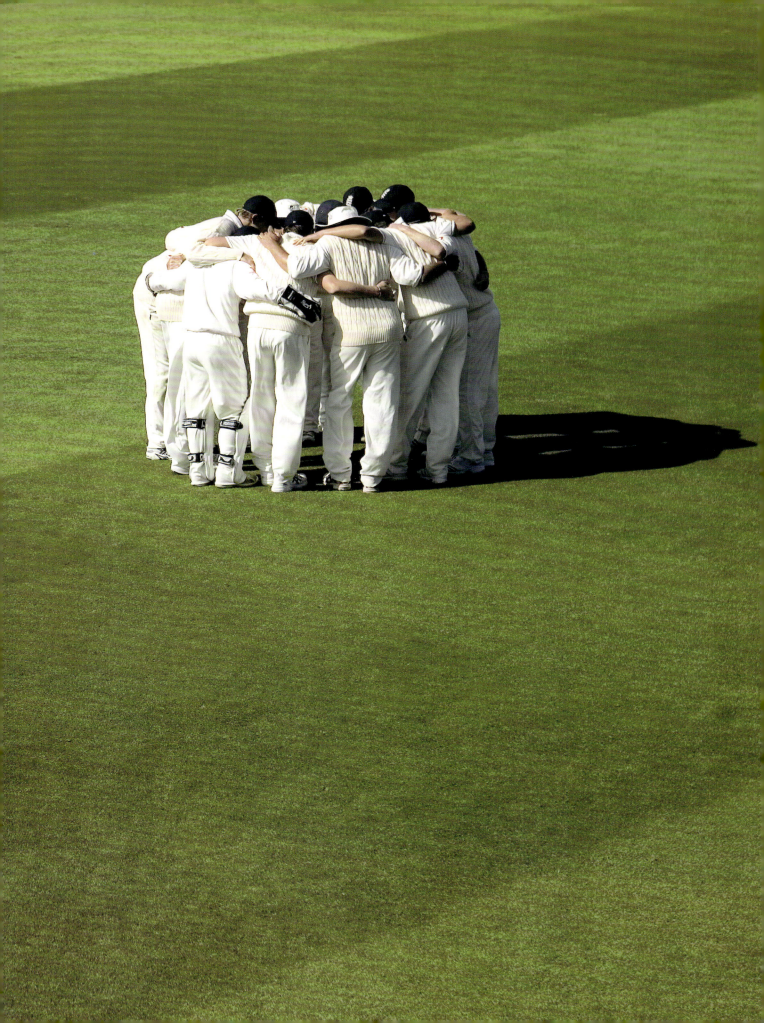

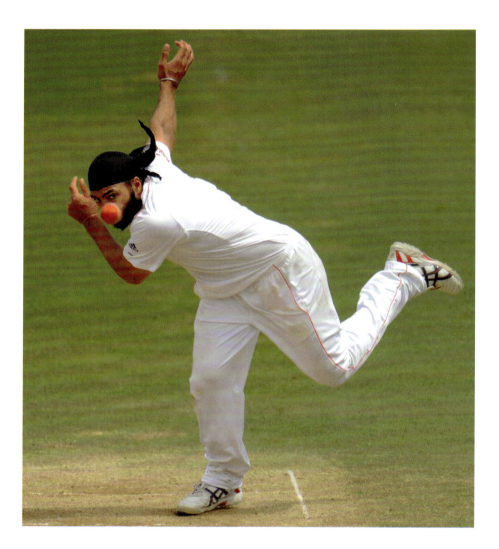

Affectionately known throughout the game as Monty, Mudhsuden Singh Panesar quickly gained a cult following after being promoted to the England team in India in 2006. Admired for his guileful orthodox slow left arm bowling and gently teased for his ineptitude as a fieldsman, Panesar always brought exuberance to the England team with his joyful celebrations after a wicket. He played his 50th Test match in Melbourne in December 2013.

England fast bowler Chris Tremlett—at 200.66 cm the tallest Test cricketer since the retirement of Sir Curtly Ambrose in 2000—sways inside the line of a bouncer from Ryan Harris on the final day of the opening Ashes Test at Brisbane in November 2013. His survival was short-lived and he fell to Harris for seven as Australia triumphed by 381 runs.

THE PHILIP BROWN COLLECTION

These images evoke the beauty and serenity of a glorious game rich in history, art and literature. At sundown on Galle Face Green (above) in the Sri Lankan capital of Colombo, in cricket's new world, a boy emulates his heroes as pedestrians pass by. Scarborough (right) is a quintessential setting in cricket's old world. Here Yorkshire hosts Kent in a championship fixture in August 2008. For many years Australia traditionally ended a tour of England with a match at Scarborough.

THE PHILIP BROWN COLLECTION 181

Australia's brilliant all-rounder Lisa Sthalekar is poised to take a return from the deep during a Twenty20 World Cup semi-final against India, the country of her birth, at Gros Islet, St Lucia, in May 2010. Indian opener Poonan Raut, who top-scored with 44, just makes her ground. Australia won by seven wickets with seven balls to spare and went on to defeat New Zealand by three runs in a thrilling final.

OPPOSITE: *Bowling with pace and venom on the rock-hard pitches of the Indian subcontinent is not for the faint hearted. Here England's gifted swing and seam bowler James Anderson loses balance in his follow through on the second day of the First Test with India at the M.A. Chidambaram Stadium, Chennai, in December 2008. Six years later he had his eye squarely on becoming the first England bowler to reach 400 Test wickets.*

THE PHILIP BROWN COLLECTION

End of play, start of play: victory over England by an innings and 80 runs in three days at Headingley in August 2009 allowed Australian captain Ricky Ponting precious time for extracurricular activities with one-year-old daughter, Emmy. Parenthood softened Ponting in the eyes of critics and his legion of followers.

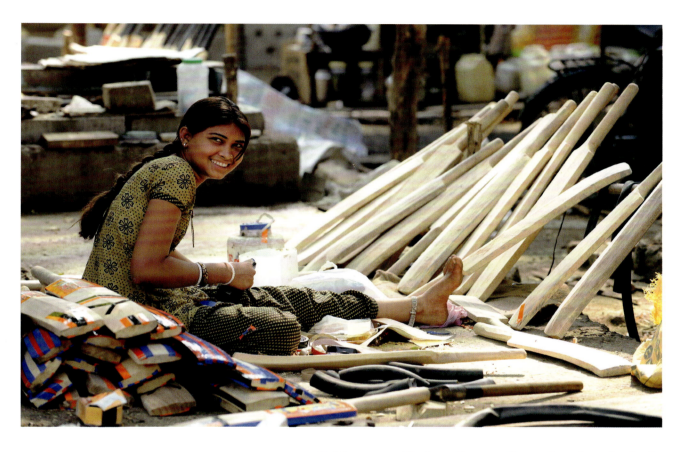

Podshavers, as cricket bat craftsman are known, have downed tools after fashioning blades of various weights and dimensions on a roadside at Nagpur in the geographical centre of India. This young woman seizes the opportunity to add various markings to the bats, which will be shipped to sports stores across India and beyond.

THE PHILIP BROWN COLLECTION

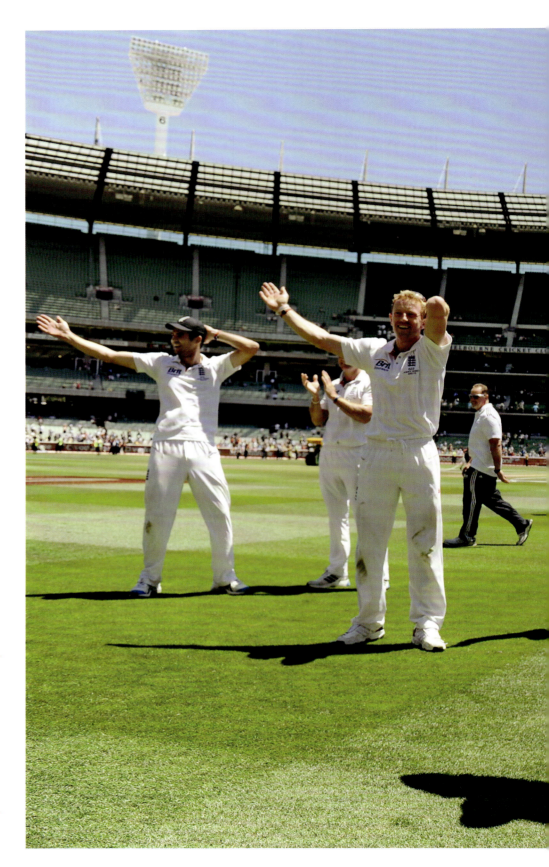

Led by the ebullient spin bowler Graeme Swann, England cricketers give a stirring demonstration of the 'Sprinkler Dance' to celebrate the retention of the Ashes for the first time in 24 years at the MCG on 29 December 2010. The dance, which involves holding an arm out and imitating the bouncy rotation of a garden sprinkler, was cheekily described by captain Andrew Strauss as England's version of the New Zealand haka.

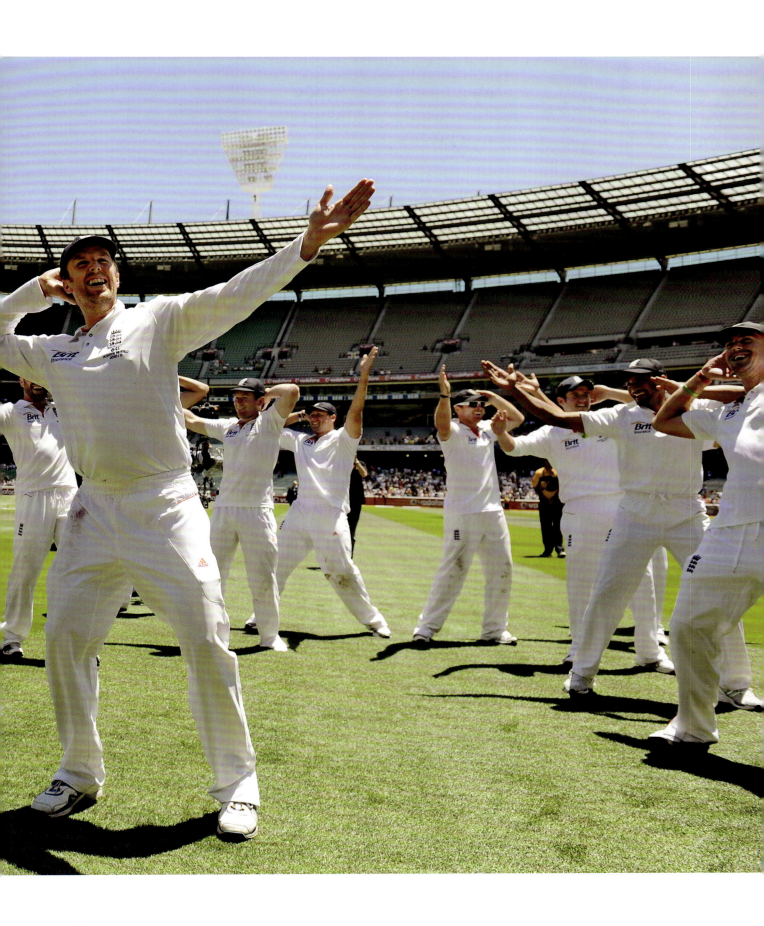

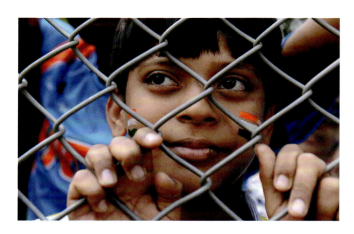

With the Indian flag stencilled on his left cheek, this young fan rejoices in finding his way to a prime position on the fence as India and England do battle in the Second Test match at the Wankhede Stadium, Mumbai, in November 2012.

Historically the lathi favoured by Indian police has been a metal-bound bamboo stick. But even the lathi has changed in modern India and a policeman uses a state-of-the-art lathi to control men and boys queuing for tickets for the India–England World Cup match at Bangalore in February 2011. Boys have been known to play a dangerous game by taunting policemen and then hiding in the queue.

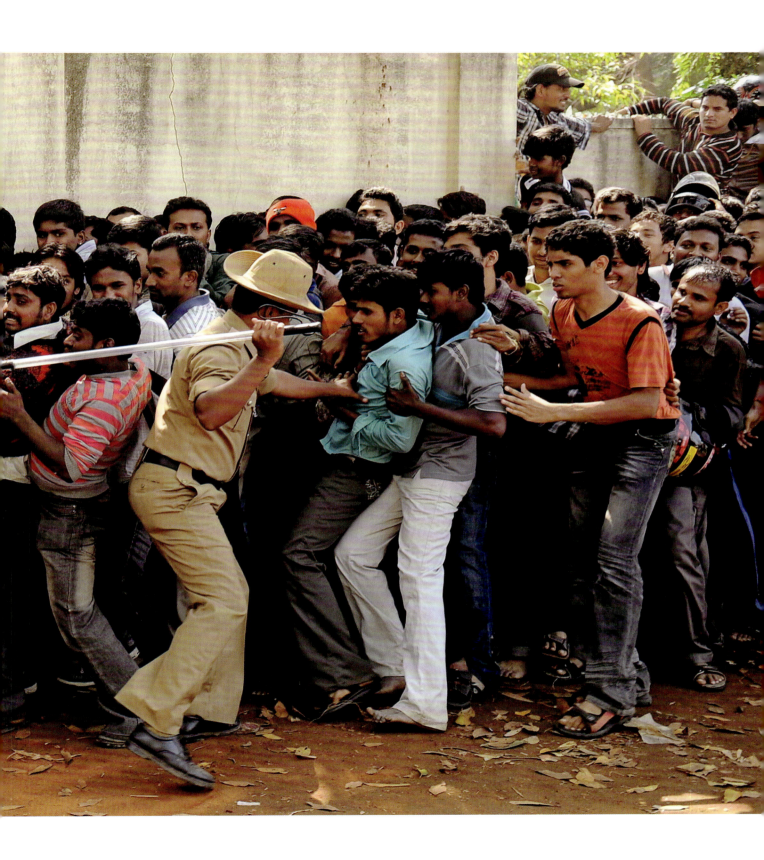

THE PHILIP BROWN COLLECTION

Casual and competitive cricket is played by day and by night on streets throughout the Indian subcontinent. Even the narrowest and busiest of alleyways stage communal matches. This magnificent photograph shows a young Bangladeshi bowling in front of a sizeable crowd in a Chittagong street on the eve of Bangladesh's World Cup match with England in March 2011.

THE PHILIP BROWN COLLECTION

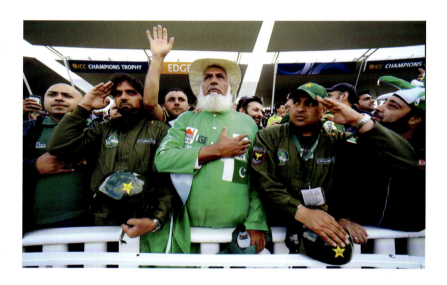

With hand over heart, 'Cha Cha' (uncle) Abdul Jalil and fellow patriots pause for the national anthem before the ICC Champions Trophy match against India at Edgbaston, Birmingham, in June 2013. Jalil is a cheerleader and mentor to many and has been photographed at Pakistan matches throughout the world over many years.

Spectators react in various ways as it becomes obvious that a photographer is going to be struck by a white-seamed missile in the ICC Champions Trophy match between India and the West Indies at The Oval, London, in June 2013.

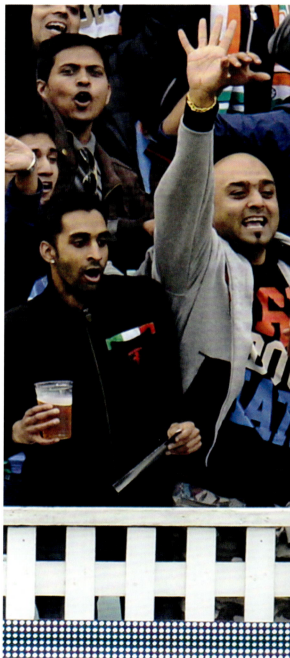

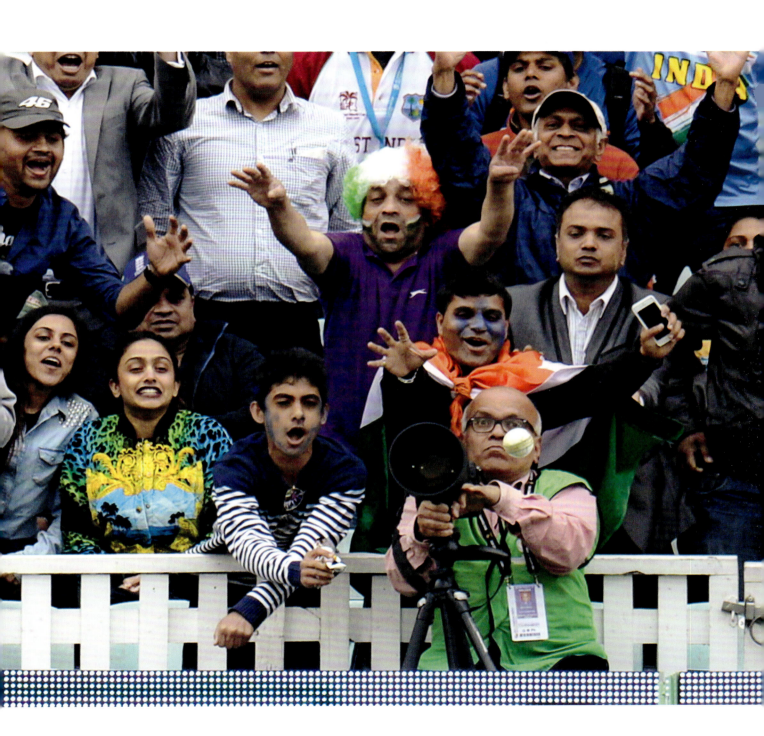

THE PHILIP BROWN COLLECTION

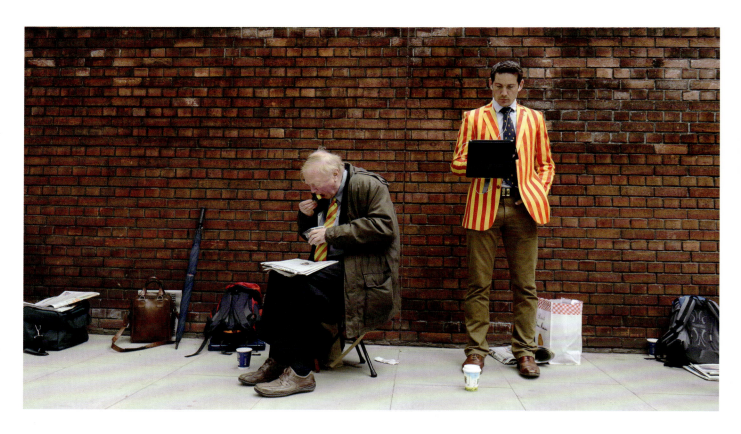

Marylebone Cricket Club members in signature garb observe the daily rituals of their time while waiting patiently in a queue outside Lord's before the fourth day of the First Test between England and New Zealand in May 2013.

Where there's a will, there's a way. Determined not to let unseasonably cold weather ruin his day at the cricket, this dedicated fan brought a sleeping bag to the county ground at Hove for the match between Sussex and Warwickshire.

FOLLOWING PAGE: *Majestic Lumley Castle forms a spectacular backdrop to the Riverside ground at Chester-le-Street near Durham, England, but superstitious cricketers and fans have been disconcerted to learn that a ghost is said to reside within its walls. Australia played a Test match at Riverside for the first time in 2013; while no ghost was reported, the Australians lost by 74 runs when within sight of a victory that would have earned them some redemption.*

THE PHILIP BROWN COLLECTION

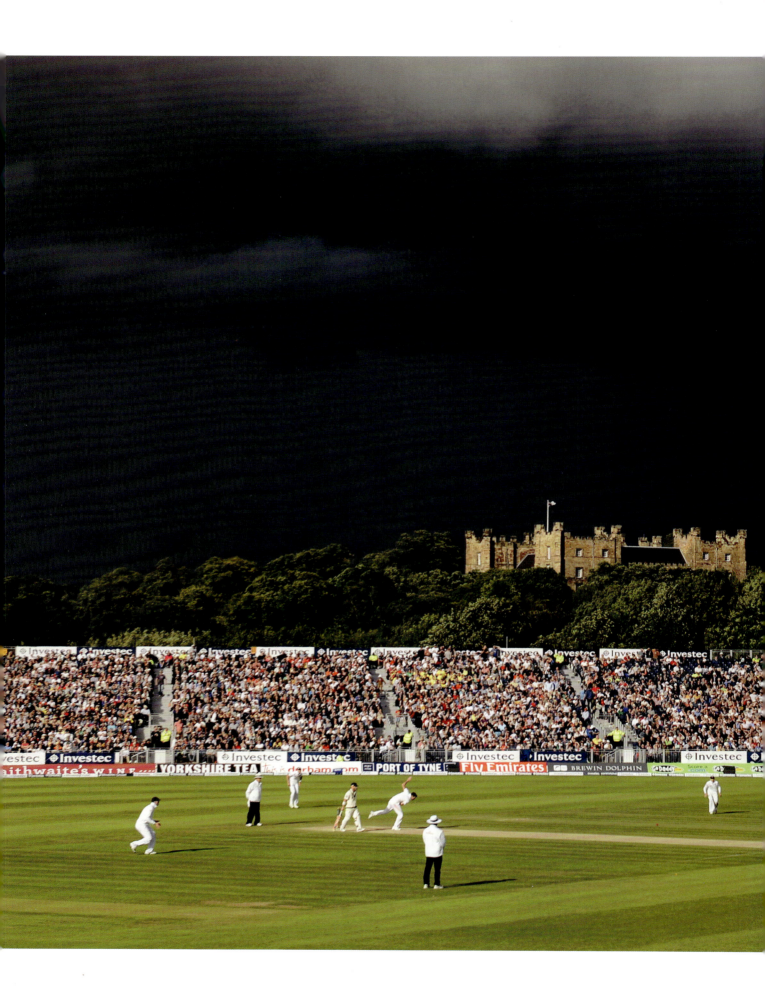

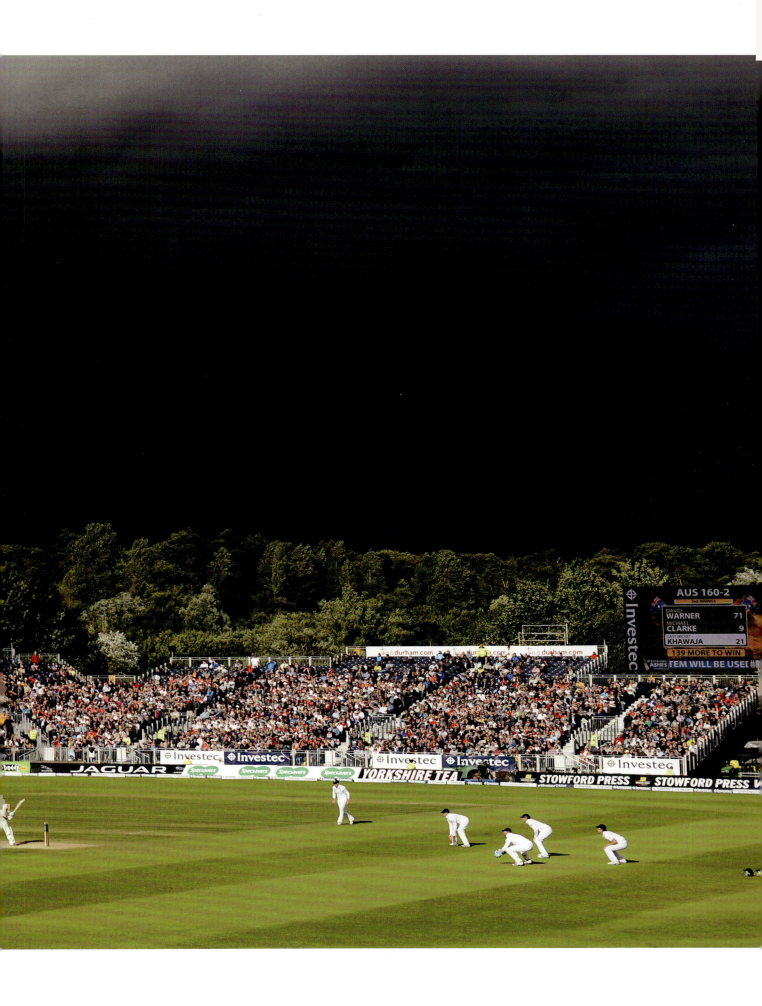

ACKNOWLEDGEMENTS

THE BRADMAN MUSEUM wishes to thank the legions of people who have worked so hard to create a world-class museum with what began merely as an intriguing idea. Against all odds the museum has survived and prospered in Bowral, the childhood town of the world's greatest batsman. A successive array of talented individuals from diverse backgrounds, united in their respect for Sir Donald and their belief in cricket as a force for good, have brought the concept to fruition and ensured its sustainability. One hopes Bradman would approve of their efforts to meet his objective of the museum to 'honour and strengthen the game of cricket' and that it now adequately reflects the international nature of the game he loved.

The museum wishes to gratefully acknowledge the many people whose contributions made this book possible. We are indebted to the photographers who have entrusted the museum with the results of their life's work in the spirit of sharing their skill and creativity with the visiting public. Their imagery has engagingly complemented and adds stimulus to the museum's rich collection. The affable and enthusiastic Bruce Postle has been a delight to work with, his generosity knowing no bounds. Jan Johnson, widow of Viv Jenkins, took a leap of faith in giving the museum her late husband's superlative collection of over 1000 images. We are permanently indebted to her for her trust and unqualified support. Since Philip Brown first dashed into the museum some eight years ago to deliver a 1989 black and white photograph of Bob Hawke sharing a joke with Dean Jones and Allan Border at Lord's, his generosity of time and supply of creative and insightful images from both within and beyond the cricket field has been unstinting. We thank him for his patience, honesty and flexibility.

Author Mike Coward has been an indefatigable supporter of the museum's work for over a quarter of a century. His authoritative text reflects a wisdom gleaned from his careful observation of all aspects of the game over many decades—players, officials, the diverse cultures and locations where the game is played together with colleagues from the 'Fourth Estate'. We extend heartfelt thanks for his guidance and loyalty.

Publishers Allen & Unwin have always cared deeply about cricket and cricket publishing and the museum is very grateful for the expertise and encouragement of Patrick Gallagher, Angela Handley and Siobhan Cantrill who guided the project.

Finally, without the generosity of the public the Bradman Museum's wider collection would be a mere rump. Over 700 generous donors have built a unique collection nearing 11,000 individual objects. This legacy for future generations of Australians and overseas visitors cannot be overstated. It is to them, for their confidence and trust in the institution, that this book is dedicated.

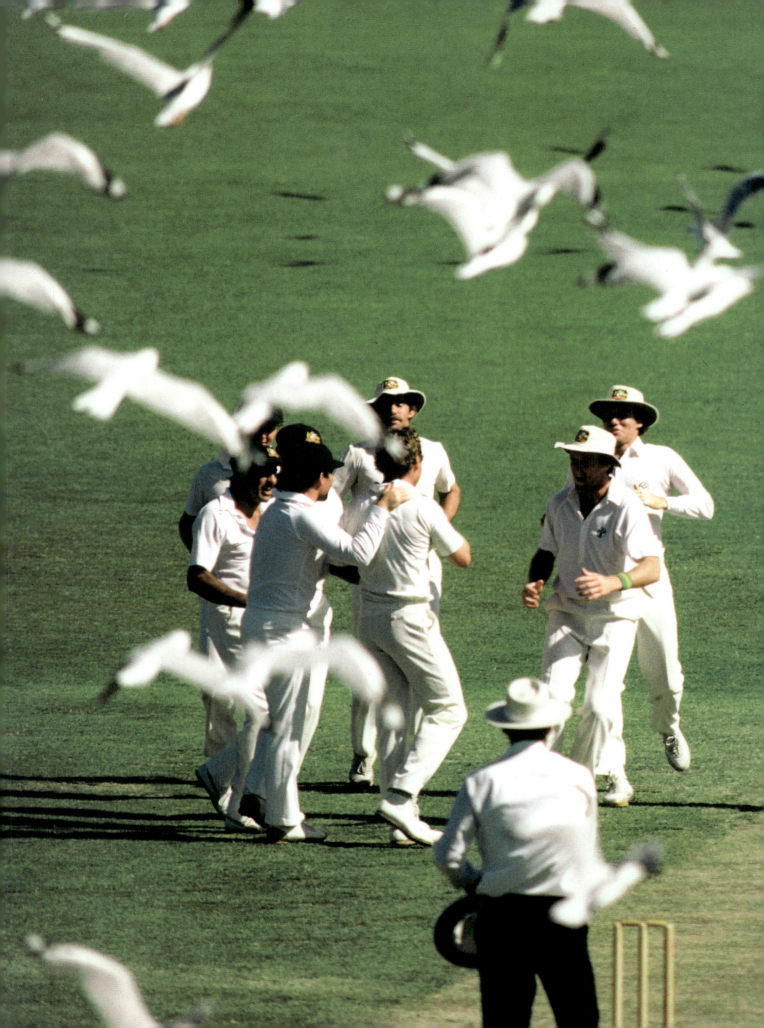